Oxford
IN *Prints*

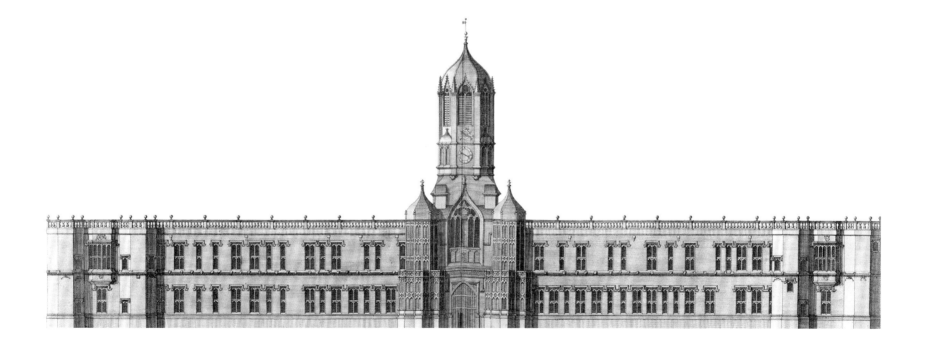

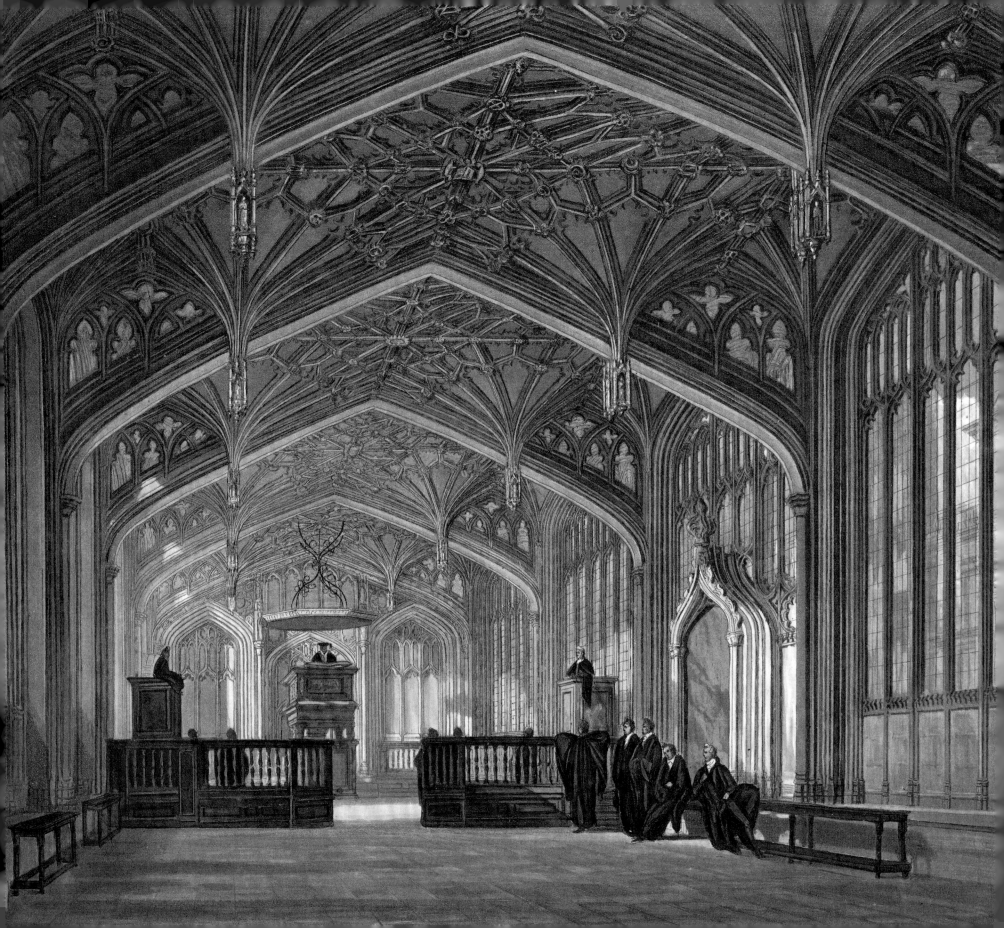

Oxford
IN *Prints*

1675–1900

Peter Whitfield

Bodleian Libraries
UNIVERSITY OF OXFORD

First published in 2016 by the Bodleian Library
Broad Street, Oxford OX1 3BG

www.bodleianshop.co.uk

ISBN 978 1 85124 246 7

Cover design by Dot Little at the Bodleian Library
Designed and typeset in Farnham by Laura Parker at
Paul Holberton Publishing, London
Printed and bound in China by C&C Offset Printing Co. Ltd
on 157gsm matt art (Chinese Hua Xia Sun)

British Library Catalogue in Publishing Data
A CIP record of this publication is available from
the British Library

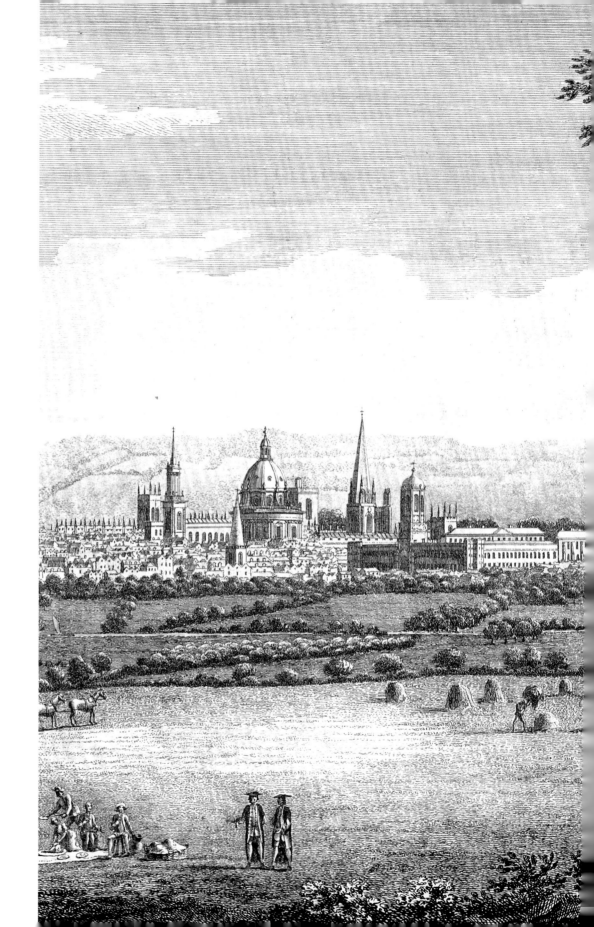

Contents

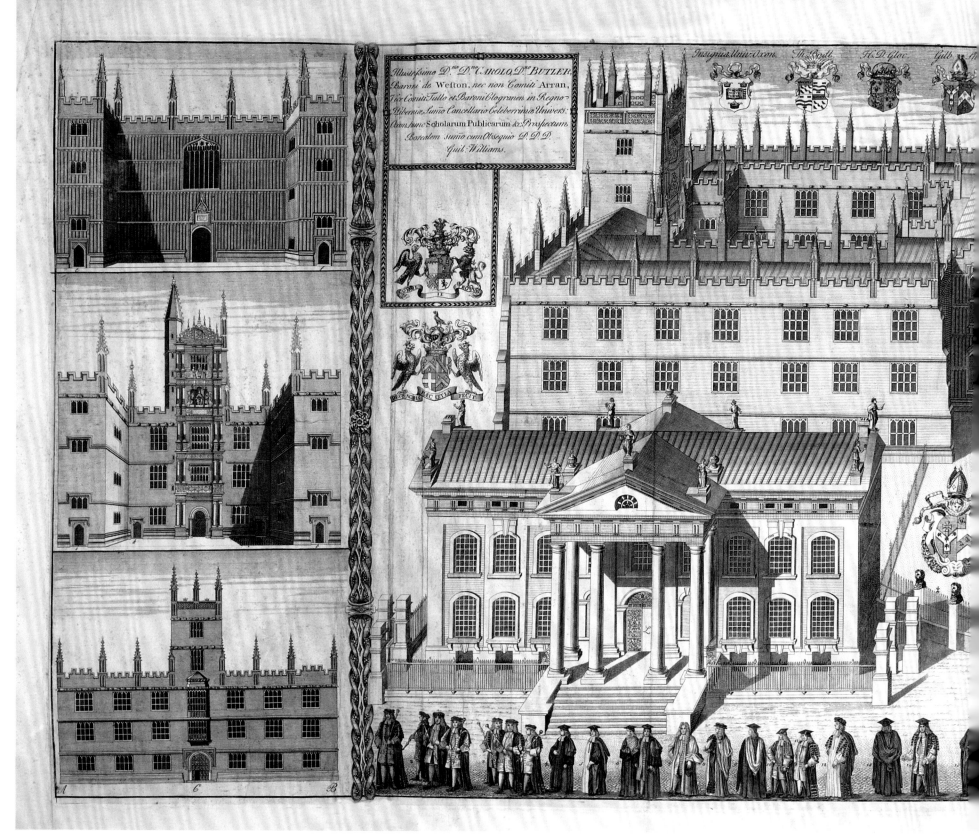

Illustrissimo D.no D.no CAROLO D.no BUTLER,
Baroni de Weston, nec non Comiti Arran,
Vice Comiti Tullo et Baroni Clogrenen in Regno
Hiberniæ, Summo Cancellario Celeberrimæ Univers:
Oxon. hunc Scholarum Publicarum &c. Prospectum,
Borealem summo cum Obsequio D.D.D.
Guil: Williams.

Insignia Univ: Oxon. Th: Bodl. H: D: Gloc. Gilb: &c.

DOMINUS ILLUMINATIO MEA

DEUS NOBIS HÆC OTIA FECIT

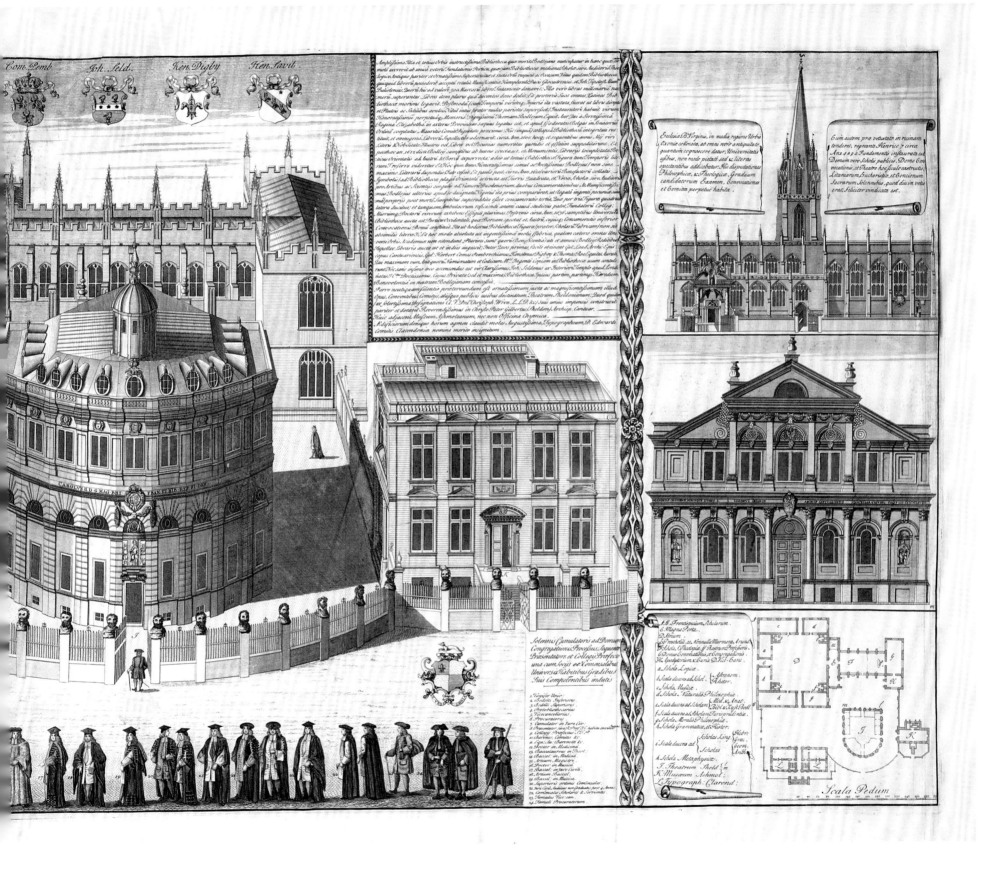

Introduction

THERE IS NO CLEAR FOUNDATION DATE FOR THE UNIVERSITY OF OXFORD, but what is certain is that even by the year 1200 a large number of academic halls were flourishing in the city. Some of the halls were maintained by the monastic orders as places where the more intellectually inclined monks could go to study. Given the scarcity of books, teaching took the form of lectures and personal tuition. The halls were to some extent regulated and their status guaranteed by the university, and this was signified by the awarding of degrees – those of Bachelor, Master and Doctor. These academic halls could simply be houses, leased by the master and run in the way that a private school would be, and like private schools they could come and go.

Perhaps Oxford might have continued to grow and progress through the academic halls, but a significant turning-point in its history came with the founding of the earliest colleges in the thirteenth century – University, Balliol and Merton. These colleges were sited on land bought by the founders and owned by the colleges themselves, they were endowed with assets which could guarantee their existence in perpetuity and they were self-governing entities. This was an institutional model which would be replicated again and again in Oxford, and simultaneously in Cambridge, too. In this model lay the seeds of the way Oxford would function for the following 600 years, and the way the physical fabric of the city would take shape, becoming one of the great architectural gems of Europe.

Architecturally the beginnings were modest enough and the model was the monastic community – a range of buildings in which to sleep, to study, to eat and to worship; libraries and gardens were luxuries that came later. The idea of four wings and a gatehouse built around a central courtyard came naturally from the monastic model, and this is exactly what we see in the 1578 plan of the city published by Ralph Agas: we instantly recognize Balliol, Trinity, St John's and most of the others as conforming to this pattern, while Magdalen, Merton, New College and the half-finished Christ Church are evidently larger and more complex in structure. Thus the medieval pattern was established that, despite many exceptions and innovations, would continue to dominate the character of Oxford for centuries. Continuity with the past was an ideal which colleges, benefactors and architects prized highly, and the clearest way to demonstrate that continuity was to keep alive the medieval form and fabric of their institutions.

It should not be forgotten that the architecture, the outward form of the college, was ultimately always less important than the people within it. The college originally meant the fellows, the scholars and the students, not the stone walls which they inhabited. During the years of Renaissance and Reformation, students came to be drawn from a wider social base – the sons of nobility or gentry, who came to Oxford to receive an education to fit them for lives spent in politics and the law – no longer purely within the Church. The suppression of the monasteries and the break with Rome could not fail to encourage this gradual process of secularization. No one has ever claimed that Oxford as a whole rushed to embrace Renaissance Humanism and the intellectual openness which it encouraged, but there were significant figures who were in touch with the new European scholarship: Erasmus himself paid tribute to them, proclaiming

When I hear my Colet I seem to be listening to Plato himself. In Grocin, who does not marvel at such a perfection of learning? What can be more acute, profound and delicate than the judgement of Linacre? What has nature ever created more gentle, more sweet, more happy than the genius of More?

All the scholars named had studied or taught in Oxford. In the early political moves of the English Reformation, it was perfectly possible that the wealthy colleges, as pillars of the old Catholic order, might have been despoiled like the monasteries; but the Crown had a genuine respect for Oxford's educational value to the nation, both religious and secular, so the danger passed, and they became participants in the Reformation. New colleges like Trinity, St John's and Pembroke were founded now by laymen. The university's intellectual and social identity was shifting subtly but profoundly, making an Oxford education a prized possession in many avocations outside the Church, including that simply of 'gentleman'. This was a historic shift, not planned by anyone, but a component of social change, and it was clearly vital to Oxford's survival.

Nor did the colleges stand still architecturally. They were enlarged and partly rebuilt, made more comfortable, had gardens laid out, and had chapels, halls and libraries refitted. During this process new architectural ideas were occasionally grafted on to the old structures. St John's was awarded a second quadrangle, built in

a daring, Italianate style, but this was exceptional. Wadham, newly built in 1610–13, was embellished with an inner gate-tower framed by pairs of classical columns, yet its overall plan, the hall and the chapel were still largely medieval, as was the other new college of this period, Pembroke. Merton, Oriel, University, Lincoln, Jesus and Exeter were all modernized without altering their traditional character. Balliol, New College, Magdalen and All Souls did not participate in this spate of seventeenth-century rebuilding, which was in any case halted by the Civil War. The last significant work of pre-war architecture in Oxford was the fan-vault of the Hall staircase in Christ Church, which, while dating from 1638, could nevertheless have been designed and built two centuries earlier. By far the most important building of this period was not undertaken by the colleges but by the university itself: the Schools Quadrangle was utterly conservative, the latest of late Gothic, with spiky turrets rising into the skyline, a great church-like central window and the striking vertical stone 'panelling' of the inner walls.

It should be remembered that much of this building, if not all of it, from the Late Middle Ages through to the nineteenth century, was accomplished at the cost of removing existing townhouses and tenements. The Radcliffe Library waited twenty years to be built, while the late medieval and Tudor houses which stood on the site were bought up and demolished. The old domestic architecture which we now see here and there, in Holywell Street for example, disappeared as the university and the colleges bought up the land and the common people were squeezed out, to live as best they might in suburbs such as St Ebbe's and St Clement's. Conflict between town and gown has deep roots in Oxford's history, and this process was a perpetual grievance.

The revised, expanded, but essentially medieval Oxford was recorded in 1675 by the artist-engraver David Loggan. Of Scotch descent, but born and trained on the Continent, he came to Oxford in 1665 to escape the plague. His monumental work *Oxonia Illustrata* contained over forty plates of the university buildings, the colleges, and a few surviving academic halls. It served as a companion to Anthony à Wood's history of the university, which was published in the preceding year. Some of Loggan's pictures are natural, ground-level drawings of façades, such as St Mary's Church or the Sheldonian. But a drawing of one outer wall was clearly inadequate to do justice to the colleges and Loggan therefore constructed bird's-eye views, so that the spectator could see into the quadrangles and grasp the complex layout of the community built around it. His line work is crystal clear and he enlivens almost all the pictures with picturesque details: magnificent coaches drawn by teams of horses, street pedlars, barking dogs, grave scholars, and early tourists admiring the sights of the city. One of the most delightful details must have been based on personal observation: it shows New College Tower, around which nine birds are wheeling,

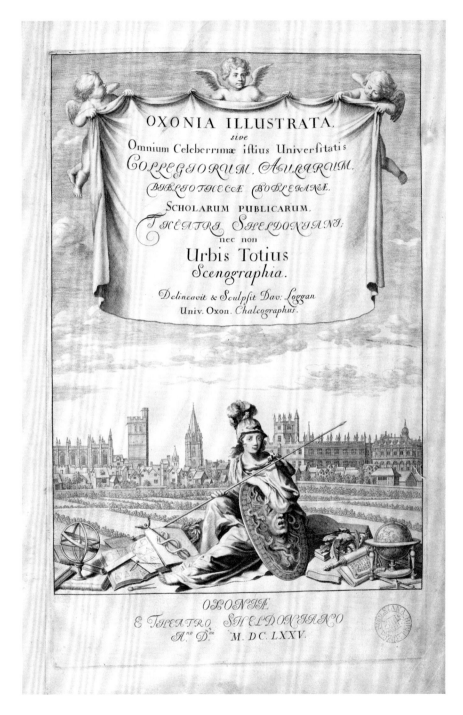

The university buildings with New College and St Mary's Church, 1675.
Athena, Greek goddess of wisdom, sits before the buildings, surrounded by symbols of learning.

OXONIA ILLUSTRATA *(title page)*

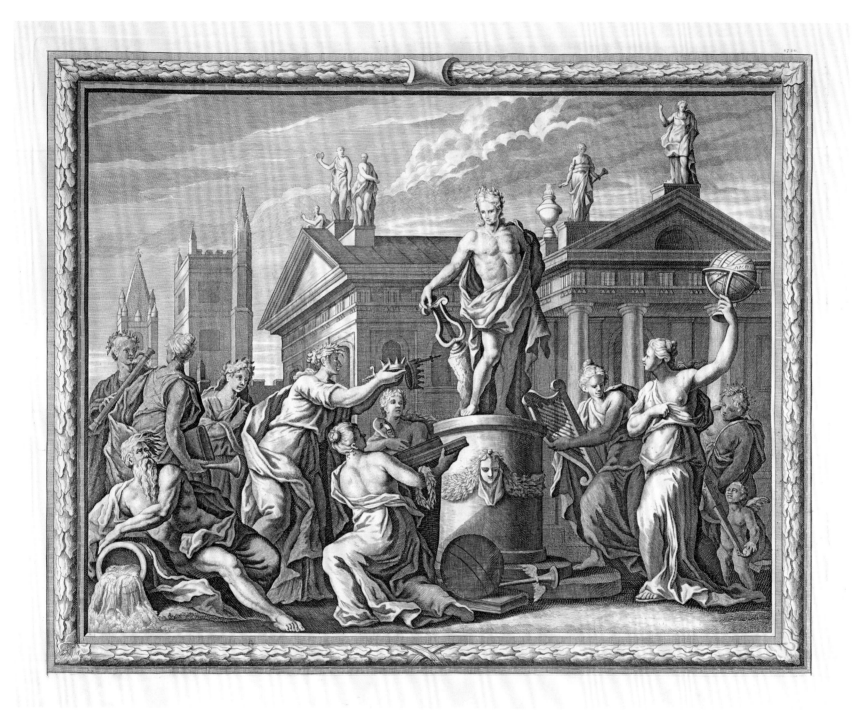

The new Clarendon Building with the Tower of the Five Orders and the spire of St Mary's Church in the background, 1720.
Apollo and the Muses celebrate the completion of the university's new printing house.

OXFORD ALMANACK

presumably having been driven out of the tower into the sky by the sudden pealing of the bells. Loggan's title page is equally ingenious: it shows the figure of Athena, Greek goddess of wisdom, leaning on a shield which displays the head of the Gorgon. The coded message seems to be that Oxford's wisdom has become embodied in the stone structures.

Loggan's was the first of a series of invaluable pictorial works which preserve a historical snapshot of Oxford at a given moment. His timing was in some ways fortunate since a very recently completed building like the Sheldonian, of 1669, could be included; on the other hand, the magnificent view of Christ Church missed Tom Tower by six years. More generally, it preceded the most momentous half-century in Oxford's architectural history, when the vogue for classical styles took over the city. One of the most striking aspects of this new style is the way in which the university swung immediately and exclusively behind classicism. The Sheldonian, the Clarendon Building, the Radcliffe Library and the Old Ashmolean Museum were built adjacent to the Bodleian, creating for the first time a true university quarter, the work of the supreme British architects of their time, Wren, Hawksmoor and Gibbs, and all its components avowedly and brilliantly in the classical style, though sometimes with an element of Restoration Baroque.

Some of the wealthier colleges quickly became involved in the rage for rebuilding. The chief works of this period were the new range, to Wren's designs, at Trinity, Peckwater Quadrangle at Christ Church, the New Building at Magdalen, the Garden Quadrangle at New College, the transformation of Gloucester Hall into Worcester College, the partial reconstruction of All Souls, and the far-reaching reconstruction of Queen's – the only case of a college breaking radically with its past and opting for a total rebuild. In the case of Magdalen and All Soul's, the new work was originally intended as part of still more ambitious plans which were never completed, while at Brasenose a grandiose new plan by Hawksmoor was never begun at all. Among the university personnel, the leading influence was Henry Aldrich, dean of Christ Church, who designed Peckwater Quad himself. After his death he was succeeded by George Clarke, a fellow of All Souls, and both were ably supported by the Oxford mason-contractor William Townesend, who collaborated in the design and building of most of these new projects. Why was it done? Simply because the masters of the colleges, many of the dons and the students, too, wished to participate in the new fashion of neo-classical architecture, brought home to England by connoisseurs returning from Italy and the Grand Tour. They wished their colleges to be elegant and civilized, and to resemble aristocratic country houses. To this end, where space permitted, a formal garden might be added, as at Trinity and New College, and the new quadrangle left open to it, as if to a gentleman's park.

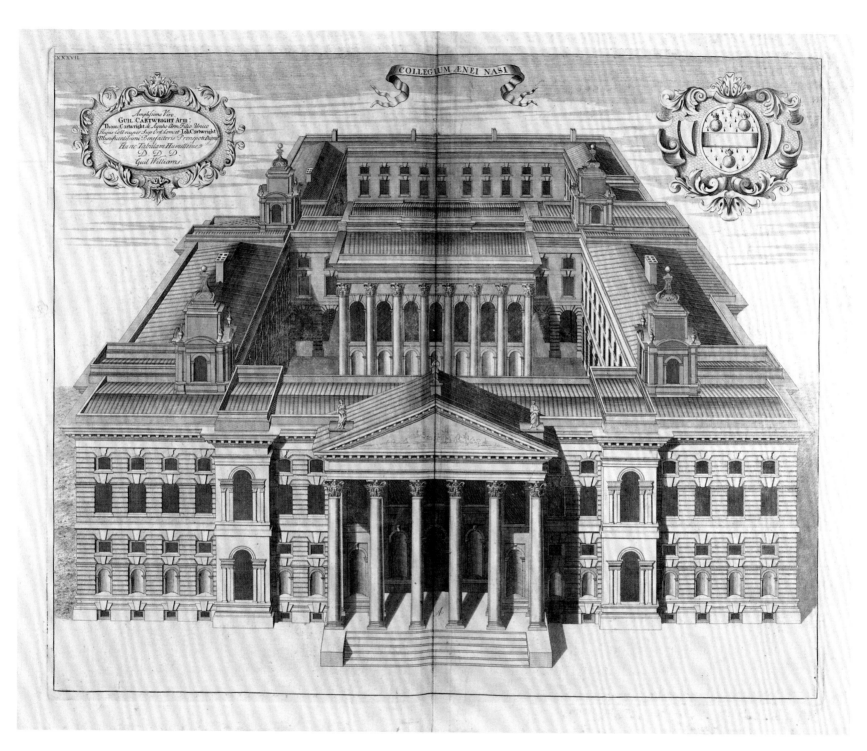

COLLEGIUM ÆNEI NASI

Amplissimo Viro
GUIL. CARTWRIGHT Arm:
Thom: Cartwright de Aynho Arm Filio Unico
hujus Coll nuper Sup Ord Com et Ioh Cartwright
Munificentissimi Benefactoris Pronepoti Digno
Hanc Tabellam Humillime?
D. D. D.
Guil Williams.

Design for Brasenose College, 1733. This grandiose design by Nicholas Hawksmoor with a classically inspired High Street frontage was never built.

OXONIA DEPICTA

This revolution in Oxford's architecture was captured in part in a new book, a kind of updated Loggan, entitled *Oxonia Depicta*, by William Williams, published in 1733. Williams is an enigmatic figure, who produced the Almanacks for 1725 and 1726 and who had worked on an important map of North Wales with the cartographer and engraver John Senex. *Oxonia Depicta* was a work clearly aimed at the architectural connoisseur, with carefully drawn elevations and plans of all the college buildings. Williams largely did not emulate Loggan's visually appealing bird's-eye views and his drawings are spare, with few if any figures or picturesque details. His distinctive innovation was a series of very long perspective views of some colleges, clearly designed to show the new style of garden stretching out far beyond the walls of the college itself, as in Trinity, St John's and Wadham. He also shows Hawksmoor's sensational design for the new Brasenose, which was never realized. The new All Saints Church, another Aldrich project, is represented in a fine double view, outside and in, showing the new classicizing trend in a town church.

Between Loggan and Williams the richest and most valuable series of images of Oxford had been taking shape, namely the Oxford Almanacks. These were broadsheet calendars published by the university and printed at the Press, originally in the Sheldonian. They tabulated the significant events in the academic year and at first their margins were ornamented with graphic devices. But this graphic element soon became larger and more elaborate and, by 1690, it was the practice for the upper section of the sheet, probably two thirds of the whole area, to be filled with some highly artistic scene, usually allegorical, representing the battle between ignorance and learning, vice and virtue, truth and falsehood, and so on. Some of these images were directly copied from well-known paintings and they were almost all classical in their theme and their figures, although a biblical or Christian subject might be used occasionally. By 1715, when Oxford's great wave of rebuilding was under way, the idea presented itself of depicting scenes of Oxford itself, and especially this process of renewal, which could be seen imaginatively as bringing the university closer to classical ideals of beauty and learning. This intention is seen dramatically and unmistakably in the 1720 Almanack, where Apollo and the Muses stand before the new Clarendon Building. For the next twenty years there was evidently a kind of competition to see which college would have its new building celebrated in the Almanack. When this phase of renewal came to an end, the designers went back to the other colleges and showed them with an imagined cavalcade of founders and benefactors, holding charters and plans, going as far back as King Alfred, enthroned before University College, and Wolsey looking very apprehensively at King Henry VIII in front of Christ Church. A little later, interiors such as college halls, chapels and libraries would also be featured, and general views of Oxford, sometimes with

little or no specific university architecture, for example the charming 1780 picture of a couple of dons stepping gingerly into a punt at Folly Bridge (p.76). Reputable artists came to be commissioned to make the original drawings, none more distinguished than J.M.W. Turner, who provided the basis of several Almanacks in the years 1800–10, which the leading engraver James Basire turned into printed form. The Almanack images were, of course, influenced by changing artistic tastes, and around Turner's period they became more romantic, concerned to produce a work of art that embodied a feeling rather than a plain visual record of a certain building: sunset light and windblown trees came into fashion, often stealing the show from the architecture.

Both Loggan and Williams had emphasized the buildings rather than their context, but in 1755 John Donowell, an architect and draughtsman, produced his *Eight views of Oxford*, in which the streets and their occupants became as important as the buildings they contained. This romantic element in the artist's view of Oxford continued when the new technique of aquatint engraving was first applied to Oxford by Thomas Malton in his series *Picturesque Views of the City of Oxford*, published between 1802 and 1804, but never completed owing to his early death. The trend continued in one of the most famous of all Oxford books, Rudolph Ackermann's *History of the University of Oxford*, published in 1814 with a text by William Combe. Ackermann employed expert engravers who worked from drawings by noted architectural artists such as Augustus Pugin and William Westall. The aquatints were skilfully coloured by hand, with the result that Oxford was seen not as a city of severe grey stones, but as a place of colour and life, not simply in the sky, but in the college lawns, in clothing, in stained-glass windows, in furnishings, in horses and in flowers. Although the plates were all of historical sights, they were humanized, and to some extent frankly glamourized. This was the perfect souvenir of Oxford for the visitor, the tourist or the departing student, yet the text was serious and workmanlike, ensuring the book's classic status. Just as Williams had produced a 'new Loggan', so in 1843 would come a 'new Ackermann', the work of William Delamotte in his *Original Views of Oxford, its Colleges, Chapels and Gardens*. Here the drawings and the hand-coloured lithographs are of very fine quality, but the overall feel now seems very Victorian and sentimental, with a little too much emphasis on elegant ladies and pretty children enlivening the streets outside the colleges.

View of Oxford from New College Tower, 1814.

HISTORY OF OXFORD

Between Ackermann and Delamotte had appeared another comprehensive university history, *Memorials of Oxford*, in three volumes, 1832–37, by James Ingram, who was president of Trinity College and keeper of the University Archives. This work contained no less than 100 drawings by Frederick Mackenzie, beautifully reproduced by John Le Keux using the new technique of steel engraving. These are small, delicate pictures full of detail and the subtle effects of shade that steel engraving gives; they restate the great appeal of the monochrome engraving, making the coloured pictures of Ackermann and Delamotte seem gaudy by comparison.

In the mid-eighteenth century, the fashion for classical architecture had not vanished overnight, but the desire to spend vast sums of money on grandiose building projects had become much rarer. In an age when the university was generally somnolent and the number of fellows and students was declining, there seemed no reason to continue college rebuilding on a lavish scale. But several new buildings towards the end of the century were as fervently classical as any in Oxford, above all the Radcliffe Observatory, directly copied from an Athenian model. Well into the nineteenth century, the university itself continued to prefer the classical style – for the new University Press headquarters in the 1820s and in the new Ashmolean/Taylorian building of the 1840s, then called the University Galleries. But the great story of Oxford architecture in these years, as elsewhere in England, was the resurgence of the Gothic style. The Ashmolean/Taylorian was the last neo-classical building in Oxford, just as the British Museum was the last in London: had either of them been commissioned a decade later, they would both surely have been in the Gothic style.

In Oxford the significant wholly new buildings in the Gothic style were the University Museum, built in the 1860s, and Keble College a decade later. But a large group of older colleges were restored, renovated or refaced in the Victorian age, and all of them chose to re-affirm their allegiance to the Gothic, as a style that was sanctified by its ecclesiastical heritage, that was dignified and eminently suitable for educational buildings, especially those of an Anglican university. Balliol, Exeter, Brasenose, University, Jesus, Lincoln, All Souls, Pembroke, New College – all these carried out work which kept faith with the Gothic style which seems to form the quintessential image of Oxford. One pressing and practical reason for this restoration work was the seriously decaying state of so much of the Oxford stone,

The Codrington Library of All Soul's College, 1814. The library, designed by Hawksmoor, has a Gothic exterior and a classical interior.

HISTORY OF OXFORD

blackened by coal smoke and eaten away by air pollution. The striking thing about the women's colleges is that by the time of their planning and construction – the 1880s onwards – their founders felt no need whatever to erect a Gothic façade around their place of study, but adopted a variety of freer non-doctrinaire styles.

Well before the end of the nineteenth century, the Gothic orthodoxy had relaxed its grip on architects and on those who commissioned them, and an architect like Sir Thomas Jackson drew on a multiplicity of styles to produce imaginative structures such as the Examination Schools, which brought to Oxford some of the energy of the Renaissance. Just as exuberant is one of the most visible new buildings from these years, the former Indian Institute, directly across from the Clarendon Building, designed by Basil Champneys, which can only be described as *fin de siècle* Baroque.

The main problem encountered by anyone compiling a book of Oxford images is choosing them from the very great number available. Works on Oxford illustrated with copper engravings, and later with aquatints, steel engravings and lithographs, first appeared at the end of the seventeenth century and continued to be published until photography took over as the main reprographic medium in the nineteenth. The images in this book, arranged in roughly chronological order, have been selected in the main from the half dozen sources described in detail above in order to give a consistent aesthetic feel to the collection and effectively to enable us to recall what Oxford once looked and felt like. The images fall within the date span of 1650–1900, but this book is not by any means an attempt to record a picture of every academic building in Oxford over this period, so it does not include, for example, every college or academic hall.

Oxford today is a very different place from the Oxford of Bodley, Wren, Radcliffe, Aldrich, Hawksmoor, Cockerell or Jackson. The world in which the university now functions, and the demands made upon it, have changed and multiplied beyond imagination. The surviving prints, however, provide a visual record of the ideals of learning, tranquility, order and beauty, ideals which have made Oxford what it is.

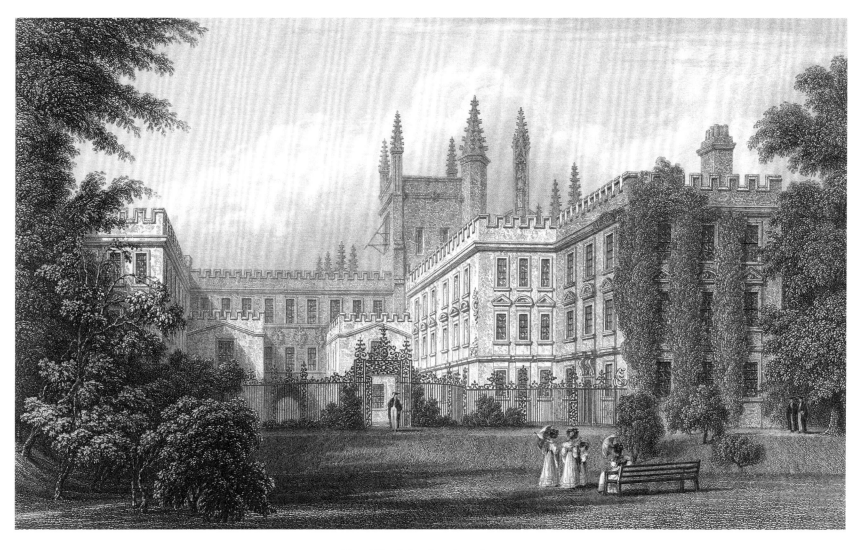

View of New College from the gardens, 1837.

MEMORIALS OF OXFORD

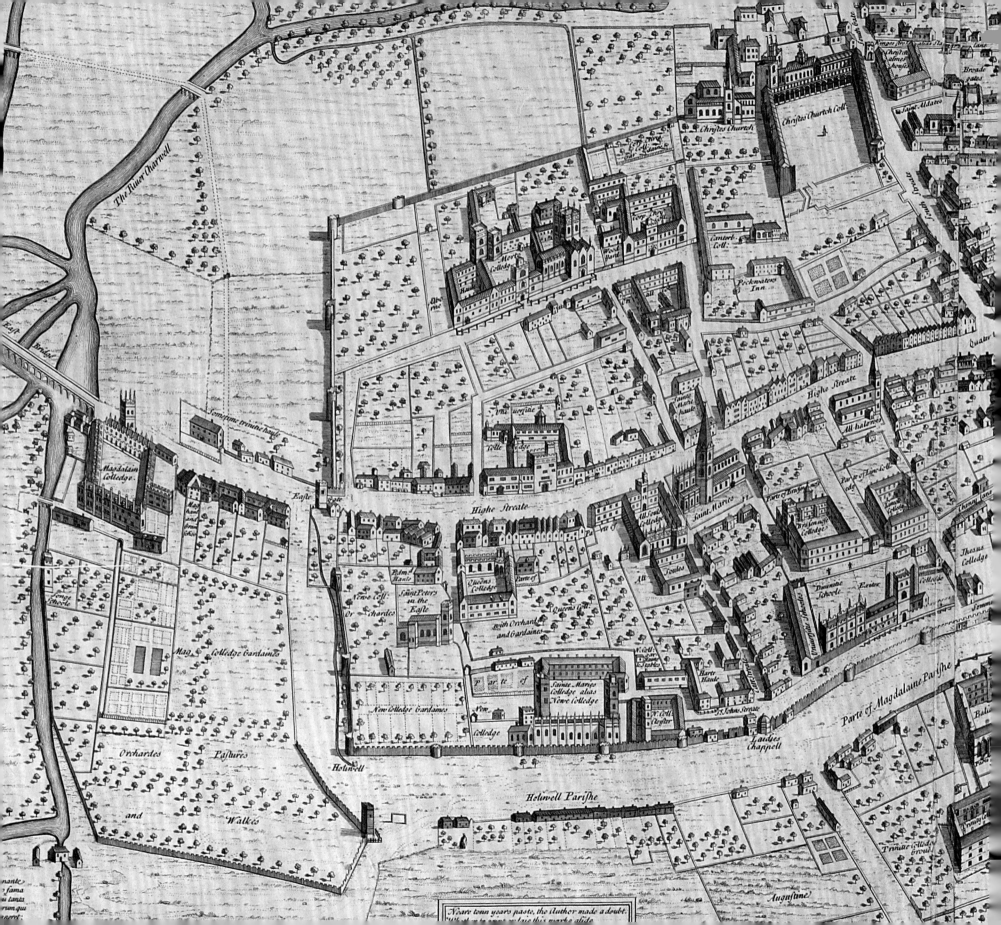

The River Charwell

Sometime trinitie haule

Magdalain Colledge.

Easte Gate

Grene Schoole

Mag: Colledge Gardaines

Orchardes

Pastures

and

Walkes

Holiwell

Christes Churtch

Christes Churtch Coll:

Kinges
Christes almes house

Broade gate

Saint Aldates

Cantor: Coll:

Pecknaters Inn

Quater

Highe Streate

All halowes

Wood haule

Highe Streate

Saint Maries

Porte of Brasen
edge

Cheney Lane

Palme
Haule

Vniuersitie

Tolle Edge

Tante Marie
haule

All Soules
Colledge

Saint Maries

Wisenache
Colledge

New Coll:
Or :chardes

Saint Peters
in the
Easte

Queens
Colledge

Parte of

All Soules

Diuinitie
Scholle

Exeter

Thesus
Colledge

Colledge

with Orchardes
and Gardaines

Queens Coll:

Vniuersitie Scholle

Summe

New Colledge Gardaines

Non
Colledge

Parte of

N. Coll:
Cloister

Sainte Maries
Colledge alias
Newe Colledge

N. Coll:
Bar
Stable

Harte
Haule

St. Iohns Streate

Laudies
Chappell

Parte of Magdalaine Parishe

Bali

Holiwell Parishe

Trinitie Colledge
Grou

Augustine)

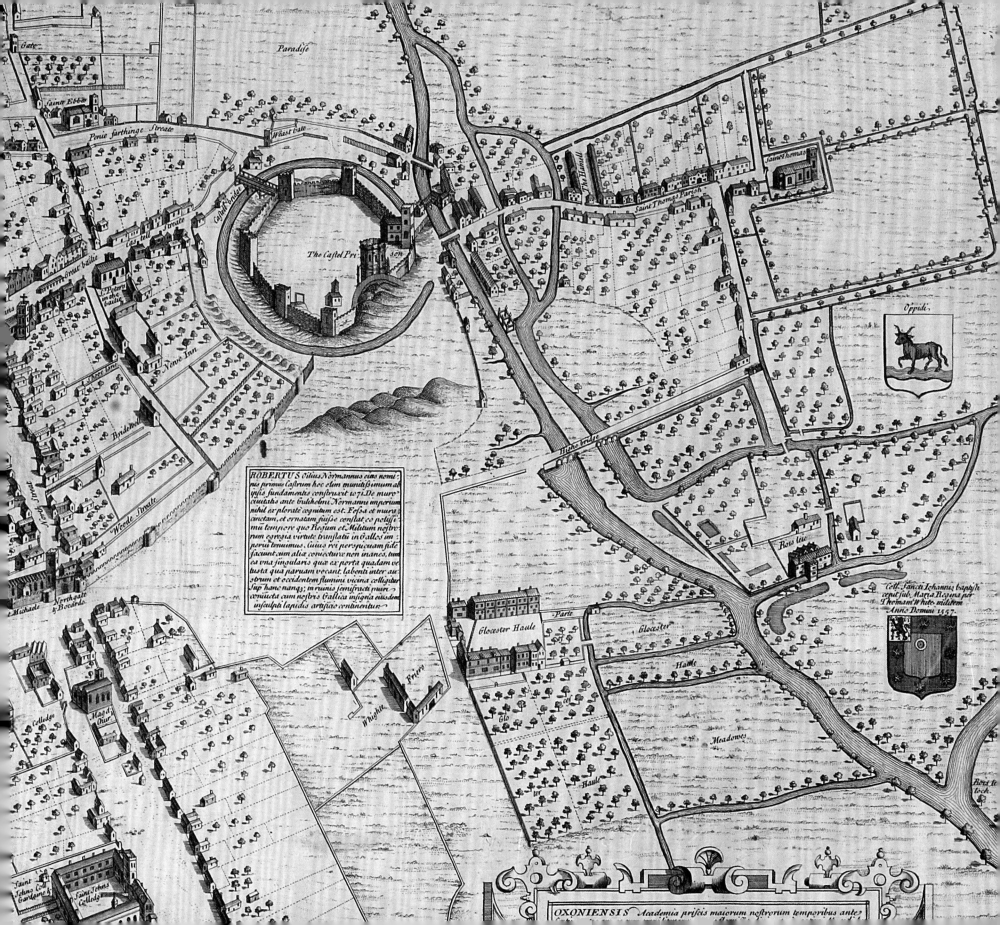

Gate
Paradise
Saint Ebbe
Penie farthinge Streate
Weast Gate
Castel bride
The Hamell
The Hamell
Saint Thomas
Castel bride
Saint Thomas Parish
Castell Streate
Bookbinder ballie
S. Peters in the ballie
The Castel Prison
Oppidi
Newe Inn
Shooe lane
Bridewell
Woode Streate
Highe bridge
North gate
Bois litie

ROBERTUS Oilius Normannus eius nomi: nis primus Castrum hoc olim munitissimum ab ipsis fundamentis construxit 1071. De muro ciuitatis ante bulholmi Normanni imperium nihil ex plorate cognitum est. Fossa et muro cinctam, et ornatam fuisse constat, eo potissi: mo tempore quo Regum et Militum nostro: rum egregia virtute translatu in Gallos im: perii tenuimus, cuius rei perspicuam fide: faciunt, cum aliæ coniecturæ non inanes, tum ea una singularis quæ ex porta quadam ve: tusta qua paruam vocant, labenti inter au: strum et occidentem flumini vicina colligitur Sup hanc nanq; in ruinis semifracti muri conuicta cum nostris Gallica insignia eiusdem insculpta lapidis artificio continentur

Coll. Sancti Iohannis baptistæ cepit sub Maria Regens per Thomam White militem Anno Domini 1557.

North gate
& Bocardo
S. Michaels
Glocester Haule
Parte
Glocester
Haule
Colledge
Whightie
Friers
Meadowes
Haule
Magd. Chur
Glo
ster
Haule
Colledge
Boids lte
lock
Saint Iohns Coll Gardens
Saint Iohns Colledg

OXONIENSIS *Academia priscis maiorum nostrorum temporibus ante*

THE AGAS/RYTHER MAP

THIS DELIGHTFUL scenographic map of Oxford was published in 1588 and is the earliest such image of the city. It was based on a survey commissioned by the university in 1578 from the estate surveyor Ralph Agas. Whether the original survey included a map of the city is not known, but, with the assistance of the English draughtsman and engraver Augustine Ryther, Agas published the large map in 1588. Only one copy of this engraved map survives, in the Bodleian Library, and it is in very poor condition. It is best known today through two reduced-size facsimile engravings, one published in 1728 by Robert Whittlesey (pictured here) and another in 1733 by William Williams in *Oxonia Depicta*. Whittlesey was another estate surveyor and is unlikely to have engraved the plate himself. Whomever he employed to do so was also instructed to engrave around the outside of the map the seventeen images of colleges and university buildings that had been included in a manuscript book presented to Queen Elizabeth when she had visited Oxford in 1566. Either this book, or a near contemporary copy, survives in the Bodleian Library (MS. Bodl. 13a). The artist was an obscure academic called John Bereblock and, despite his shortcomings as an illustrator, his drawings are the only other evidence of how Oxford looked in the sixteenth century.

The Agas/Ryther map also served as the basis for updated maps of the city by Wenceslaus Hollar (1643), David Loggan (1675) and Williams. The buildings here are each shown in individual bird's-eye views, but there is no overall perspective: whichever building we look at – from Magdalen College in the east to Gloucester Hall in the west – we seem to be directly above it. The viewpoint is from the north, rather than the south, which would be more normal to our eyes – Agas thought this the best aspect of the city, but his view was not generally shared by those who followed. The eye is taken into the city along St Giles to the North Gate and the old Bocardo prison, where Cornmarket

now starts. Almost opposite the gate is Balliol, with a railing apparently guarding its front entrance. The city walls are intact from the Castle along the whole length of Broad Street and Holywell, then turning south to the East Gate and beyond, to front the river south of Merton and Corpus. From Christ Church they are lost to view, suggesting that the city was by now undefended by walls on the south-west side. St Giles must have already formed a suburban thoroughfare, with its houses and gardens, terminating at the church.

For us the map naturally defines itself most clearly in terms of what it does not show. There is no Parks Road leading down to the Bodleian, no Wadham College and no Radcliffe Square, while to the west, where Beaumont Street and George Street now stand, there is empty ground. The most dominant single feature is the Castle Mound, and most of the colleges appear as small rectangular courtyards, those outside the city walls, like St John's and Trinity, looking like country houses surrounded by pastures and meadows. At Christ Church, only three ranges are complete, the great quadrangle not yet fully enclosed. The map reminds us of two very significant types of institution now vanished – the monastic buildings, surviving here as ruins or simply as names on open ground, such as the Augustinian Friars, the Greyfriars and the White Friars; and the academic halls such as Hart Hall, New Inn Hall, Broadgates Hall – which was to become Pembroke – and Gloucester Hall, later Worcester College. The map is not embellished with human figures or animals or any picturesque details, as later maps and views would be. But its value and its charm lie in the image which it has recorded of Elizabethan Oxford, with its sixteen medieval and Tudor colleges, the newest being Jesus, founded just six years before the map was drawn. The university itself is virtually invisible, with no buildings of its own except the Divinity School and the adjacent old Public Schools (the Congregation House was within St Mary's Church).

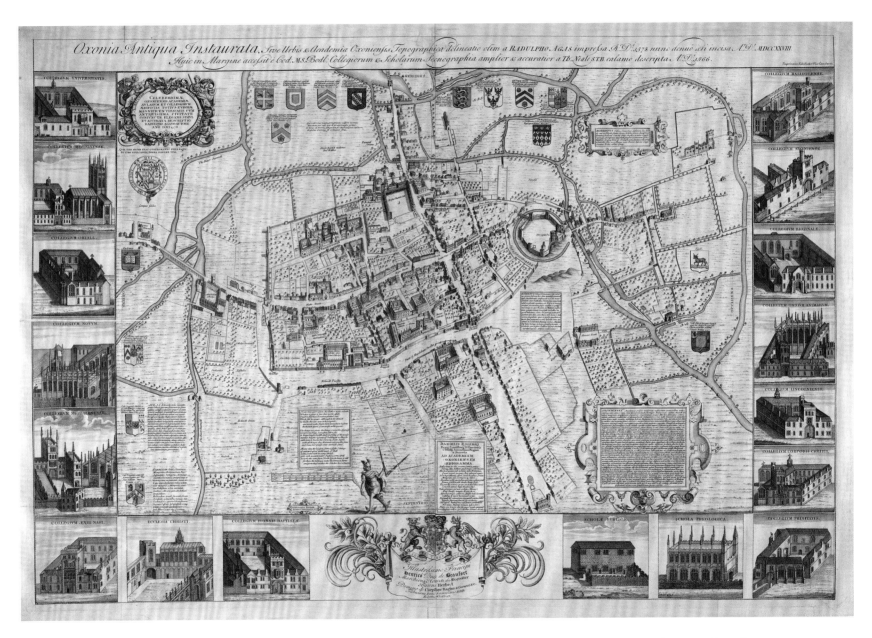

A facsimile of the Agas/Ryther map, 1728. First published in 1588, in this scenographic map the city is seen from the north and shows the sixteen oldest colleges, Jesus being the most recent. Surrounding the map are engravings of the drawings of colleges and university buildings presented to Queen Elizabeth in 1566 by John Bereblock.

ROBERT WHITTLESEY

THE OLD BODLEIAN LIBRARY

IMAGINE OXFORD in the later fifteenth century, perhaps around the year 1485, when Henry VII had recently succeeded to the throne: there were around a dozen fully fledged colleges – University, Balliol, Merton, Exeter and others – plus many more academic halls – possibly as many as fifty or sixty at this date, housed in private buildings around the city. But where was the university? Even in 1485, several centuries before the invention of tourism, the newcomer or visitor to Oxford must have puzzled over the nature of this institution, which apparently lacked any home of its own, any physical focus or tangible existence. St Mary's Church had long been the informal nerve-centre of the academic quarter, the meeting place for all who had university business, from theologians and philosophers to tradesmen and servants. Yet St Mary's was still formally a parish church, it was not university property. In fact, since the early fourteenth century its tithes and the right to choose its priest belonged to one college – Oriel – rather than to the university. The buildings that we now consider to be the heart of the university lie to the north of St Mary's Church and the earliest of these form part of what is today called the Bodleian Library.

What is now known as the Old Bodleian Library was in process of creation for almost 150 years, and it is not easy to grasp how the various pieces of the jigsaw were fitted together, in terms of architecture or of books. We have to recall that the first two floors of the large quadrangle, with its grand tower on the east side and entered from Catte Street, was not originally part of the library (although it was part of Bodley's plan) but home to the 'Schools', rooms for teaching and examining in logic, mathematics, metaphysics, theology, music and other subjects. Only in the twentieth century, and then in various stages, did these become Bodleian reading rooms.

The first seeds of the Bodleian were sown in the mid-fifteenth century, before Bodley himself had appeared on the scene. It sprang from the decision to build a library to house existing books, plus a special collection of several hundred new ones presented to the university by Humfrey, Duke of Gloucester, who died in 1447. He was the younger brother of Henry V and had fought with the King at Agincourt. In *Henry VI Part Two*, Shakespeare has him murdered by Suffolk and Beaufort, but this is unproven. The site chosen for this new library was above the new Divinity School, to the west of what is now the Schools Quadrangle. The Divinity School itself was many decades in construction, and so was the new library that was superimposed upon it, finally opening by 1488. This lengthy process, which was caused by lack of adequate funding, coincided with the printing revolution. Duke Humfrey's original collection had of course consisted of manuscripts, but, as the new library began to acquire works in the early 1500s, these would more and more commonly be printed books. The appearance of this, the first Duke Humfrey's Library, must be conjectural, but it was a chained library, with lecterns at which the readers stood.

Sixty years after its foundation, however, the turmoil of the Reformation intervened in the library's history, for in 1550 by government decree it was purged of all traces of Catholicism. Books, manuscripts and even the desks, too, were destroyed or sold for recycling, and the very room was refitted as teaching quarters for the faculty of medicine. It seems that the library cannot have ranked very high in the university's priorities, for this was still the bleak situation encountered in the 1590s by the wealthy fellow of Merton College, Sir Thomas Bodley. Appalled at the prospect of this 'ruin and waste', Bodley determined to rescue the library, and to restore it to the university, its members and to scholars generally. The old library chamber was completely refurbished at Bodley's expense, laid out with the alcove book-cases and chairs, and the

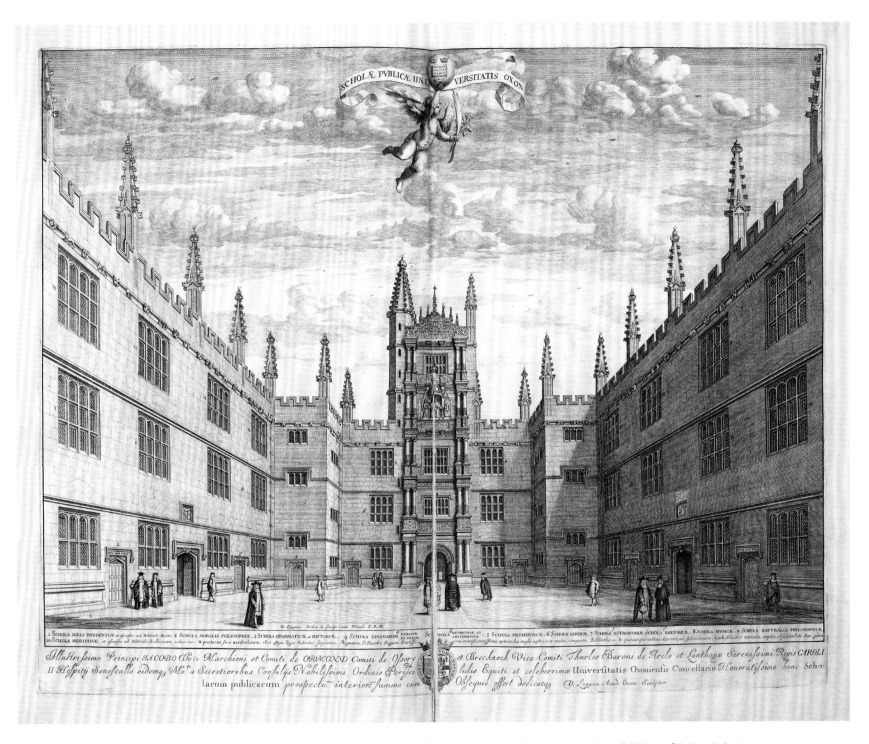

The Schools Quadrangle, looking east towards the main entrance, 1675. The gate is surmounted by the ornate and splendid 'Tower of the Five Orders'.

OXONIA ILLUSTRATA

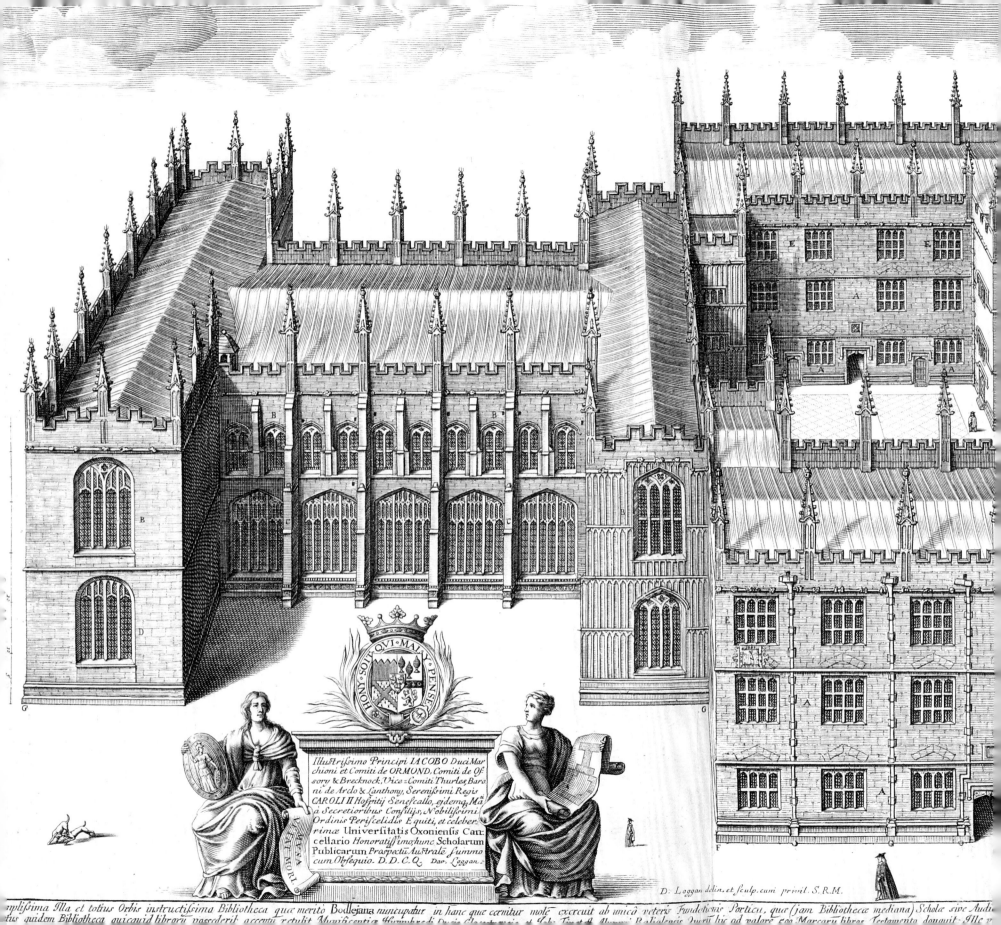

Illustrissimo Principi IACOBO DuciMar
chioni et Comiti de ORMOND, Comiti de Of
sory & Brecknock, Vice-Comiti Thurles, Baro
ni de Ardo & Lanthony, Serenissimi Regis
CAROLI II Hospitij Senescallo, ejdemq, Mª
à Secretioribus Consilijs, Nobilissimi
Ordinis Periscelidis Equiti, et celeber
rimæ Universitatis Oxoniensis Can
cellario Honoratissimo, hunc Scholarum
Publicarum Prospectū Australē summo
cum Obsequio. D.D.C.Q. Dao. Loggan.

D: Loggan delin. et sculp. cum privil. S.R.M.

amplissima Illa et totius Orbis instructissima Bibliotheca quæ merito Bodlejana nuncupatur in hanc quæ cernitur mole excrevit ab unicā veteris Fundationis Porticu, quæ (jam Bibliothecæ mediana) Scholæ sive Audi
tus quidem Bibliotheca quicquid librorū possederit accepta retulit Munificentiæ Humphredi Ducis Gloucestriæ, et Ioh: Tiptoft Aluumni Baliolensis Imprū hic ad valorē 1000 Marcarū libros Testamento donavit: Ille

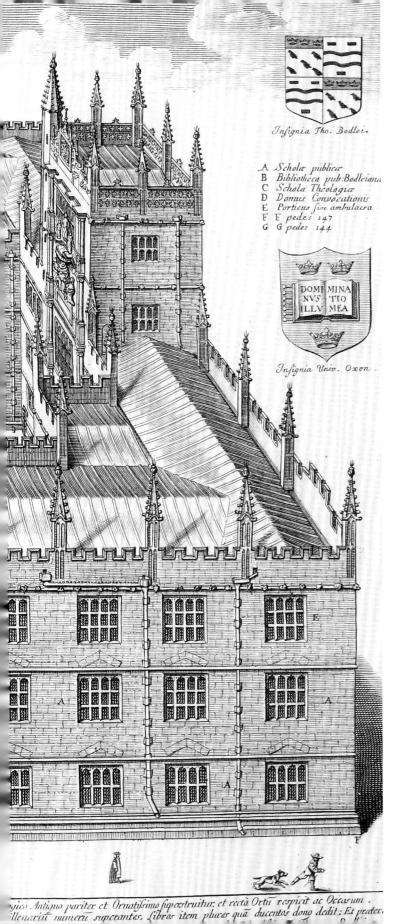

ornate beamed ceiling, as we now see it. Some 2,500 new books were acquired, many of them as Bodley's gift, a librarian was appointed, and the opening took place in November 1602. Shortly after Bodley's death in 1613, work began on the adjoining quadrangle to replace the ramshackle teaching rooms which stood there, the old Public Schools that had been owned by Osney Abbey. By 1640, on the eve of the English Civil War, the university possessed a finished and identifiable focus that was both physical and intellectual. The library was able to grow to accommodate books numbered in the tens of thousands. The library was open to *bona fide* scholars of all nations, but not originally to undergraduates, who were expected to use their college libraries. One simple detail serves to remind us of those far-off days when the library was young: there was no heating in it until the mid-nineteenth century and no artificial lighting until the early twentieth. Thomas Bodley had single-handedly created an Oxford treasure, but study then, as life in general, was far harder and more Spartan than it later became.

The Bodleian Library and the Schools Quadrangle viewed from the south, 1675. Draughtsmen such as David Loggan did not always have a convenient high point from which to draw their bird's-eye views, but in this case he was able to climb the tower of St Mary's Church.

OXONIA ILLUSTRATA

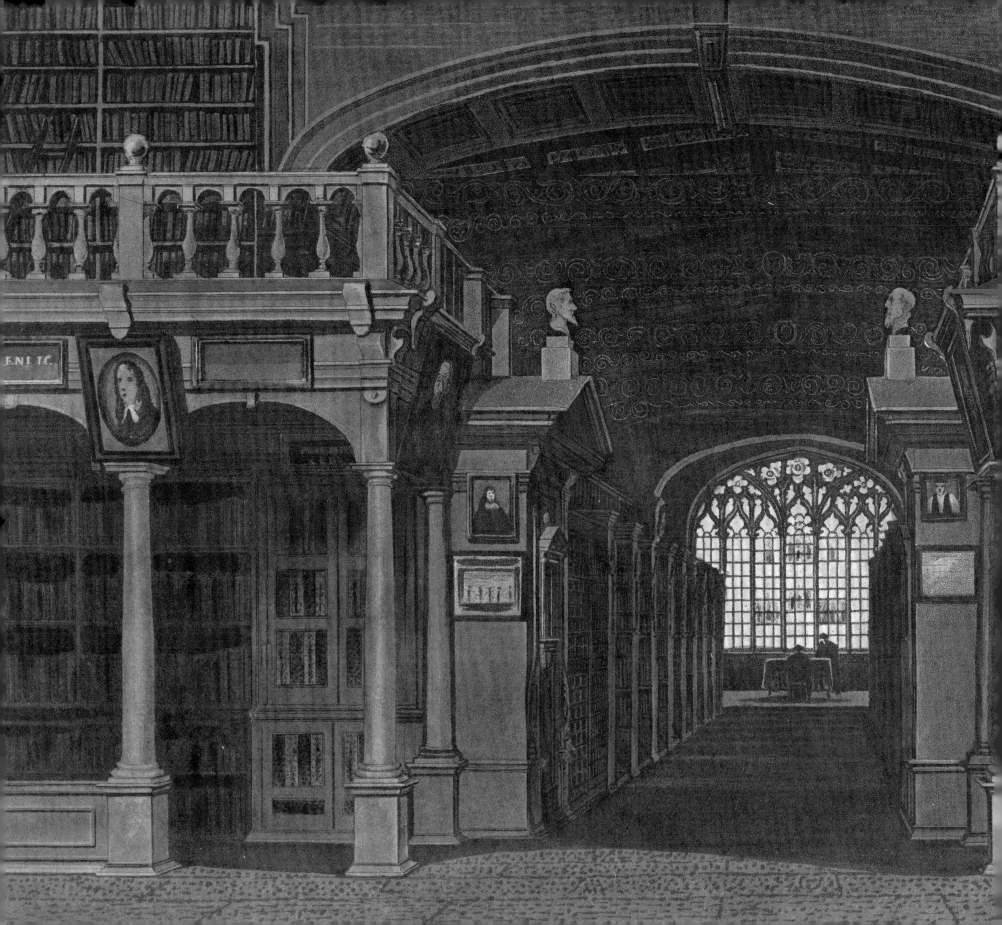

The interior of Duke Humfrey's Library, 1814. This is a view from 'Selden End', the western side of the symmetrical H-shaped library; apart from the busts and portraits, it is essentially unchanged today.

THE DIVINITY SCHOOL

IN ARCHITECTURAL TERMS, the vaulted chamber that has always been known as the Divinity School is a gem of the late medieval perpendicular style – beautifully proportioned and filled with light. The virtuoso carving of the vaulted ceiling makes a breathtaking contrast with the orthogonal lines of its design. The magical effect would have been heightened by the original windows, which were of stained glass, but they were removed or destroyed at the Reformation. The Divinity School is contemporary with St George's Chapel, Windsor, but is on a more intimate scale, and it is slightly earlier than the ornate Henry VII Chapel in Westminster Abbey. The initials 'W.O.' carved into the vault tell us that the master mason was William Orchard, who also worked on the building of Magdalen College, and who must also have created the vaulted ceiling in Oxford Cathedral, so similar in character to the Divinity School.

The Divinity School is one of the earliest university buildings, as distinct from those of the colleges and halls. It was intended as a theology lecture room, but the progress of its construction was painfully slow, lasting more than sixty years. This was a clear indication that the university as an institution was tenuous, almost abstract, compared with the reality of the colleges, and consequently that it had far less money. The building history of the Divinity School is complex; it was begun in 1423 and finally completed in 1488, as a result of many appeals for funds to private donors, some of which survive. The initials and coats of arms of some of these donors appear on the stone bosses where the ribs of the roof intersect. There are many pictorial elements to be found among the carvings too – the Virgin and Child, the Trinity, the Four Evangelists and Doctors of the Church, as well as some whimsical secular figures, such as an eagle and child, and a fox running off with a goose.

A major complication during the long period of building was the decision to build an extra storey above the lecture room, to house the books given by Humfrey, Duke of Gloucester. There were originally two spiral staircases leading up to the Library, but these were removed in the seventeenth century, when the Schools Quadrangle was built with stairs in the angle-towers. An entrance hall (Proscholium) was constructed at the eastern end of the Divinity School in 1610, replacing the shallow porch that had previously protected the eastern doorway (there was a matching porch at the western end). The Arts End extension to Duke Humfrey's Library, above the Proscholium, was completed in 1612. Construction of the Convocation House, a kind of parliament house of the university, with Selden End above it, parallel to the Proscholium and Arts End, commenced in 1634 and was completed in 1637. The door on the north side of the Divinity Schools with the pointed arch was created by Christopher Wren after the building of the Sheldonian Theatre, to permit easy movement from the Theatre to the School; Wren's initials are to be seen on the arch. Aside from lectures, the main function of the room for several centuries was as an examination hall. Traditionally, examination was by disputation, the candidate and the examiner occupying pulpits on opposite sides of the chamber, which are still in place. To judge by the old prints, the Divinity School was always one of the sights of Oxford sought out by visitors, and so it remains.

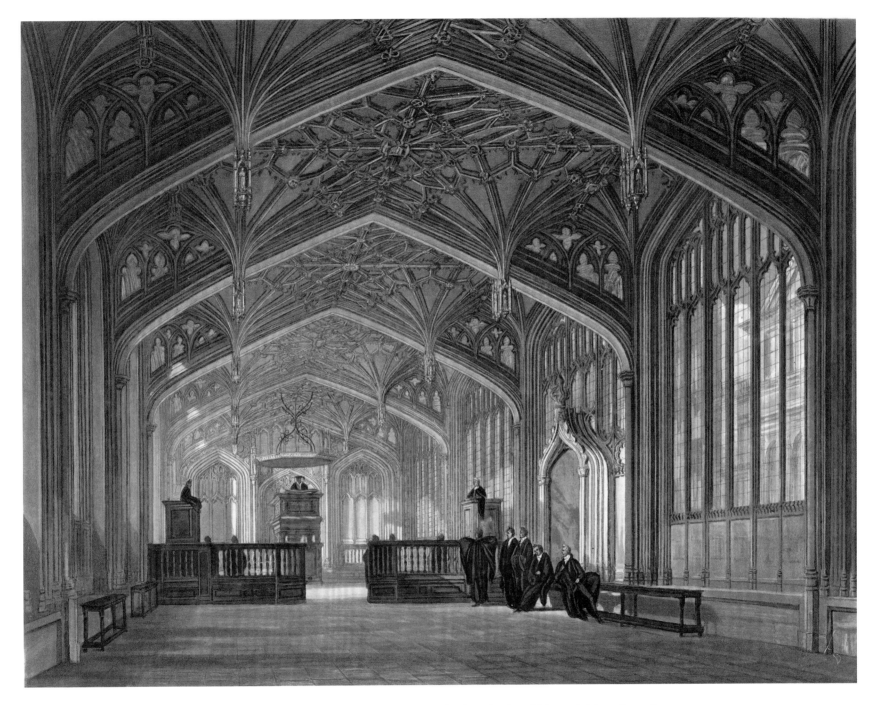

Interior of the Divinity School, 1814. In progress is a traditional oral examination, which preceded the modern written exams.

HISTORY OF OXFORD

NEW COLLEGE

BY COMMON CONSENT, the most innovative foundation in Oxford's early history was that of New College, whose importance was both educational and architectural. The founder was William of Wykeham, Bishop of Winchester and Lord Chancellor of England, a great prelate and powerful royal servant, who was determined and thorough in all that he did, not least in his creation of his two linked colleges in Winchester and Oxford. The first was a school of sound learning for boys, preparing them to move on to the second, which should turn out learned priests who would serve Church and State, and help repair the ravages that war and pestilence had inflicted upon England. The charter of the new college was issued in 1379 and by 1385 some sixty scholars were installed in the new building, erected on a substantial plot of land within the north-east corner of the city walls.

This building was laid out on a magnificent scale and on a deliberate and careful plan. A single great quadrangle was entered through an imposing gatehouse, which provided also the Warden's lodgings. To the left, the hall and the chapel formed the religious and social heart of the community, and the adjacent cloister, burial ground and great bell tower increased the similarity to a monastic house. The quadrangle was completed by accommodation for the fellows and scholars, beyond which lay a large garden bounded the city wall. This was an enclosed community, intellectually and administratively self-sufficient, made to contain a pattern of life mapped out by William of Wykeham, which should serve God and the nation. It was a model that would prove enormously influential on the statutes and the buildings of Oxford's colleges.

For the first two centuries of its life, New College produced innumerable churchmen and scholars, but then the Reformation created a painful and drawn-out crisis of identity, as it was purged of its Catholic past, its personnel and its fabric. As with many of the other colleges, there would be no easy path back to a sense of intellectual or social purpose. The English Civil War affected New College as it did its neighbour, Magdalen, causing the suspension of academic life and the garrisoning of the college. After the Glorious Revolution, the elegant new Garden Quadrangle open to the west was built.

Following the reforms of the nineteenth century, student numbers rose dramatically and, in response, substantial new buildings were put up between the 1870s and 1890s. This is the heavy Victorian Gothic range which now completely dominates the eastern half of Holywell, outside the line of the old city wall. This period of radical reform occurred during the lifetime of the celebrated W.A. Spooner, who was a member of the college for more sixty years, became Warden in 1903, and was the begetter of the delightfully dotty Spoonerism.

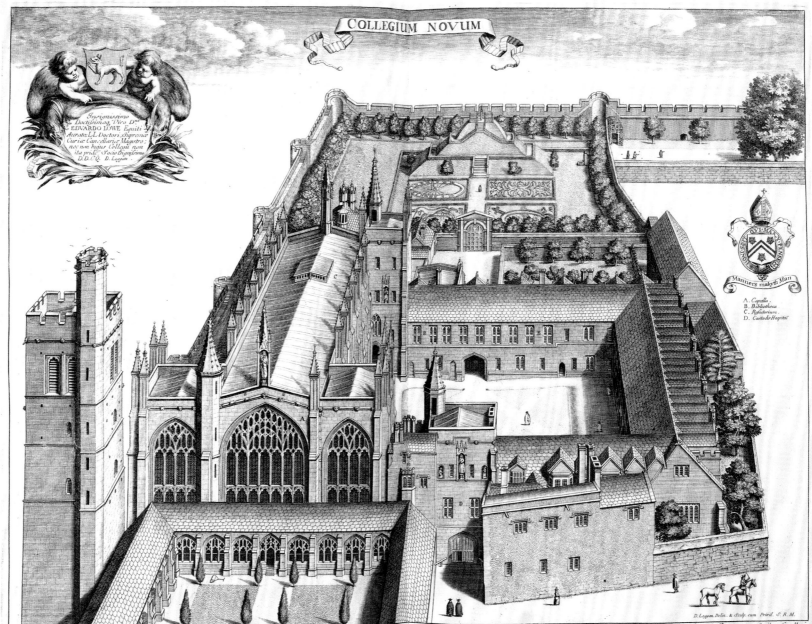

COLLEGIUM NOVUM

A. Capella.
B. Bibliotheca.
C. Refectorium.
D. Custodis Hospitiu.

New College looking east, 1675. Although the angle is not quite right, Loggan could have gained an excellent view from the Tower of the Five Orders.

OXONIA ILLUSTRATA

MAGDALEN COLLEGE

MAGDALEN may be thought of as the last of the medieval college foundations, the creation of William of Waynflete, master of Winchester, provost of Eton and later lord chancellor of England. It was forty years in the planning, chartered in 1458, and became a functioning institution by 1480. Before he died in 1486, Waynflete lived to entertain the kings Edward IV and Richard III at his college. The great tower which rises over both Magdalen and the adjacent bridge was completed a little later, in 1505, the work of the second president, Richard Mayew. At this time, Thomas Wolsey was a fellow, who later attracted other fellows to his own new Cardinal College.

As for many of the other colleges, the long years from the Reformation to the Glorious Revolution brought religious conflicts, personal power struggles and political crises to Magdalen, visibly reflected in the Chapel, which was decked alternately in the garbs of Catholicism, Puritanism and Anglicanism. During the English Civil War, it was overwhelmingly loyal to the king and to Laudianism. Because of its strategic position beside the bridge on the London road, the college was garrisoned and the tower was used as a lookout point. During the Commonwealth, many royalist and High Church fellows were expelled, only to be reinstated at the Restoration. At the very end of the Stuart era, James II again purged the college and attempted to fill it with Roman Catholics, but his flight from England finally ended this period of crisis and conflict.

Unlike other colleges, Magdalen in the eighteenth century did not rush into neo-classical rebuilding, limiting itself to the elegant Wren-like New Building across the deer-park to the north, designed by Edward Holdsworth; the planned extension of this building into a new quadrangle never happened.

It was in the years 1820–50 that some of the medieval parts of the college, including the cloister, were demolished on grounds of safety, and the great Baroque gateway in the western wall, similar in style to the Danby Gate of the Botanic Gardens, was removed, to be replaced with a gate designed by Pugin, also later demolished. In the later nineteenth century, aesthetes, sportsmen and future proconsuls all filled the college, and President Herbert Warren admitted Edward, Prince of Wales as an undergraduate in 1912.

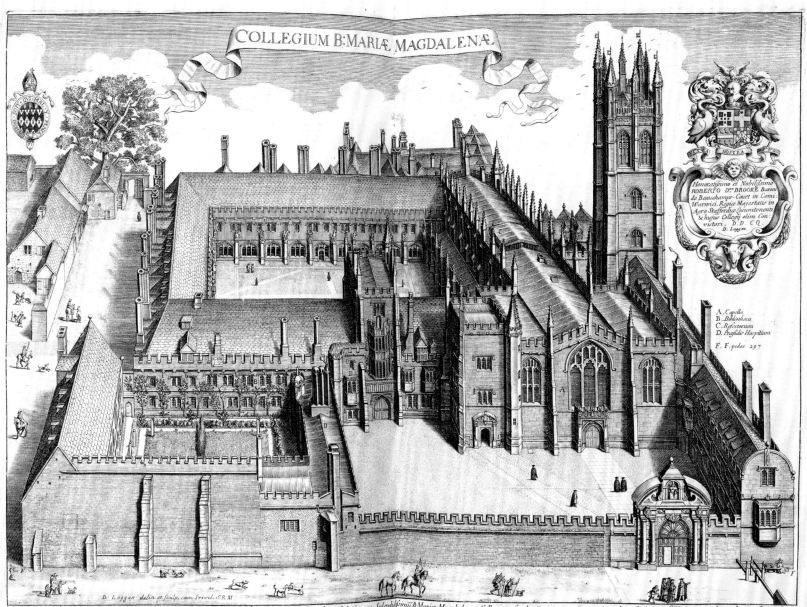

*Magdalen College looking east, 1675. The Jacobean gate in the foreground was removed in the early nineteenth century and a new gate
designed by Pugin, also later demolished, was opened into the High Street.*

OXONIA ILLUSTRATA

MERTON COLLEGE

WALTER DE MERTON was Bishop of Rochester and Chancellor of England in the reign of King Henry III. He amassed a dozen church livings and bought numerous estates in various parts of England, enabling him to establish a house of learning in Oxford. Academic halls were common in Oxford in the thirteenth century, and University and Balliol Colleges already existed, but none of them was rich, none was independent, and none of them had an assured future. By 1274 Walter de Merton had drawn up statues that would provide his foundation with the ownership of its land and buildings, with endowments bringing in money to maintain them and rules concerning the intellectual aims and the practical running of the college. The free, self-governing Oxford college established in perpetuity was born, creating a model which would soon be imitated in Cambridge as well as in Oxford.

Merton College was secular, that is, it was not open to members of the monastic orders, and the liberal arts, some of which we now call sciences, were to be studied there. The most famous figure in Merton's early history was Thomas Bradwardine, a scholar so learned that he was named by Chaucer in *The Canterbury Tales* as ranking with St Augustine and Boethius. Bradwardine was appointed archbishop of Canterbury in 1349, but he died of the plague within weeks and never took up his duties. Yet, at the same time, a group of mathematical scientists flourished at Merton, including Richard of Wallingford, who among other things invented one of the first mechanical clocks, powered by falling weights. The scientific tradition was enriched much later by Sir Henry Savile, Warden of Merton, who endowed chairs of geometry and astronomy in 1619. Savile was a close friend of Sir Thomas Bodley, a fellow from 1564, and the tower in the Fellows' Quadrangle incorporates the four classical orders of architecture, the inspiration for the later tower in the Schools Quadrangle. Savile taught Greek to Queen Elizabeth and was one of the translators of the King James Bible. Two other great figures in Oxford history were both Merton men – Anthony à Wood, the cantankerous scholar who wrote the first history of the university, and Max Beerbohm, aesthete and caricaturist, always referred to as 'the inimitable Max'.

Merton was never subjected to extensive rebuilding and consequently its walls shelter some the oldest and finest examples of architecture and applied art in Oxford. The library, among many other features, stands where it did in the thirteenth century, although the furnishings we now see are mainly Elizabethan, the work of Savile. The medieval charm of Merton seems to be summed up in the whimsical carved relief over the main gate, which shows the founder alongside St John the Baptist, a unicorn and several rabbits.

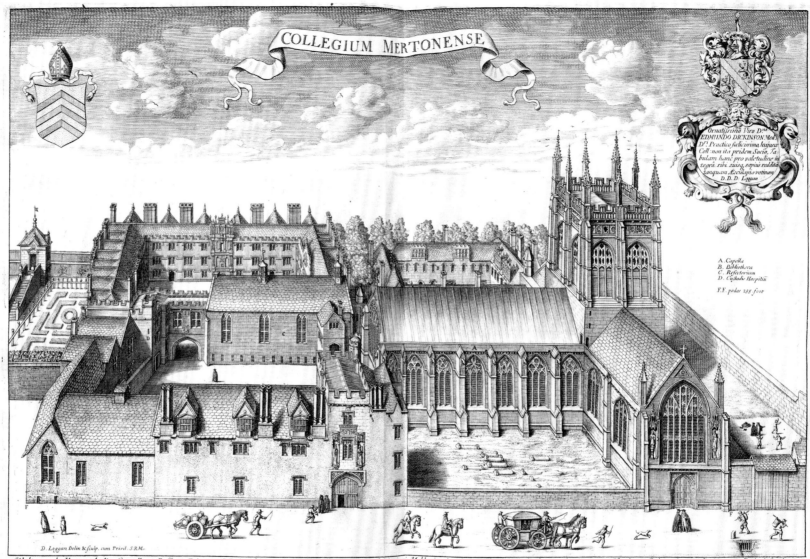

COLLEGIUM MERTONENSE

A. *Capella*
B. *Bibliotheca*
C. *Refectorium*
D. *Custodis Hospitiü*

F.F. *podes 255 foot*

Ornatissimo Viro Dno
EDMUNDO DICKINSON Med:
Dri Practico felicissimo hujusce
Coll: non ita pridem Socio, Ta-
bulam hanc pro valetudine in-
tegrá sibi suisq; sæpiùs redditá
tanquam Æsculapio votivam
D. D. D. Loggan

D. Loggan Delin & sculp. cum Privil. S.R.M.

Walterus de Merton, Angliæ Cancell. et Rossensis Episcopus, Collegium hoc (quod de suo Nomine nuncupari voluit) primùm Maldoniæ, in Agro Surriensi instituit. An. Dom. 1264. regnante Henrico 3o. inde verò post aliquot annos Regis ipsius jussu Oxon: transtulit ultimamq; et manum imposuit, Anno Dni 1274 regnante Edvardo 1mo. Scholariü hic alendorü numerum non præfiniit, sed Custodis et Sociorum curæ prudentiæq; delegavit, hac tamen interpositá cautione (cui obvenerunt singulas juramento obstrictæ fore decrevit) quod crescentibus redibus cresceret et numerus. Ex hoc Collegio currente adhuc primá á fundatione Seculo, rará Felicitate prodierunt, summa illa (Britanniæ totius dicam, an Europæ) Ingenia Rog: Bacon, Gualt: Burley, Ioh: Scotus, á Quo Scotistarü Familia, Gul. Occham, Nominaliü Pater, Cæsareæ atq; adeo Regiæ Majestatis (adversus Fraudes et Fulmina Pontificum) vindex acerrimus Tho: Bradwardin, Pelaganorü malleus; Nic: Gorcham, Rog: Swineshed, vulgò Calculator: præter Rich. de wallingford, et Ioh. de Kilmingworth, Mathematicorü Ætatis suæ Principes. Ioh: Gatisden, Sim: Bredon, Gul: Grisaunt, Medicos et Astronomos insignes, Quorü ultimus Urbani 5o Pontificii Maximi Pater exstitit. Hinc etiam prodit animosus ille veritatis Evangelicæ Assertor Iohan: Wickliffe, et nobile illud Equitü, juratorü par Dnus Tho: Bodley, Bibliothecæ Publicæ et Publicarü Scholarü Oxon: et Dnus Henr: Savile, notissimü literatis Nomen, Lectioni Geometriæ, et Astronomiæ inibi publicæ lectæ, Fundatores Munificentissimi. Taceo complures alias Hujusce Domüs Socios, qui Scriptis editis inclaruerunt; Quorü numerus (prioribus illis hic non recensitis) ad viginti quinq; plus minus excerevit. Episcopos Ecclesiæ suppe-ditavit Hæc Societas ultra viginti quorü quinq; Archiepiscopi Cantuarienses extiterunt: Eorum, Portænus Ioh: Kemp Cardinalicia etiá Dignitate effloruit. Benefactores Hoc Collegiü plurimos agnoscit; inter quos eminuerunt Ela Comitissa Warinci, Tho: Kemp Episcopus Londinensis, Iohan: Chamber Hujus et Ætonensis Collegij Socius, D. Higgs Decanus Lichtfeldensis, et Alexander Fisher nuperrimè Socius, in Sacelli ornatu pulcherrimè. Hic etiá aluntur Portionistæ (quos vocant) quatuordecim, quos instituit Ioh: Wyliot Theologiæ Doctor, quibus adjunxerunt Tho: Iessop D. Medicinæ, et Dnus Iohan: Selley Baronettus, etc.

Merton College, showing its complex plan with three quadrangles, garden and chapel, 1675.
The wheeled carriages must have had a very rough ride over the cobbles of Merton Street.

OXONIA ILLUSTRATA

CHRIST CHURCH

CHRIST CHURCH was originally founded as Cardinal College by England's lord chancellor, Cardinal Thomas Wolsey. Wolsey's fall from power, quickly followed by his death in 1530, left his infant foundation in the hands of his ruthless former master, King Henry VIII. It was the king who, after some years' delay, re-founded the college as Christ Church in 1546, making it the centre of his newly formed diocese of Oxford, whose cathedral would become the college chapel. In Wolsey's lifetime, only the hall and kitchen and part of the west range were completed, and these, together with the Great Quadrangle, remain as historic links with the earliest years of the college, by far the largest in Oxford. By the end of the sixteenth century Christ Church was already spacious and well-endowed; its distinguished students included Sir Philip Sidney; it was visited by Queen Elizabeth and King James I; and it is the only Oxford college specifically mentioned – although not named – by Shakespeare, who wrote of it in *Henry VIII*:

> *... though unfinished, yet so famous,*
> *So excellent in art, and still so rising,*
> *That Christendom shall ever speak his virtue.*

The virtue in question was Wolsey's, not the king's. The college continued its rise to the unique and dominant position which it long held in Oxford, a position reflected by Loggan in his oversized engraving, which had to be double-folded into the book. When King Charles I made Oxford his headquarters during the Civil War, the choice of Christ Church for his court and council chamber was a natural one. At the war's end Parliament took its revenge by expelling the dean, Dr Samuel Fell, but his son, John Fell, became dean at the Restoration, and he later combined

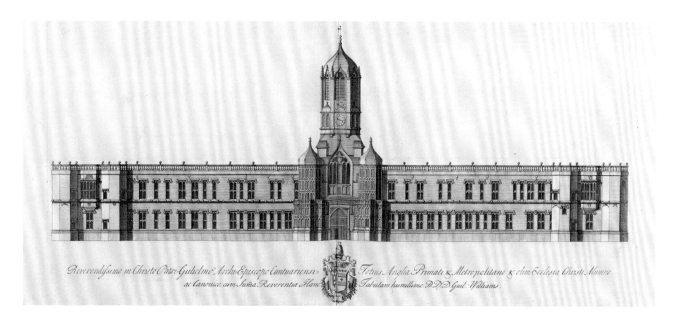

The west front of Christ Church with Tom Tower, 1733. Together with the Sheldonian Theatre,
Tom Tower was one of Wren's great contributions to Oxford's skyline.

OXONIA DEPICTA

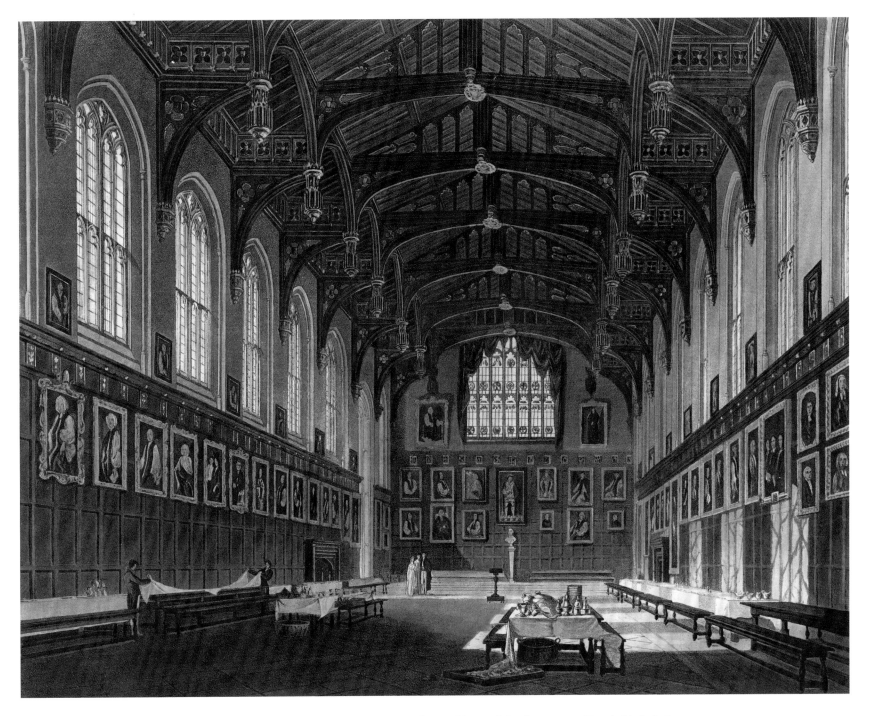

Christ Church Hall, 1814. With its hammer-beam roof, it is widely regarded as the most magnificent hall in Oxford.
Some of the portraits in this engraving are quite recognizable.

HISTORY OF OXFORD

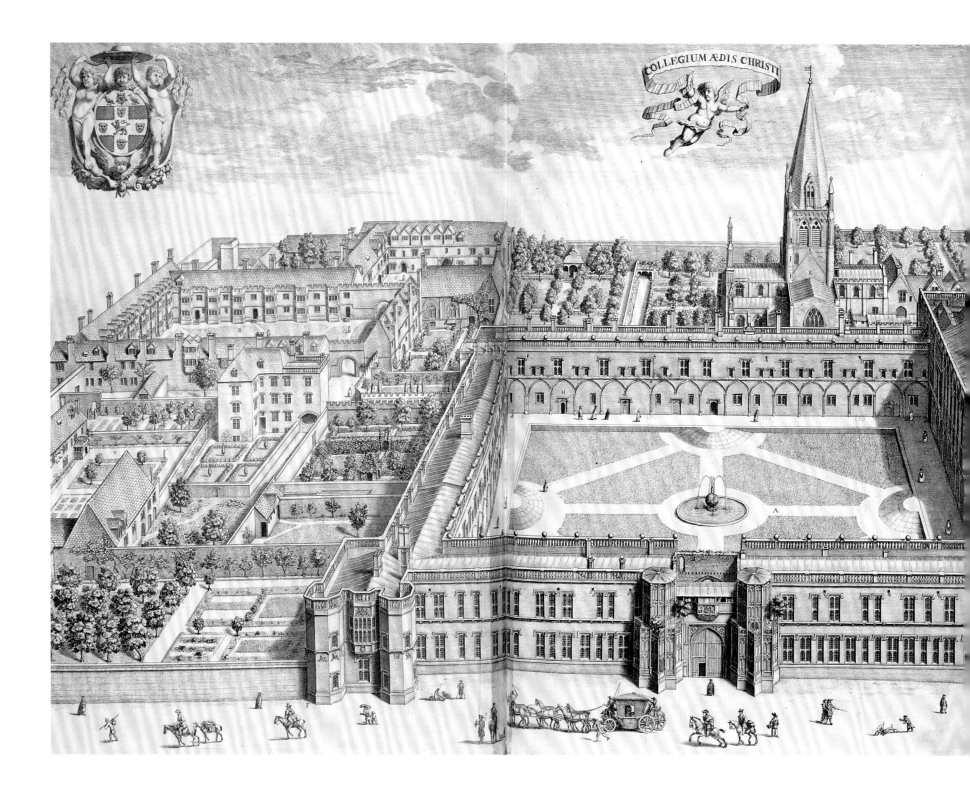

COLLEGIUM ÆDIS CHRISTI

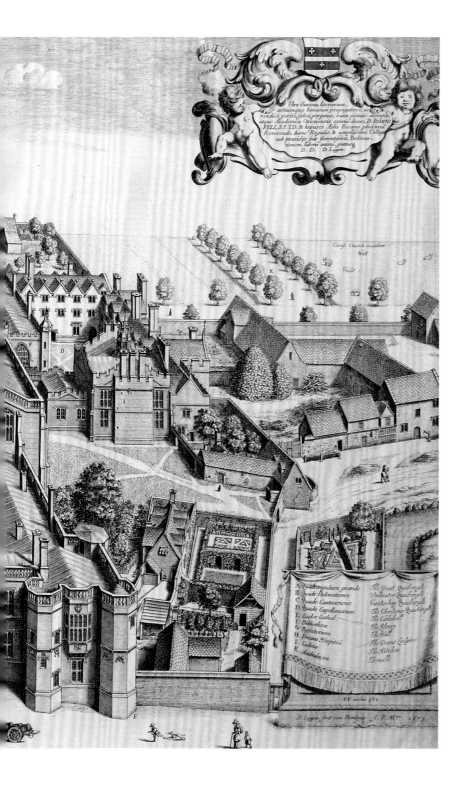

this office with that of Bishop of Oxford. Extremely zealous as both a don and a churchman, he was the subject of the celebrated rhyme 'I do not love thee, Dr Fell', composed by the undergraduate poet Thomas Brown, reputedly as a translation of an epigram by Martial; it is said that the wit and skill of this translation saved Brown from threatened expulsion.

Ranged around Tom Quad, the buildings which were begun by Wolsey were completed by Fell just in time to make it into this picture. The great landmark which did not make it was of course Tom Tower, designed in 1681 by Wren in the Gothic style 'to agree with the Founder's work'. The Mercury fountain is also missing, being set up in 1695 to replace the earlier and plainer fountain. The foreshortened perspective from the west and from above slightly disguises the fact that the Great Quadrangle is almost perfectly square. The area on the left, the north-eastern side, would be rebuilt between 1705 and 1720 to form Peckwater Quadrangle; formerly this was the site of the academic hall Peckwater Inn. The new buildings and, later, the library were largely the creation of Dean Henry Aldrich, an amateur architect whose influence was felt all over Oxford. Peckwater was built specifically to house the wealthy private students, known as commoners. The eastern entrance, through the smaller Canterbury Quadrangle and the severely classical Canterbury Gate were the work of James Wyatt in the 1770s.

Through the lives of those who studied there, Christ Church has played a major role in Britain's history – sixteen prime ministers, including Peel and Gladstone, and figures as diverse as Locke, Wesley, Ruskin and Lewis Carroll. The college's prestige did not depend only on its size and rich endowments, but on its conscientious standards of conduct and scholarship. No less a figure than Edward Gibbon remarked that under the deans of Christ Church in the later eighteenth century 'learning has been made a duty, a pleasure, and even a fashion.'

Christ Church, 1675. The classic view from the east, but lacking the landmark Tom Tower, which was built a few years later; the Mercury Fountain is also missing.

OXONIA ILLUSTRATA

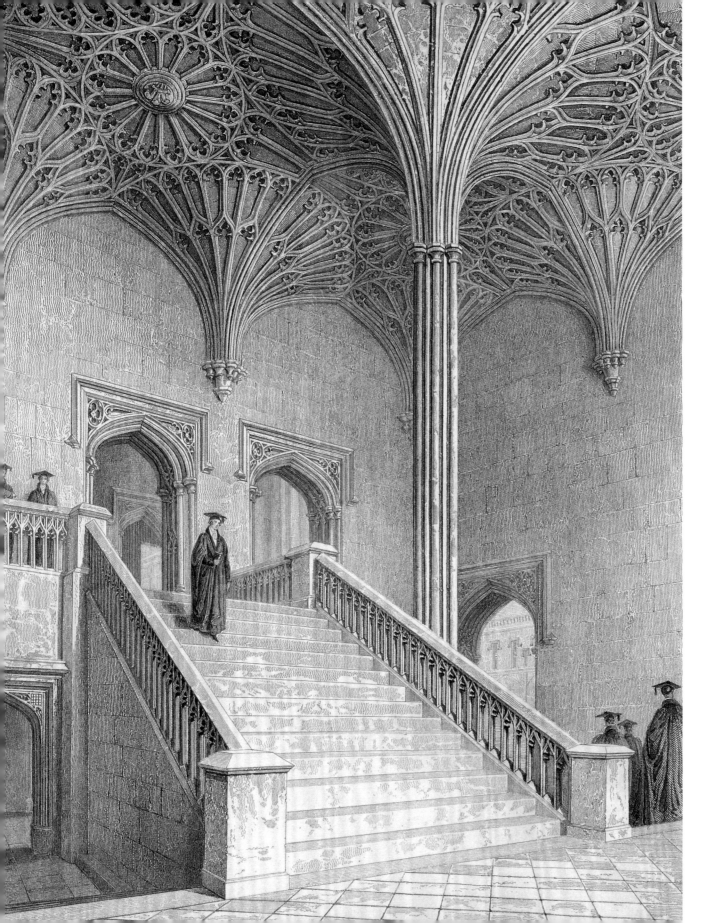

Christ Church Hall staircase, 1837. Although completed a few years before the English Civil War, the vaulting of this stairway is late Gothic in style.

MEMORIALS OF OXFORD

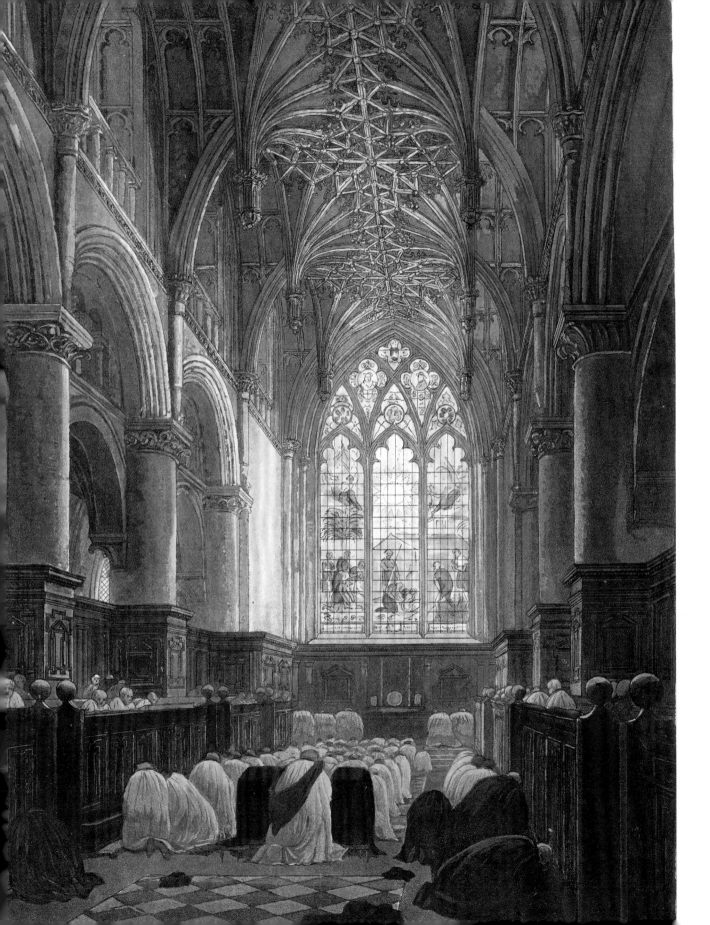

Christ Church Cathedral, 1814. The interior seen here no longer exists, having been remodelled in the nineteenth century, but the magnificent vaulting is original and is a little earlier than that in the Divinity School.

HISTORY OF OXFORD

THE CHURCH OF ST MARY THE VIRGIN

THE ANCIENT CHURCH of St Mary in the High Street was always technically a parish church, but as early as the fourteenth century it had acquired such a central role in university life that the chief parishioner could be said to be the university itself. The majority of the halls and colleges were established close to the church, so that it formed the nucleus of the academic quarter of Oxford, distinct from the tradesman's quarter further west. The university then having no buildings of its own, the church became the meeting point for all those having university business, a situation that was formally recognized in the 1320s with the building of a small Congregation House on the north side of the church, which was put to a multitude of uses. At the same date the ornate spire was raised, at 57 metres still the tallest building in Oxford. There had been a church on this spot from the eleventh century, but the structure that we now see is largely the result of rebuilding in the early Tudor years. The Baroque-style south porch, with its twisted columns, dates from the beginning of the seventeenth century. The heads of the Virgin and Child over the porch were vandalized by puritan soldiers in 1642.

The distinct identity of this academic quarter emerged very clearly during the infamous riot of February 1355, when gangs of students fought violent battles with townsmen for three days. The scholars came off worst, with many deaths and dreadful injuries and their belongings looted and destroyed. When order had been restored the punishments were severe, while the mayor and bailiffs of the town were ordered to attend St Mary's to hear mass for the souls of the slain every St Scholastica's day (10 February) thereafter, and to swear to respect the privileges of the university. In subsequent centuries, the church was the setting for several events of historic importance. In 1554–6, the trials were held here of Bishops Latimer, Ridley and Cranmer prior to their executions, and it was here that Cranmer disavowed the previous confession of his errors, thus making certain his martyr's death.

In a later and less cruel age, St Mary's became the centre of the Oxford Movement for the 'second reformation' of the English Church, under the influence of Keble, Pusey and Newman. Newman in particular, as vicar of St Mary's from 1828 to 1843, achieved his pre-eminent position through his magnificent sermons from the pulpit. In those years when Newman first attempted to recall the Anglican Church to the Catholic tradition, then turned back, setting out instead on his own personal journey to Rome, St Mary's became the focus of a national religious struggle, which altered its character for ever.

Between these two events St Mary's was one of the main Oxford settings of the birth of Methodism. John Wesley was a fellow of Lincoln College, and in 1744 he preached the university sermon, of which William Blackstone recorded his impressions:

> We were last Friday entertained at St Mary's by a curious sermon from Wesley the Methodist ... he informed us first that there was not one Christian among all the Heads of Houses; secondly that pride, gluttony, avarice, sensuality and drunkenness were the general characteristics of all Fellows of Colleges; lastly that the younger part of the University were a generation of triflers, all of them perjured, and not one of them of any religion at all.

From this point on, Wesley, not surprisingly, decided to take his message out into more receptive pastures.

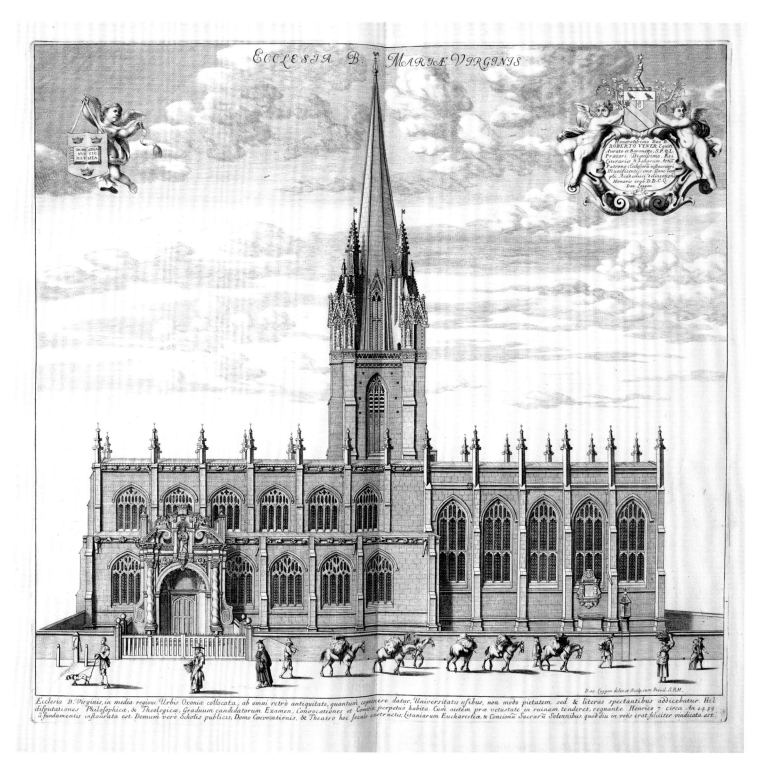

Southern view of the University Church of St Mary the Virgin, 1675. Part of the visual impact that this church always has is the spire rising from the centre and behind the church, on the north side, rather than at the more normal western end, where space was lacking.

OXONIA ILLUSTRATA

THE SHELDONIAN THEATRE

AFTER THE DISRUPTION caused to Oxford life by the Civil War had been brought to an end at the Restoration, the university and the colleges embarked on an unprecedented phase of building, or in many cases rebuilding, in a style fitted to the new age. Sir Thomas Bodley's great generosity had given the university an intellectual centre in the Library and the Schools, but it still lacked a public, ceremonial one. This need was answered by another great benefactor, Gilbert Sheldon, who was archbishop of Canterbury and soon to become chancellor of the university. Sheldon provided the enormous sum of £14,000 to build a ceremonial hall immediately adjacent to the Bodleian, thus confirming once again the identity, in this particular quarter, of the university independently of the many colleges. The man chosen to design and build it was not yet an architect, but was the Savilian Professor of Astronomy, who would subsequently become the most celebrated architect in English history – Christopher Wren. In 1661 Wren had just been offered the chance to rebuild the harbour and fortifications of Tangier, but Oxford suited him better and he remained there to see through the Sheldonian Theatre as his first completed work.

For his model Wren chose that of the Roman theatre of Marcellus, known to him and his contemporaries through engravings in architectural books. This consisted of a large semi-circle, where the audience was seated, facing the square house-front. The original was open to the air and could be protected by a large canvas covering rigged with ropes. Wren of course needed to produce a roofed version extending over a space seventy feet wide, which he did with a complex timber structure that was to be hidden by a painted ceiling. The artist was the king's serjeant-painter, Robert Streeter, whose allegorical scheme is rather lost in the great expanse of sky seen through a pulled-back curtain, which ingeniously recalled the Roman original.

The exterior of the building has several oddities. In the first place it is not truly semi-circular but multi-angled, composed of a succession of arches each built in a flat plane. But, more importantly, the space containing the theatre was not really sufficient, so that it was built too close to the Divinity School, with the result that the back somehow became the front and *vice versa*: the classical façade has to be looked for, while the curved hindquarters are the landmark of Broad Street. This squeezed-in effect was described by one critic as being 'like a man with his trousers pulled up to his neck'. This back-to-front perception is strengthened still further by the building's most famous feature – the 'Emperors' Heads', commissioned by Wren from the Oxford stonemason William Byrd. There is no record of who or what they were actually supposed to be but they were probably inspired by Roman 'herms'. After two hundred years of weathering, they were replaced in 1868, but with stone so poor that they soon became unrecognizable, and had to be carved anew yet again in 1970–72.

For three and half centuries the Sheldonian has hosted all the university's great ceremonial occasions, but for the first fifty years of its life it also housed the University Press, before it moved to the Clarendon Building. Books printed by the Press in the Sheldonian in those early years bore a vignette of 'The Theatre' on the title-page.

Interior of the Sheldonian Theatre, 1820. The allegorical ceiling, painted in 1670 by Robert Streeter, the king's serjeant-painter, shows clouds being drawn back by cherubs to reveal Truth surrounded by figures of Justice, Science, Drama and so on.

OXFORD ALMANACK

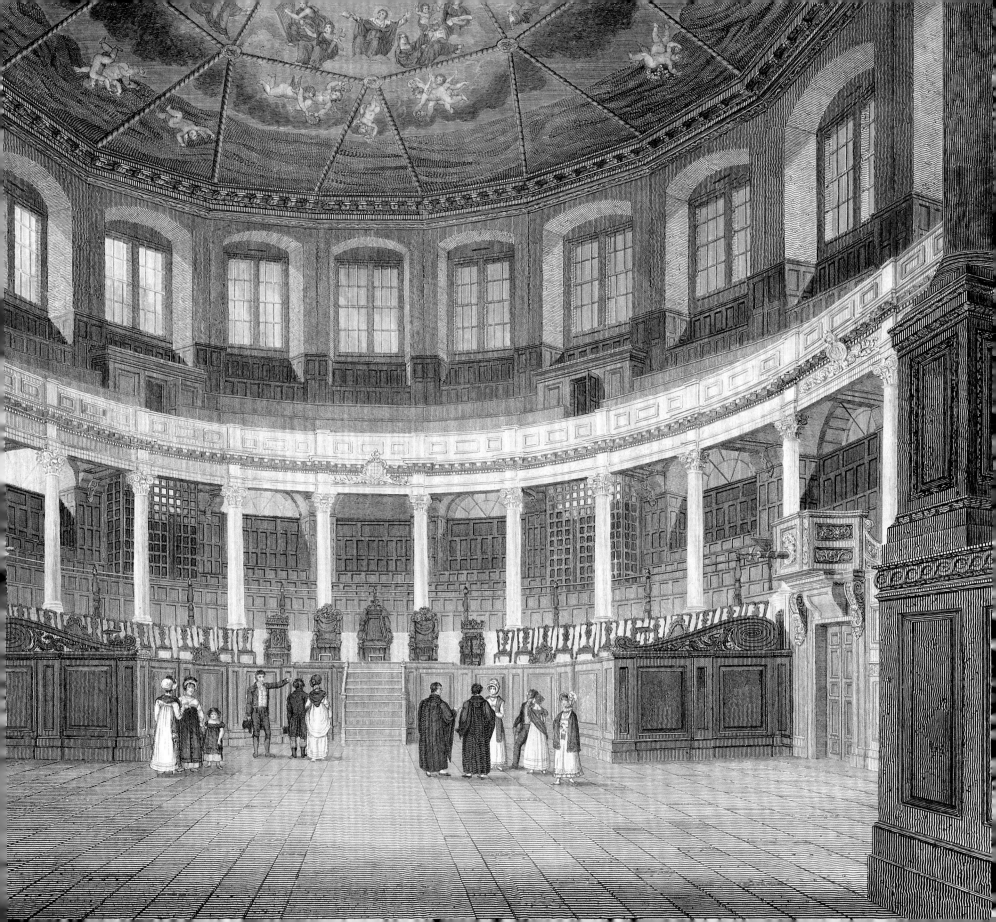

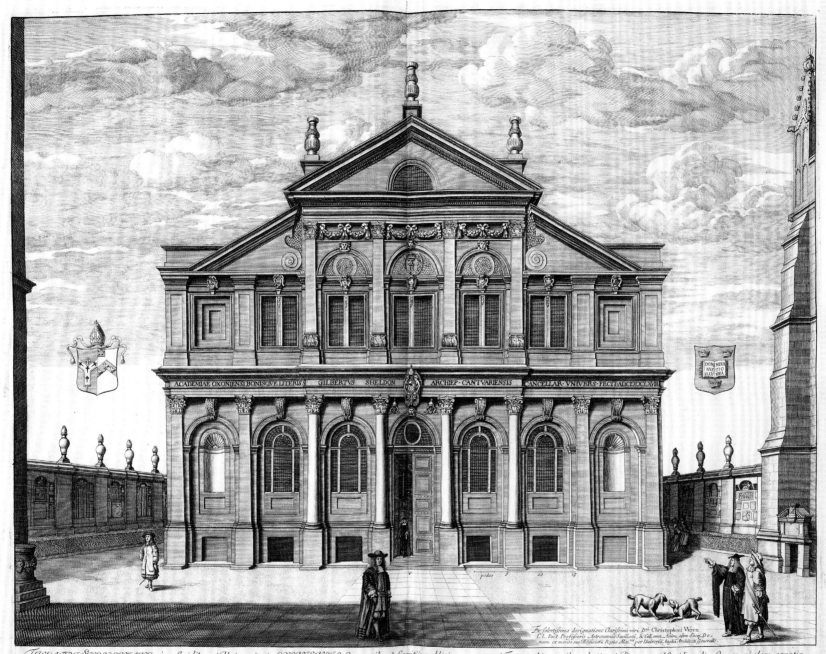

South side of the Sheldonian Theatre, 1675. The theatre was Christopher Wren's first important work,
a classical façade fronting the building on the south side.

OXONIA ILLUSTRATA

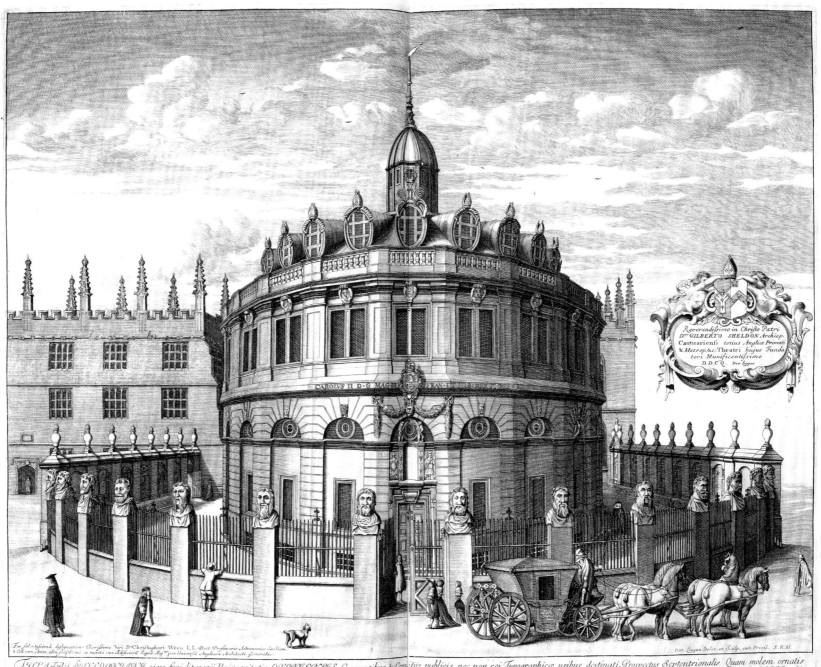

North side of the Sheldonian Theatre, 1675. The rear of the building, which, owing to its position facing Broad Street, seems to be the front. The staffage includes a splendid four-horse carriage, something of a Loggan trademark.

OXONIA ILLUSTRATA

UNIVERSITY COLLEGE

According to legend, University College is emphatically the oldest college in Oxford, having been founded by King Alfred in the late ninth century. Unfortunately the legend was born in the 1380s, in consequence of a legal dispute in which the college was seeking royal protection from King Richard II. To claim a royal founder was an attractive strategy, especially one so far back in history as to have left no records which might be disputed. This version of the foundation story, however, was confirmed in law in the eighteenth century and the college celebrated its millennium in 1872, adding burnt cakes to the menu of the official dinner.

To return to reality, a scholar named William of Durham bequeathed to the university a sum of money to maintain a dozen students of divinity. This was in the year 1249, which still qualifies University as Oxford's oldest college, although there are no statutes surviving from that date. *Aula Universitatis* – the Hall of the University – was established on the south side of the High Street, where it has always remained. As in the case of a number of other medieval colleges such as Exeter, no architectural traces of its origins remain. Between 1630 and 1680 the college as we now see it took shape, built in the Oxford Gothic style, but distinguished by rows of rather ornate gables both inside and outside the main quadrangle. A statue of Queen Anne was placed on the front of the gate tower (which would later face that of Queen Caroline of Ansbach over The Queen's College gate) while that of King James II stands on the inner side. When the new Radcliffe Quadrangle was built in the eighteenth century (thanks to a legacy from John Radcliffe, former undergraduate of the college), a statue of Queen Mary II was placed there, so that, whether by accident or design, the last three Stuart monarchs are all commemorated. That new quadrangle was explicitly required by Radcliffe to be 'answerable to the old', that is, built in the same style, which was considered the norm for Oxford.

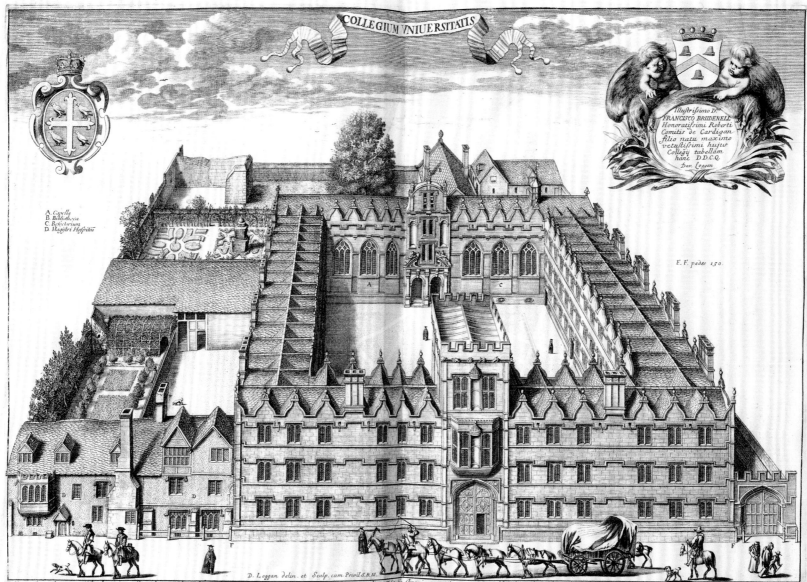

A. Capella
B. Bibliotheca
C. Refectorium
D. Magistri Hospitiu

F. F. pedes 150.

Illustrissimo D.
FRANCISCO BRUDENELL
Honoratissimi Roberti
Comitis de Cardigan
filio natu maximo
vetustissimi hujus
Collegij tabellam
hanc D.D.C.Q.
Dan. Loggan.

D. Loggan delin. et Sculp. cum Privil. S.R.M.

Circa An: Sal: 872 Alfredus sive Alvredus Occidentalium Saxonum Rex vere magnus pene internortua literaria studia Oxonie recuscitaturus Grimoaldu, sive Grimbaldum, virum sanctitate et doctrina celebrem nec non Regisdum Roman perseret) hospitem, e Gallia accersivit. Qui consilio et sumptu Regis Collegiu hoc (hodie Magne Aulae Universitatis appellat) theologiae, ut et binae alia Philosophiae et Grammaticae destinata, fundavit; et liberalibus stipendijs; primu e fisco regio dein e certis fundorum reditibus tam pro Professoribus quam studiosis, dotavit Quibus postea, Danoru Normannorumq; invasione bellica, aciribus, interciscie, Collegii desolatione, & tantum non ruina, passum est Donec Gulielmi Archidiaconi Dunelmensis pietate refectu, & instauratum, & aliorumsinaxcuna ex parte Alumnoru suorum) Gualteri, scilicet Skirlaw Episcopi Dunelmensis, Henrica Northumbriae x inclita Percoru stirpe, Comitis Secundi, Caroli Greenwood, et D. Simonis Benet, aliorumq; liberalitate auctum, et in praesentem statum evectu fuit. In quo Magister, Socii 12, Exhibitionarij munere honoratissimi Roberti Comitis Leicestriae dotati /2 una cu Scholaribus compluribus, servientibus, & ministris, in honore Dei et augmentu Cleri honeste sustentantur. Praeter S. Grimbaldu ab Alfredo Magistru constitutum, primumq; Socii S. Joanne de Beverleio, tulit hoc Collegiu S. Edmundum, Richardu Armachanum, Georgiu Abba, Joh: Mathew, Archiepiscopos; Richardu Fleming Episcopu Lincolnuensem; aliosq; plurimos, tum vitae sanctitate tum scriptis celeberrimos.

University College, 1675. The date of this engraving was perfectly timed to show the seventeenth-century rebuilding
of the college in the dominant 'Oxford Gothic' style, which had obliterated all traces of its medieval origins.

OXONIA ILLUSTRATA

WADHAM COLLEGE

IN COMPARISON with the long drawn-out process of founding colleges like Magdalen and Christ Church, Wadham came into being at lightning speed. Nicolas Wadham, a Somerset landowner of no particular distinction except his wealth, died in 1609, leaving in his will a very substantial sum to be spent in creating a new Oxford college bearing his name. The scheme was embraced by his energetic widow Dorothy, who added further funds of her own, and only four years after Nicolas's death the statutes were agreed, the building was complete, and thirty-five fellows and scholars were moving into the new institution. The forceful Dorothy became something of a legend in the history of the Oxford colleges, directing the whole project from her Somerset home and never visiting Oxford, not even once, before she died in 1618. This rather strange childless couple are commemorated in their statues, together with that of King James I, set into an elaborate façade in the quadrangle of the college which was their substitute child. Behind this façade is the spacious hall with its great hammer-beam roof, a style magnificent but, in 1612, already becoming antiquated.

Wadham was seen immediately as a suitable place for the education of West Country gentlemen's sons, including Carew Raleigh, son of Sir Walter, and Robert Blake, the future admiral, son of a Bridgwater merchant. Under the wardenship of John Wilkins from 1648 onwards, a group of notable mathematicians and scientists, the most famous being Sir Christopher Wren, gathered together at Wadham, and this 'invisible college' merged with other such groups to become established as the Royal Society in 1660. A less savoury figure who was educated there was John Wilmot, later Earl of Rochester, the notorious rake and poet of the Restoration court.

The physical structure of the college was, and has remained, essentially simple, with the original main quadrangle entered from Parks Road. But this picture has been complicated by a second 'back quadrangle' and the acquisition of land and buildings fronting on to Holywell, including the Holywell Music Room. The extent of the land once owned by the college can be gauged by the fact that the large tract of property to the north was sold by Wadham in the 1920s for the building of Rhodes House and its grounds. Still, much remained, including the Fellows' Garden, which, when seen by moonlight, has been described as 'the most enchanting spectacle which Oxford can afford'. This remark came from the pen of Lord Birkenhead, formerly F.E. Smith, one of a group of significant figures who were undergraduates of Wadham in the 1890s; the others were the statesman Sir John Simon, the renowned athlete and cricketer C.B. Fry, and the flamboyant conductor Sir Thomas Beecham. The personality who left a significant imprint on the college in recent years was Sir Maurice Bowra, warden from 1938 to 1970. A scholar of Greek and Russian, Bowra was also a legendary socialite and giver of dinner parties, whose name appears in virtually every memoir of the smart set between 1930 and 1960. A bronze statue of Bowra can be seen in the college garden.

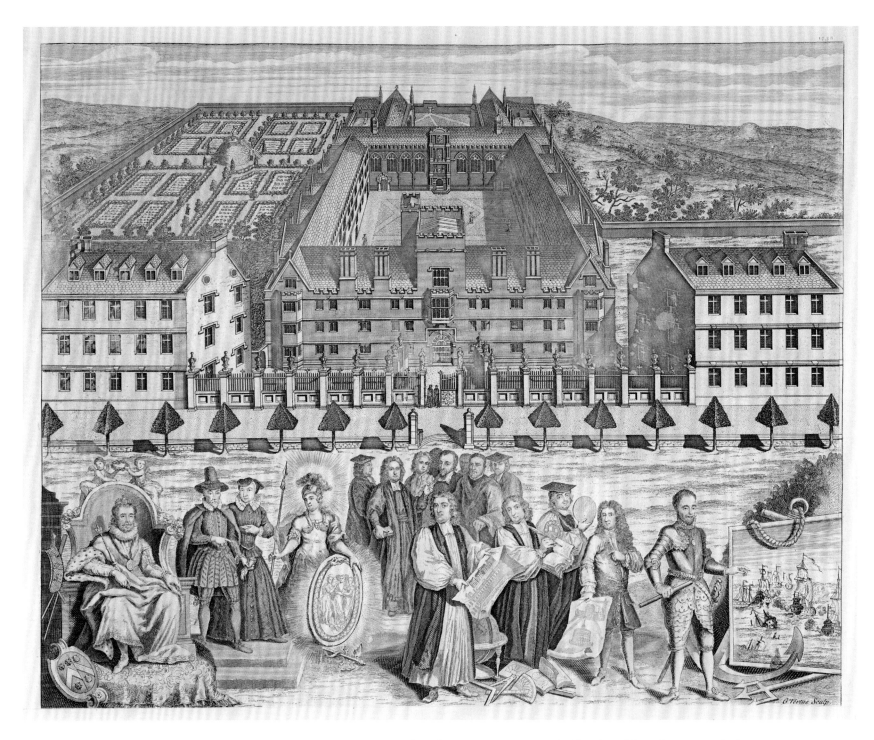

Design for Wadham College, 1738. Of the two buildings shown in front of the main structure, that on the left, in front of the garden, was never built.
This is a classic example of the Almanack fashion for showing the colleges with fanciful portraits of their founders: on the left is James I beside
Nicholas and Dorothy Wadham; on the right stand Wren, holding a picture of St Paul's Cathedral, and Admiral Robert Blake with a naval scene.

OXFORD ALMANACK

ST JOHN'S COLLEGE

ST JOHN'S COLLEGE has a prehistory as St Bernard's, which was founded in 1437. Dissolved as a college a hundred years later, it survived briefly as an academic hall, before the site and remaining buildings were acquired by Sir Thomas White and revived in 1555. White was a wealthy clothier, who was one of the founders of the Merchant Taylors' School and who became Lord Mayor of London. White re-dedicated the college to St John the Baptist, as the patron saint of tailors. The fellows were all to be chosen from guilds or corporations, or were founder's kin, thus it was a closed institution. It was also one with strong Catholic sympathies, for White was a supporter of Mary Tudor, and several prominent Catholics of Elizabeth's reign were St John's men, including Edmund Campion, the Jesuit Martyr, admitted to the college by White himself. A less controversial Elizabethan fellow was John Case, whose 1585 commentary on Aristotle's *Ethics* has some claim to be the first book published by the Oxford University Press.

A prominent figure in the history of the college, though not a Roman Catholic, was certainly a high churchman: William Laud was first a scholar, then a fellow, then president, resigning only to pursue his ecclesiastical career, which took him to the archbishopric of Canterbury, and the role of right-hand man to King Charles I, soon to be a fatal position. Nevertheless, his concern, indeed obsession, with his former college and university never ceased, and it showed itself in funds, donations and buildings, and in the severe statutes of procedures and conduct which he issued as chancellor in 1636. Laud's most visible memorial is the second quadrangle of St John's, known as Canterbury Quad, completed in 1636. Here the eastern and western sides were constructed as Italianate open loggias, with beautifully carved columns. Both sides are punctuated by massive and ornate arches, bearing statues of King Charles and Queen Henrietta Maria, cast in lead by the French artist Le Sueur.

Laud's high churchmanship and his mania for control made him one of the least popular figures in English history, and, even as his enrichment of his college was in progress, he and his king were both doomed, Laud meeting his end on the scaffold in the year before Charles surrendered to his enemies. Laud was succeeded as president by William Juxon, the future archbishop of Canterbury, who attended King Charles at his execution. It has often been noticed how this handful of St John's men – White and Campion, Laud and Juxon – seem to concentrate in their lives the national drama and personal tragedies of England in its period of deep religious conflict. In 1895, when Roman Catholics were again admitted to the university, a Jesuit foundation was permitted to start life in an annexe of St John's, and was soon afterwards dedicated to the memory of Edmund Campion.

On a completely different plane, and much later, St John's had a role in the social re-shaping of Oxford. In the second half of the nineteenth century the college found itself far from wealthy, but then discovered itself possessed of an enormous treasure bequeathed by its founder, Sir Thomas White, in the form of large tracts of agricultural land in North Oxford. The radical changes in university life meant that dons could now marry and live outside the colleges, thus creating a huge demand for new houses. St John's began selling building plots on what became known as the Norham Estate, reaching from the Parks to Belbroughton Road, on which were built the grand Victorian (and later Queen Anne style) villas which are so admired today.

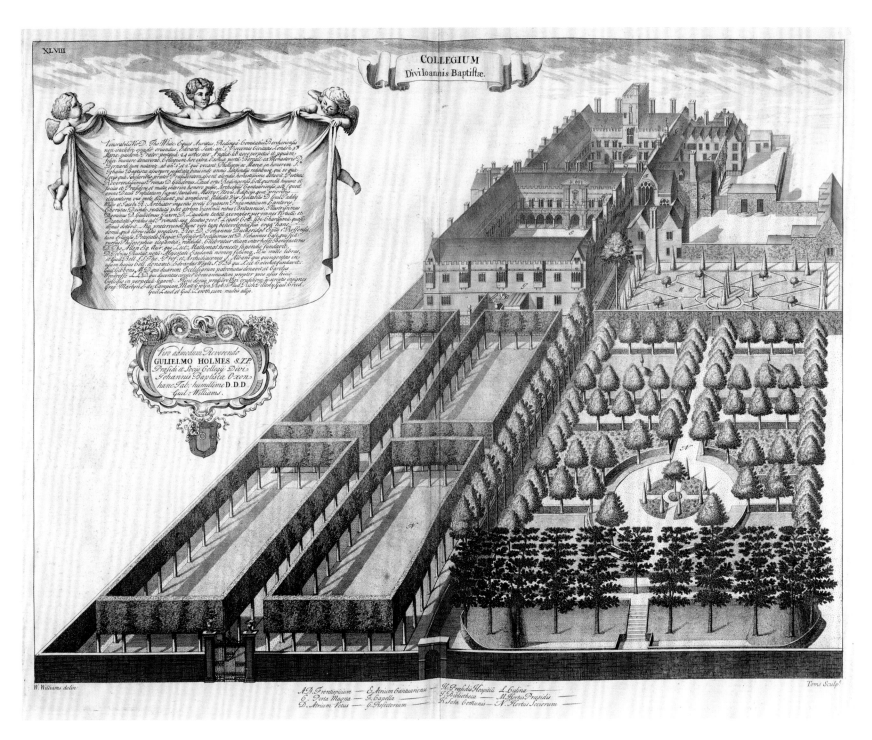

St John's College, 1733. An unusual view from the east over the college gardens, with the two quadrangles beyond.

OXONIA DEPICTA

CORPUS CHRISTI COLLEGE

THE FOUNDING OF CORPUS CHRISTI in 1517 – the very year in which Luther ignited the spark that was to fire the Reformation – provided a small but significant foretaste of that event. The founder was Richard Foxe, Bishop of Winchester, and a leading prelate and statesman during the reign of Henry VII, but less in favour with his son and successor. For some years Foxe had been meditating a new monastic college in Oxford for the Benedictine monks of Winchester Abbey, but he was dissuaded from this scheme by his friend the courtier Hugh Oldham, who was deeply hostile to the monastic orders. Oldham harangued Foxe in the plainest language:

Shall we build houses and provide livelihood for a company of bussing monks, whose end and fall we ourselves may live to see? No, no, it is more meet, a great deal, that we should have care to provide the increase of learning, and for such as who by their learning, shall do good in the church and commonwealth.

This was a remarkable prophecy of the end of monasticism in England, and Foxe was persuaded by it to found a college dedicated to secular learning, in which, within just a few years, forty scholars would be in residence.

Foxe secured a site lying between Christ Church and Merton on which stood five academic halls, all fallen into decay, which were removed to make way for the new foundation. The statutes of the college were clearly shaped by Foxe's personal wishes, in particular their territorial criteria for admission: scholars had to be natives of one of the counties where the college held land, or of the dioceses where Foxe had been bishop at various times, namely Durham, Bath, Exeter and Winchester. These rules were not altered until they were swept away in the reforms of the Victorian era. Less formally, there was a college tradition that a fox was kept in a small yard within the college, in memory of the founder. Indeed, in Loggan's view of the college a fox can be seen on a leash in the woodyard. Foxe died in 1528 never having seen his college, for during the last ten years of his life he was afflicted by total blindness; but he took great delight in it, referring to it as his beehive, humming with learning and intellectual activity.

The Tudor buildings, with the fine gate-tower and the hall with its hammer-beam roof, were the work of two royal craftsmen, William Vertue and William East. Edward Turner, the 'rich and liberal' president of Corpus in the early eighteenth century, initiated a programme of new building, including the neo-classical Fellows' Building, which resembles an elegant country mansion, overlooking the meadows to the south. Among the many celebrated alumni of Corpus may be numbered Richard Hooker, the great theologian of the Anglican Church, William Buckland, the pioneer geologist, and Sir Isaiah Berlin, the political philosopher.

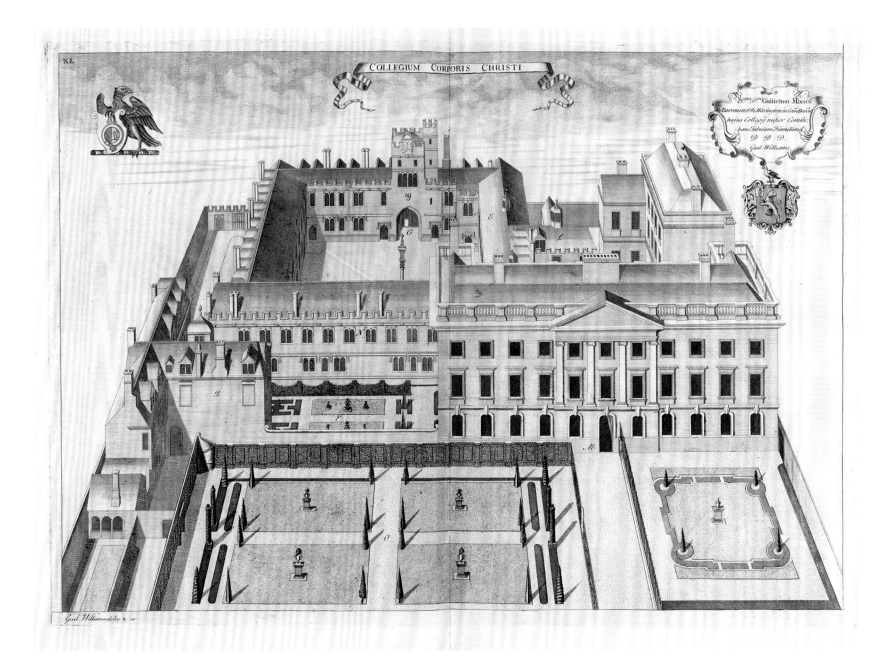

Corpus Christi College, 1733. The college is seen from the south, the meadows side, accentuating the recently completed Fellows' Building and gardens.

OXONIA DEPICTA

TRINITY COLLEGE

TRINITY shares some remarkable similarities with its neighbour St John's. Both were founded during the brief reign of Queen Mary Tudor and, in fact, in the same year of 1555. Trinity's charter was given by Mary and her husband, King Philip II of Spain. Both founders were laymen, but both colleges were for many years strongly associated with Catholicism. In both cases the new foundation was a metamorphosis of an old monastic college suppressed some years earlier. Trinity was formerly Durham College, where monks from Durham Cathedral monastery had been educated since 1291. Trinity's founder was Sir Thomas Pope, an Oxfordshire-born lawyer who had risen in the service of the Crown, and had been in charge of the dispersal of monastic property, buying the Durham College site for his own use. The new college took over the existing buildings, improving and replacing them over the following two centuries. The site is L-shaped, lying north of Broad Street, but with extensive grounds opening on to what is now Parks Road. Sir Thomas Pope was buried first in a London church, but was later re-interred in the chapel of Trinity. He is the only founder of any college in Oxford to rest in a tomb within his own foundation.

Famous men associated with Trinity in the seventeenth century include Gilbert Sheldon, archbishop of Canterbury and donor of the Sheldonian Theatre, and the very different character, John Aubrey, the genius of brief biography, who was described by Anthony à Wood as 'shiftless, roving, maggoty-headed and little better than crazed'. The fabric of the college was modernized in the late 1600s by the president, Ralph Bathurst, who employed his friend Christopher Wren to create a new range of modern, neo-classical buildings, clearly visible in the Williams engraving. Wren also gave Bathurst advice about the new chapel constructed between 1692 and 1694, as did Henry Aldrich, dean of Christ Church. The chapel was the first Oxford college chapel not built in the Gothic style. It is a graceful work of Restoration Baroque, with a painted ceiling and carved woodwork by Grinling Gibbons. A few years later the majestic gates which we now see on Parks Road were erected, and these in turn were matched by similar gates on Broad Street. This 1733 view by Williams emphasizes the splendid long gardens ornamented with formal parterres in the French style, but recent historians have questioned whether they were ever laid out, since, apart from this one picture, there is no shred of evidence for their existence.

Trinity was home to some famous undergraduates – Pitt the Elder, John Henry Newman, Walter Savage Landor, the irascible poet who was sent down for firing a gun in the quadrangle, and the great traveller Sir Richard Burton, also sent down for indiscipline. James Ingram, president of Trinity from 1824 to 1850, was the author of *Memorials of Oxford*, 1832–7, a history of the city and the university, illustrated with many beautiful engravings by John Le Keux.

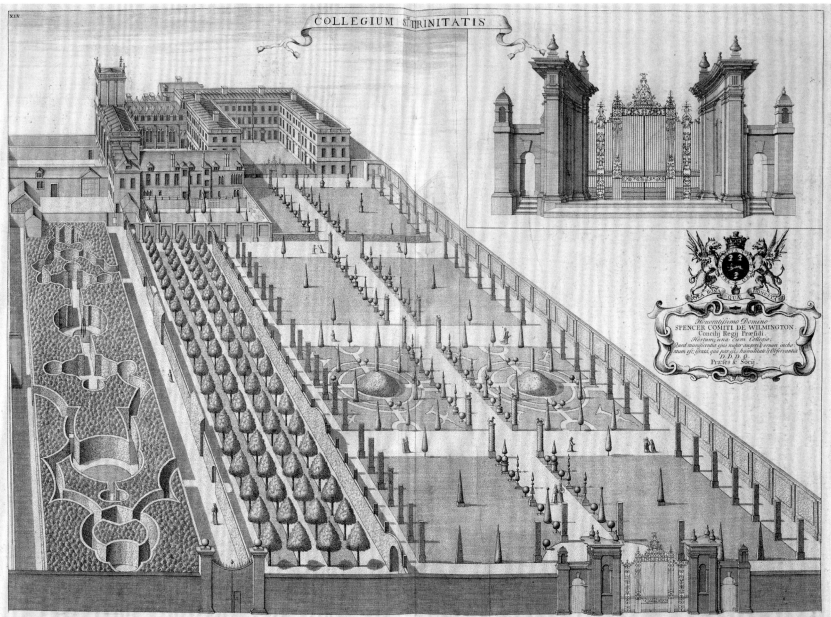

XLV

COLLEGIUM S^t TRINITATIS

Honoratissimo Domino
SPENCER COMITI DE WILMINGTON
Concilij Regij Præsidi.
Hortum, una cum Collegio.
Quod munificentia ejus nuper augeri & ornari inchu:
atum est; gratâ, quâ par est, humilitate & Observantiâ
D. D. D. Q.
Præses & Socij.

COLLEGIUM DUNELMENSE, *ab antiquo Monasterij Dunelmensis Seminarium, Bibliotheca Aungervillana, in publicos Academicorum usus extructa, olim celebre, post Cœnobiorum stragem sub Henrico VIII.*
aliquandiu derelictum & incultum jacens THOMAS POPE Miles A°D^ni MDLV. *doctrinæ & religioni redemit; parietes antiquos resarsit & Præsidenti, Duodecim Socijs, totidemque Scholaribus inibi alendis*
accommodatos reddidit. Cum vero paupercula Societas diu ingloria latuisset, tandem sub Kettello Præsidente vigilantissimo caput extulit, sub Bathursto Patrono munificentissimo doctrinâ, disciplinâ & Convic-
torum frequentiâ cum primis extitit conspicua: in hoc autem præcipue celebranda, quod publicum incolarum beneficium magis quam lucrum privatum continuo meditata fuent; id quod testantur (præter
antiqua mœnia fere universa instaurata, præter Capellam, eximia elegantia opus, Refectorium, Culinam) tum Arbustum novâ & elegantiori formâ donatum, tum Hospitia etiam, Benefactorum Symbolis undique
impetratis, de novo penitus condita; quæque Collegij limites antiquis duplo fere ampliores constituunt; quin quod & plura adhuc, nec inauspicato uti sperandum est, moliatur. _____

Trinity College, 1733. This dramatic view from the east highlights the ornamental iron gate, now on Parks Road, and the large formal garden. However,
historians have recently questioned whether this garden was ever constructed, since aside from this picture there is no evidence that it ever existed.

OXONIA DEPICTA

THE CLARENDON BUILDING

THERE IS A POPULAR STORY that the Clarendon Building came into being as the new printing-house for the University Press on the proceeds of a book, *The History of the Rebellion and Civil Wars in England*, by Edward Hyde, Earl of Clarendon. This was published in three volumes between 1702 and 1707 and became Oxford's first best-seller. Clarendon himself had died in 1674, but the manuscript and the copyright in it were presented to the university by his son and the work of editing was undertaken by a small group of Oxford scholars. What is less well known is that the proceeds from the publication were first embezzled by William Delaune, president of St John's College, and the money had to be prised out of him. But he was a popular man, and in those free-and-easy days, he was forgiven and later elected Professor of Divinity. In fact the story of the Clarendon money is only partly true, for the building fund had to be supplemented by a large sum given by John Baskett, whom the university licensed to run the Press.

By 1713, the Press, which until then had had no proper home of its own, but had squatted in the Sheldonian Theatre, found itself housed in a moderate-sized palace, the first work in Oxford by the great architect Nicholas Hawksmoor. Hawksmoor modelled the building on the Propyleum, the gateway or entrance to the Acropolis in Athens, and the Bodleian Library was therefore being cast in the role of a temple of learning; the open passageway that divides the Clarendon into two halves is aligned on the entrance to the Schools quadrangle. The classical theme is emphasized by the very fine statues of the Muses placed on the roof; these are in lead and were designed by Sir James Thornhill. The north entrance with its massive Doric portico is reached up a broad flight of stairs – in summer now invariably blocked by picnicking tourists. Both the north and south entrances are surmounted by attic pediments, but so are the east and west gables, so that a photograph from above seems to show two classical temples strangely intersecting one another at right-angles.

Once the Press was established, one of the two wings was used for printing Bibles, the other for learned books. The Clarendon Press imprint was first used in 1713, but the Sheldonian Theatre imprint continued in use, rather bafflingly, for some years more. Naturally Clarendon's own history showed at first the Theatre imprint, but later editions were from the Clarendon Press – a generous and probably unique tribute from a publishing firm to the author who had helped make its fortune.

The Clarendon Building with the theatre and the museum just visible along Broad Street, 1814.
A charming and atmospheric view, but there seems to be a Muse missing and we wonder whether the stone was ever quite this brown, sandstone tint.

HISTORY OF OXFORD

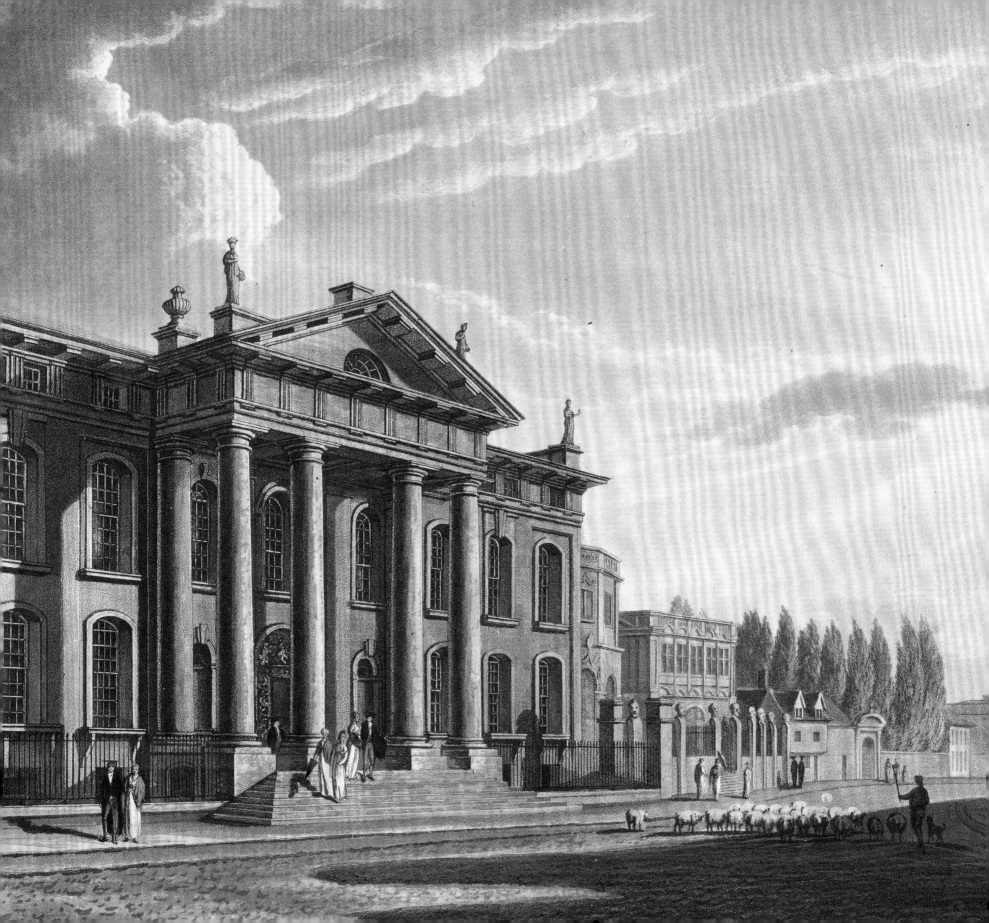

THE BUCKS' VIEW OF OXFORD

THE TWO BROTHERS Samuel and Nathaniel Buck, from Richmond in Yorkshire, were draughtsmen and engravers whose work was very influential in stimulating the eighteenth-century taste for the picturesque and the antique and also in encouraging tourism in historic cities and sites in Britain. Active between *c.*1720 and *c.*1760, they travelled throughout the country making their meticulous drawings of antiquities, towns and cities in pen outline, shaded with grey wash, which they would later engrave and publish. In 1774 Robert Sayer collected them together and re-published them in volume form as *Bucks' Antiquities*. Modern admirers of their work have traced their steps in many of the locations and found their drawings to be remarkably accurate, both in the general view they offer and in the treatment of individual buildings.

One of their earliest publications, in 1731, was the 'South West Prospect of the University and City of Oxford', but in the two decades that followed Oxford changed a great deal. Their second attempt, 'South East Prospect of the University and City of Oxford', was published in 1752,

a favourable date which ensured the inclusion of such recently finished landmarks as the Radcliffe Camera, the twin towers of Hawksmoor's All Souls building, the new tower of All Saints Church, the new library of Christ Church, and Magdalen's New Building. Thirty-two such sites are identified in the key below the print, and the Bucks tell us helpfully that 'The station where this drawing was taken is between Eafley and the Henley Road'. In 1752 there would have been no obstruction from this site when looking across the Cherwell at a sweeping view from Friar Bacon's Study on the left to Magdalen on the right. The human figures in the foreground were an essential part of any picturesque view, and here the Bucks have drawn them with a delicacy that is not very far removed from figures in the paintings of Watteau. Their art was restrained and understated, certainly not strictly romantic in the later sense. Nevertheless this view conveys an impression that to us is wistful and nostalgic, a city without sprawling suburbs and with a wide skyline interrupted only by graceful towers and spires.

'South-East Prospect of the City and University of Oxford', 1752. Possibly the most elegant and natural of all Oxford views, well timed to show the eighteenth-century rebuilding of the university and colleges.

BUCKS' ANTIQUITIES

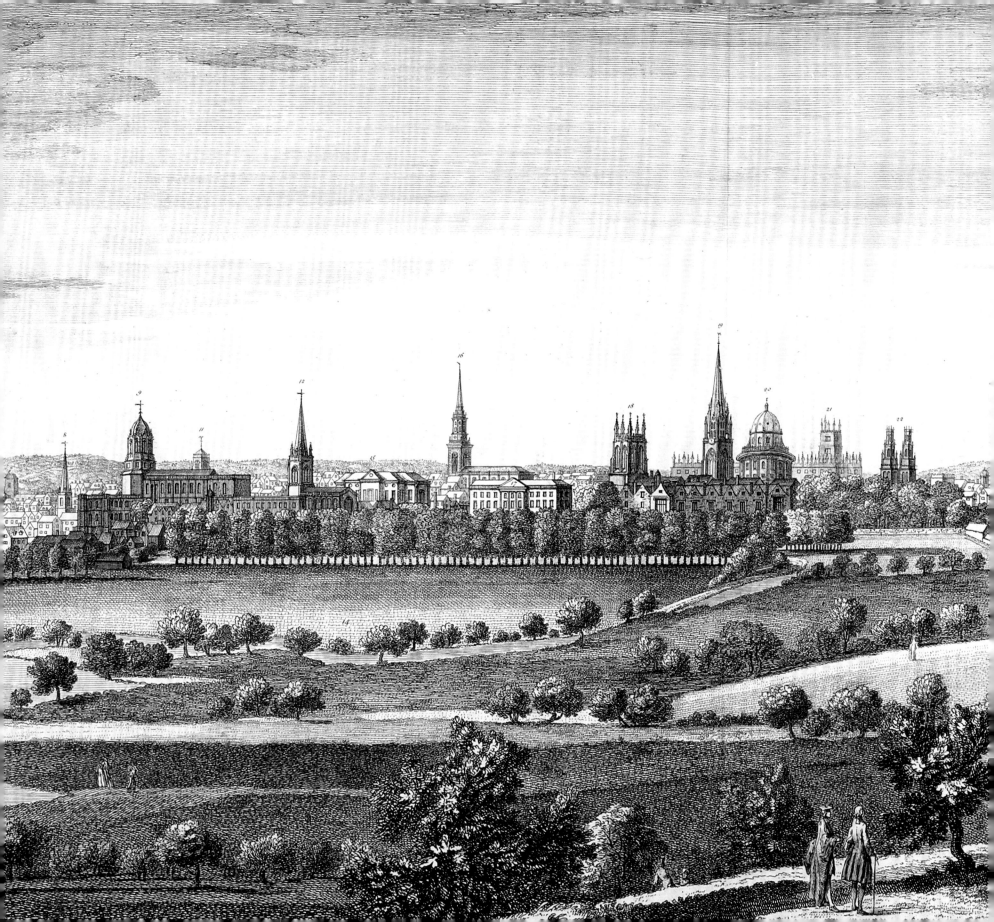

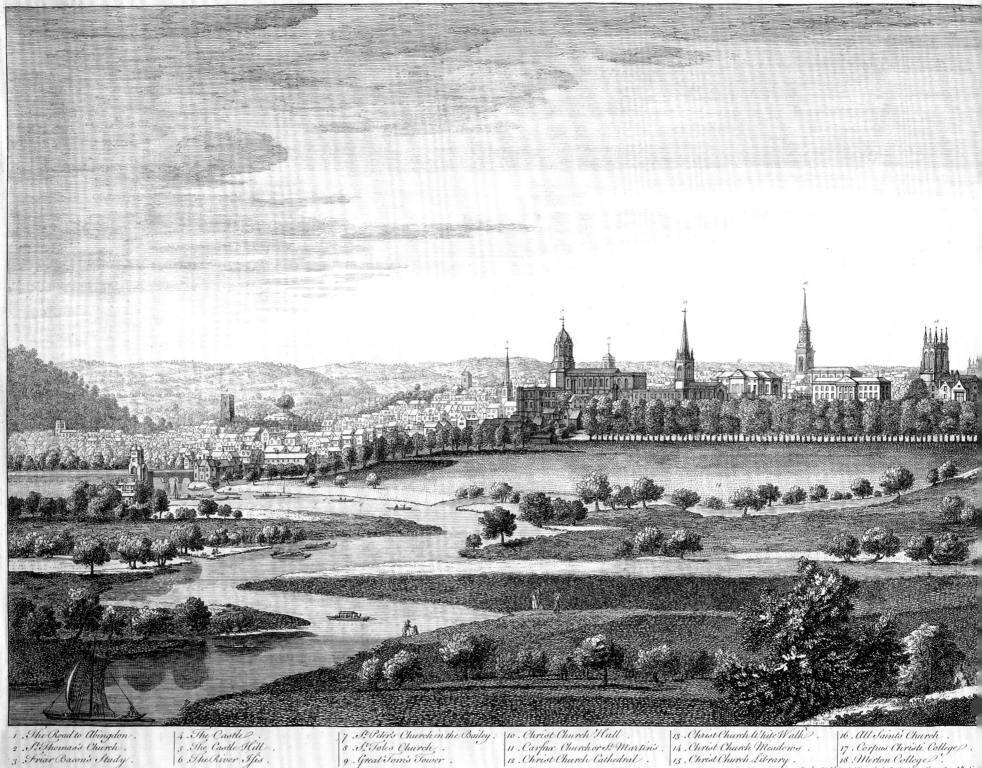

1 . The Road to Abingdon .
2 . St Thomas's Church .
3 . Friar Bacon's Study .
4 . The Castle .
5 . The Castle Hill .
6 . The River Isis .
7 . St Peter's Church in the Bailey .
8 . St Tole's Church .
9 . Great Tom's Tower .
10 . Christ Church Hall .
11 . Carfax Church or St Martin's .
12 . Christ Church Cathedral .
13 . Christ Church White Walk .
14 . Christ Church Meadows .
15 . Christ Church Library .
16 . All Saints Church .
17 . Corpus Christi College .
18 . Merton College .

Sam.l & Nath.l Buck delin. et Sculp. Publish'd according to Act of Parliam

UNIVERSITY, AND CITY OF OXFORD.

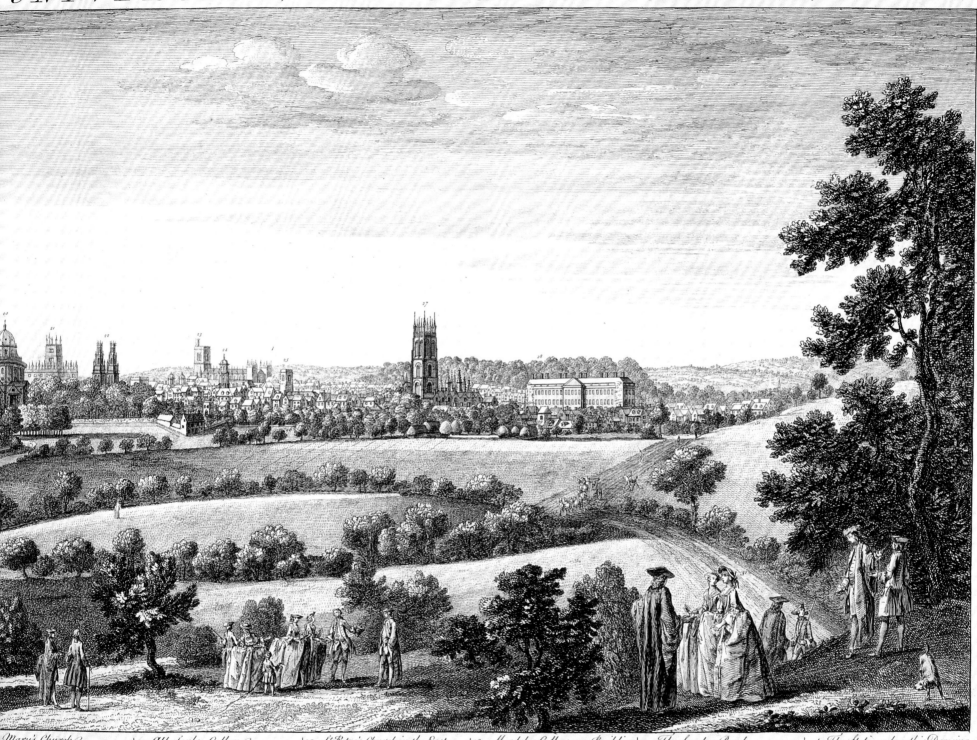

Mary's Church.	22. All Souls College.	25. St Peter's Church in the East.	28. Magdalen College new Building.	31. The London Road.
adcliff's Library	23. New College.	26. The Physick Garden.	29. St Clements Church.	32. The Henley Road to London.
e Publick Schools	24. Queen's College.	27. Magdalen College.	30. Magdalen College Water Walk.	33. The Station where this Drawing was taken, is between Easley and the Henley Road.

Garden Court Nº 1. Middle Temple. London.

CARFAX CONDUIT

THE ORIGINAL CENTRE of the life of medieval Oxford was Carfax, the point where the east-west road crossed that running north-south. The word Carfax is thought to be derived from the Latin *quadrifurcus*, 'four-forked'. Here stood the medieval church of St Martin, which was rebuilt in 1820 and largely demolished in 1896, leaving only what we now call Carfax Tower. Shakespeare's godson, playwright and unofficial poet laureate William Davenant was christened in this church, and it is tempting to imagine that Shakespeare himself was present.

At this crossroads was built in the year 1610 a fine new water conduit, which brought fresh spring water from Hinksey Hill into the city by way of a lead pipe. The upper outlet of the conduit provided water for several of the colleges, the lower one water for the townspeople. It was a gift to Oxford by Otho Nicholson, a graduate of Christ Church, who went on to a successful career as lawyer and diplomat. The construction was carried out by a Yorkshire stonemason, John Clark. Nicholson's initials were carved around the conduit, and the whole structure was ornate and fanciful, symbolic and heraldic, in the manner of a Jacobean triumphal arch. On notable high-days and holidays, wine was sometimes added to the water. On the Restoration in 1660, for example, the council decreed that a hogshead of claret should be poured out from it. The lower half of the conduit was surmounted by a carved ox, and one contemporary description of it claimed that the water was conveyed into the body of the ox 'and thereby the city is supplied with good and wholesome water issuing from his pizzle'.

For almost 180 years the Carfax conduit was a conspicuous landmark in central Oxford, until the narrowness of the road and the hindrance it caused to traffic brought about its demise. It was not destroyed, however, but dismantled, and the stones were acquired by Lord Harcourt, who had the whole structure rebuilt in the park of his house at Nuneham, where it formed a picturesque feature that was much admired and depicted by artists.

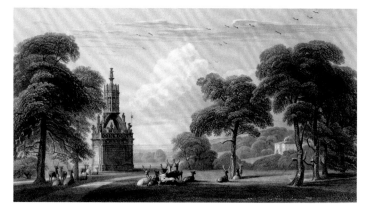

Carfax Conduit, removed and re-erected in Nuneham Park, 1833.

OXFORD ALMANACK

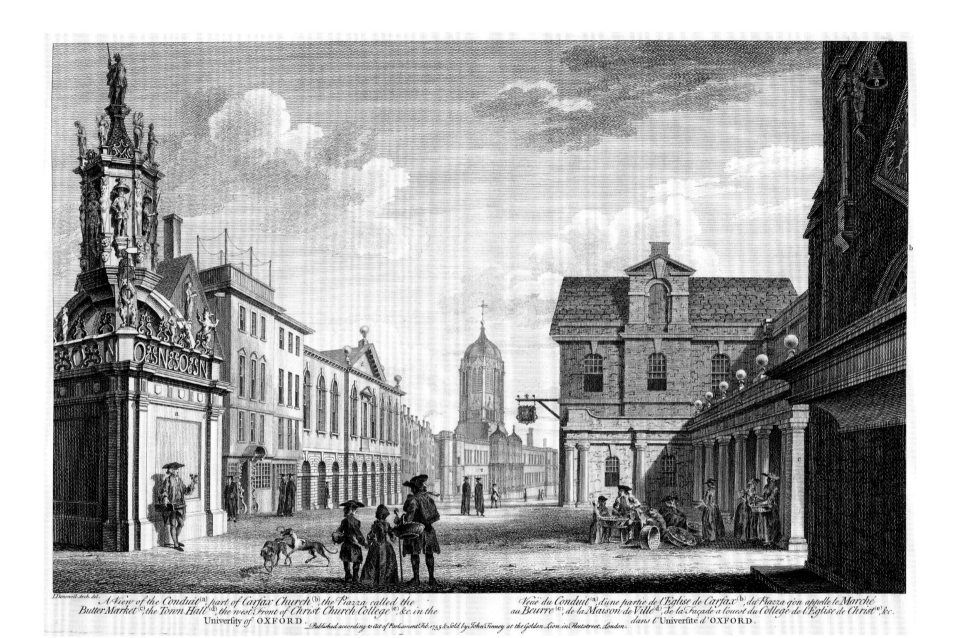

A View of the Conduit (a) *part of Carfax Church* (b), *the Piazza called the Butter Market* (c), *the Town Hall* (d), *the west Front of Christ Church College* (e), *&c. in the University of* OXFORD. *Published according to Act of Parliament Feb. 1755 & Sold by John Tinney at the Golden Lion in Fleetstreet, London.*

Veüe du Conduit (a) *d'une partie de l'Eglise de Carfax* (b), *du Piazza qon appelle le Marché au Beurre* (c), *de la Maison de Ville* (d), *de la Façade a l'ouest du Collège de l'Eglise de Christ* (e), *&c. dans l'Université d'* OXFORD.

Carfax Crossroads, 1755. Carfax was for centuries the heart of Oxford, with the Town Hall, the Buttermarket, St Martin's Church and the ornate water conduit, built in 1610 by Otho Nicholson, a graduate of Christ Church. Of these structures, only the church tower survives today.

EIGHT VIEWS OF OXFORD

THE OLD ASHMOLEAN MUSEUM

WITH BODLEY AND RADCLIFFE, Elias Ashmole is one of the trio of figures who have left their name imprinted on the university's most famous institutions. Ashmole was a lawyer with wide intellectual interests, who held a royal appointment and came to Oxford in the entourage of King Charles during the English Civil War. He entered Brasenose College when he was almost thirty years old and then married a woman who was twenty years older than himself and already the wealthy widow of three previous husbands. This piece of good fortune enabled Ashmole to pursue his scholarly career as he pleased. The most significant event in his earlier life was his friendship with the two John Tradescants, father and son, who, as well as being gardeners to the king and various noblemen, had brought together a large collection of curiosities and antiquities, which they exhibited in their house in Lambeth. In 1662 John Tradescant the younger left this collection to Ashmole, who, after a lengthy dispute with Tradescant's widow, and negotiations with the university (to which he intended to donate the collection along with his own books and manuscripts), packed it up and shipped it in huge boxes by barge to Oxford. An impressive new home for the collection was built beside the Sheldonian in a handsome, Wren-inspired, late Stuart-Baroque style, and was opened in 1683 by the Duke of York, the future King James II, accompanied by his young daughter, the future Queen Anne. They inspected the 'rareties', witnessed some scientific experiments in a laboratory, and enjoyed a fine banquet. Exactly why the university embraced this innovative but expensive project is something of a mystery, but it made a significant addition to the buildings in the university quarter. It might perhaps more justly have been named the Tradescant Museum, but Ashmole imposed his name on it, in spite of the fact that he did not fund the very costly building himself, but somehow persuaded the university to do so.

The collection was a heterogeneous mixture – botanical, zoological and geological specimens, coins, clothing, arms, pictures and artefacts from many parts of the world. It was a sign of the new spirit of intellectual enquiry, which also saw the birth of the Royal Society, of which Ashmole was a member. Yet many in Oxford remained sceptical, dismissing the collection as baubles, unworthy of serious attention, or of Oxford. For once, however, the city was ahead of its time, for the Ashmolean became the first public museum in England, and indeed the first use of the word 'museum' seems to have been to describe it. It seems that during the eighteenth century the collection was not professionally cared for, and some specimens, most famously the unique dodo, were lost. By the nineteenth century, many more collections, historical and artistic, had been gifted to the university, and the new Ashmolean was built to house them. Further, later donations included several rich collections of scientific instruments, which were felicitously placed in the Old Ashmolean, giving it an important new identity as the Museum of the History of Science, a very different kind of science from that understood by the Tradescants.

The (Old) Ashmolean Museum with Exeter College beyond, 1837. This imposing Jacobean building was opened in 1683 to house Elias Ashmole's collection of 'curiosities'. This is the ceremonial entrance facing the Sheldonian, on what we now regard as the side of the building.

MEMORIALS OF OXFORD

ORIEL COLLEGE

ORIEL has always been celebrated as the birthplace of the Oxford Movement, since its leading figures – Newman, Pusey, Keble and Froude – were all members of the college. Yet Oriel is among the oldest of the colleges and the first to have a royal founder, in the figure of King Edward II. It is thought that the college's familiar name was taken from the house in which it was first established, known as La Oriole, derived from *oratoriolum* – a projecting upper window. There are several such windows to be seen on the college buildings, but none of them can be the original one, since Oriel joined enthusiastically in the wave of rebuilding that took place in the early seventeenth century. The cramped medieval accommodation was swept away, to be replaced by the handsome late-Stuart quadrangle and garden which we see in Loggan's engraving of 1675. The most eye-catching feature is the ornate projecting porch and stairway surmounted by the large carved stone letters spelling out *Regnante Carolo* – 'In the reign of Charles'. Above this are the figures of Virgin and Child, reminding us that college's original and official designation was 'The House of the Blessed Mary the Virgin'. Placed there in the 1630s, this statue was highly contentious during the years of religious conflict and was removed during the Commonwealth.

Among famous Oriel men were Sir Thomas More, William Prynne, the puritan martyr, Gilbert White of Selborne, Thomas Arnold and his son Matthew, and Cecil Rhodes. Thomas Arnold was a leading figure in the group of liberal churchmen known as the Noetics, whom the Oxford Movement saw as their enemies in their campaign to recall the Anglican Church to its Catholic and spiritual roots. At issue were the character and future direction of the Church and the university, and it was clear to the Noetics that the aims of Oxford Movement must be defeated if those two institutions were to be modernized. The opposite conviction was expressed in defeat by Newman's conversion to the Church of Rome, 'because there is no other Church', the Church in England having become a secularized political body; and it was expressed in Pusey's words, when he argued that:

The special work of a university is not how to advance science, not how to make discoveries ... but to form minds religiously, morally and intellectually All things must speak of God, refer to God, or they are atheistic. History, without God, is a chaos without a design, an end or aim.

This philosophical warfare, which developed within the walls of Oriel College and spread throughout England, is a vivid reminder of the days when the life of nation could be influenced by intellectual events in Oxford.

Oriel College, 1814. This is the Front Quadrangle, the southernmost of three, seen from the gatehouse on Oriel Lane. Oriel, like University College, was rebuilt in the mid-seventeenth century, when the carved Madonna and child visible over the raised entrance porch were highly controversial.

HISTORY OF OXFORD

ALL SOULS COLLEGE

THIS SPLENDID VIEW of All Souls was drawn from the parapet of the Radcliffe Camera. It highlights one of the most easily recognized features of Oxford's skyline, the paired towers which appeared as part of the great rebuilding of the college overseen by Hawksmoor between 1715 and 1734. The style chosen was Gothic, and these towers clearly recall the west front of cathedrals such as York or Canterbury, though modified and pinnacled to suit the taste of the eighteenth century. Internally, however, the new buildings were classical in style, seen above all in the magnificent Codrington Library, financed by an particularly cultured and wealthy soldier. The Hawksmoor plan was to be extended to the whole college, but in time the Hawksmoor style lost its appeal, the architect himself died and the work was halted, restricted to the northern quad only, which is what we see here. Hence the front of the college on the High Street remains close to its medieval origins, naturally restored and improved, but giving little hint of what lies behind it.

Hawksmoor's unique and much admired structure was the product of a brief window of time when the Gothic style was in vogue; a decade either way in the commissioning of the work at All Souls might have resulted in an entirely different building.

The original statutes and ethos of All Souls were closely modelled on those of New College, not surprisingly since the founder, Henry Chichele, archbishop of Canterbury, had been a fellow of New College. He shared the ideals of William of Wykeham, which aimed at producing a scholarly militia who would strengthen Church and State through their sound learning. From the first, All Souls was unique among the colleges in taking no undergraduates: it was to consist only of fellows who had already studied for at least three years at the university, and who were now to pursue higher studies leading to doctoral degrees. Fellows of the college have included some very distinguished figures indeed – Gilbert Sheldon, Christopher Wren and William Blackstone, among many others.

All Souls Quadrangle, 1814. A classic view from the Radcliffe Camera looking eastwards across the screen into Hawksmoor's inner quadrangle, with the Codrington Library on the left.

HISTORY OF OXFORD

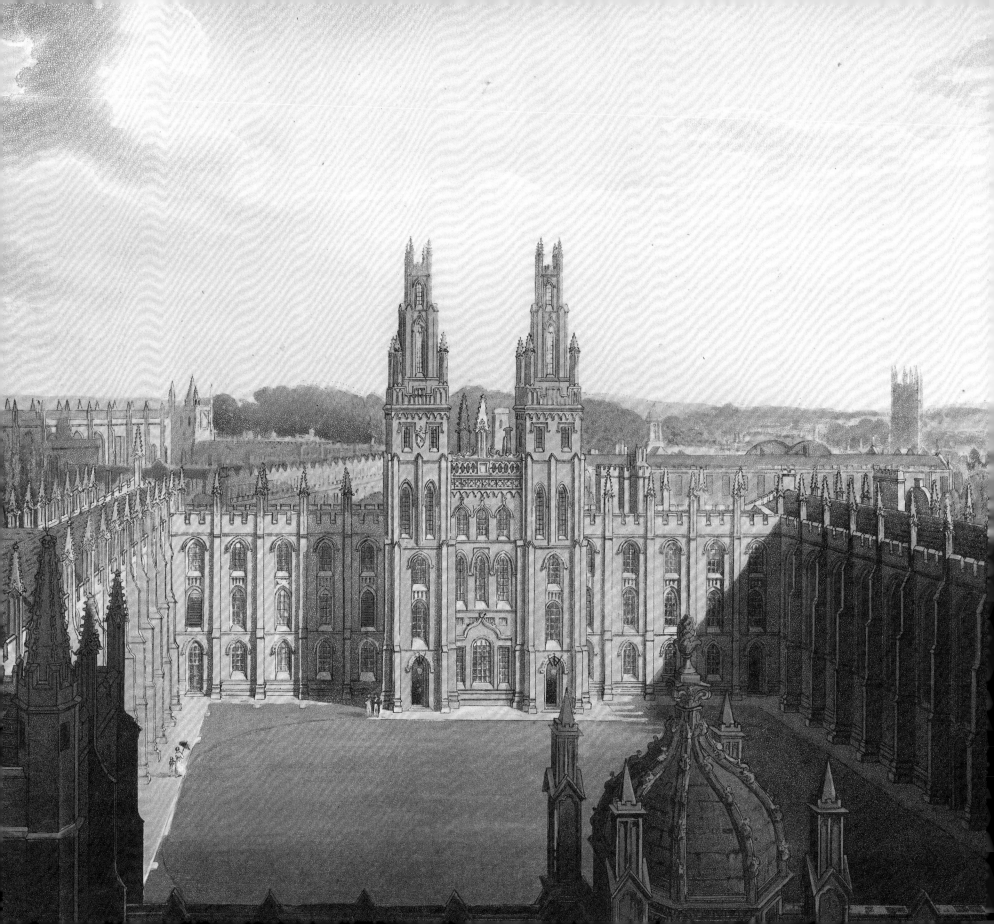

FOLLY BRIDGE

MANY PEOPLE imagine that the name Folly Bridge – long ago known as South Bridge, leading to the Abingdon Road – must refer to the whimsical house decorated with stone statues and iron balconies that stands on the island. This is not so, however, for the name was current before the year 1700, and its true origin is now lost in history. The first stone bridge on this site was built by Robert D'Oilly, the Norman who landed with the Conqueror and became the great landowner of Oxford. The bridge is in two sections with a central island, on which stood what was for centuries its most famous feature, the tower known as Friar Bacon's Study. Here the medieval scholar, philosopher and reputed magician Roger Bacon, the *doctor mirabilis*, is said to have lived and worked; perhaps it was here that he created his legendary 'talking head' and other fabulous inventions, including a telescope. The tower was an early tourist attraction in Oxford, being visited in 1668 by the enthusiastic Samuel Pepys, who wrote, 'So to Friar Bacon's study. I up and saw it and gave the man a shilling Oxford mighty fine place.' The tower was removed in 1779, but many years elapsed before the ancient and crumbling bridge itself was finally rebuilt, in 1825–7. The house which replaced the tower was occupied for many years by a more modern scientist, Sir Robert Gunther, who established the Museum of the History of Science in the 1920s, in the Old Ashmolean Museum. Gunther was the author of the magisterial work *Early Science in Oxford*, which appeared in fourteen volumes, tracing every aspect of scientific history within the university. As this print shows, Folly Bridge has long been the focus of boating in Oxford, on the river which is here correctly named the Isis (not the Thames). The bridge is known as the home of Salter's Steamers and Salter's boat-building yard, and as a place to hire punts. Downstream from the bridge are the university boat-houses and, formerly, the moorings for the traditional college barges, but now no longer.

Folly Bridge, 1780. The ancient tower known as Friar Bacon's Study was demolished in 1779, so perhaps this is the final recorded view of it. The bridge itself was rebuilt in the 1820s.

OXFORD ALMANACK

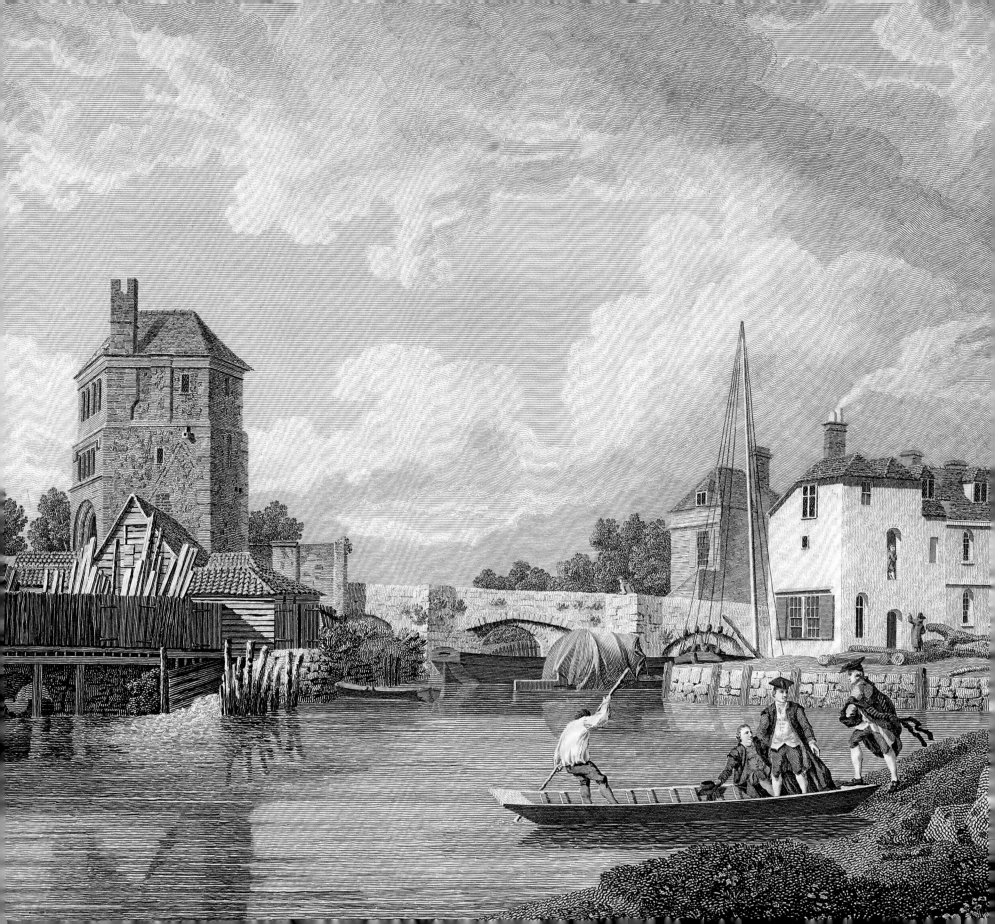

THE RADCLIFFE CAMERA

ORIGINALLY KNOWN as the Radcliffe Library, the Camera is *the* iconic building of Oxford, the image which tells you, especially as a silhouette on the skyline, that this is Oxford. The Camera was the gift of the man who has left his name in many places in Oxford, John Radcliffe, a London physician who amassed a vast fortune, most of which he bequeathed to Oxford building projects. For this library he earmarked no less than £40,000, a sum which in 1714, the year of his death, would buy a dream-library, an architectural treasure – as indeed it did.

A location south of the Bodleian Library was eventually decided upon, but the site was not vacant in 1714 and twenty years elapsed before all the existing properties on it could be purchased and cleared. The leading architects who were in the running for the commission were Nicholas Hawksmoor and James Gibbs, and it was Hawksmoor's idea to build a rotunda. This was the first use of this form for a library in Britain, and one of the first in all Europe, although there was one at Wolfenbüttel, built shortly before the Oxford project. Hawksmoor died in

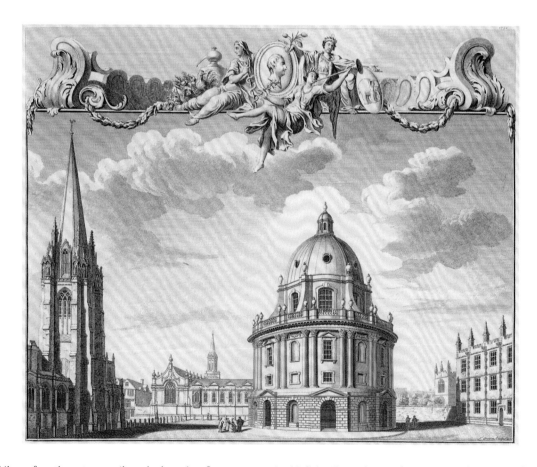

The Radcliffe Library from the east, 1752. Above the dome three figures representing Medicine, Benevolence and Fame surround a portrait of Dr John Radcliffe.

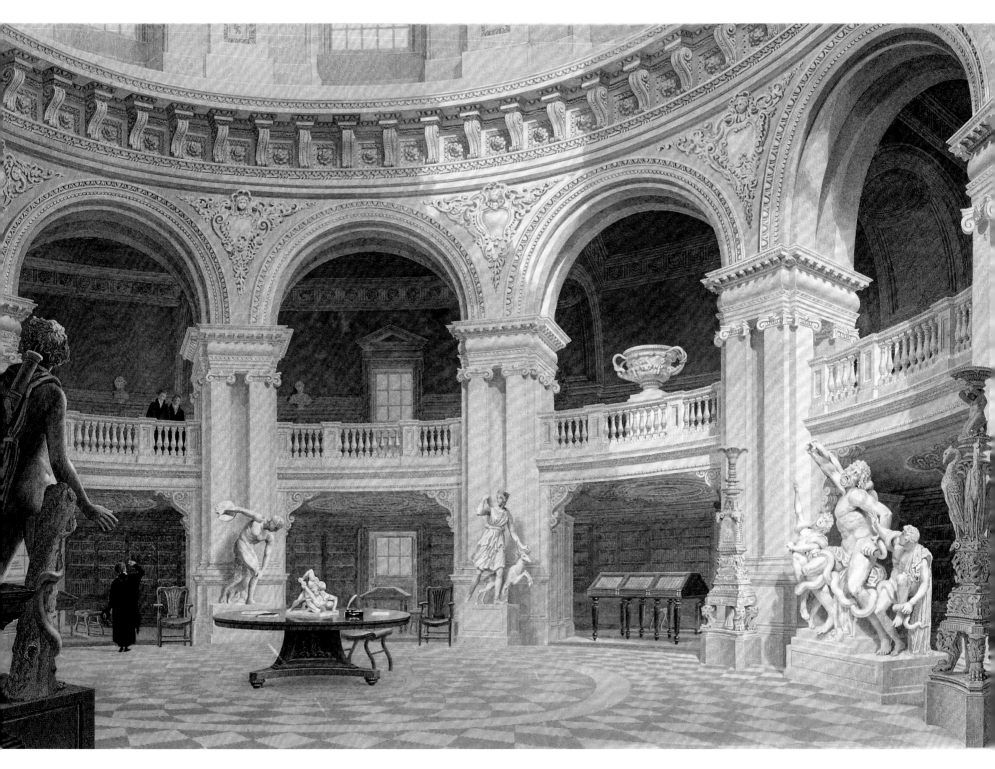

The interior of the Radcliffe Library, 1836.

OXFORD ALMANACK

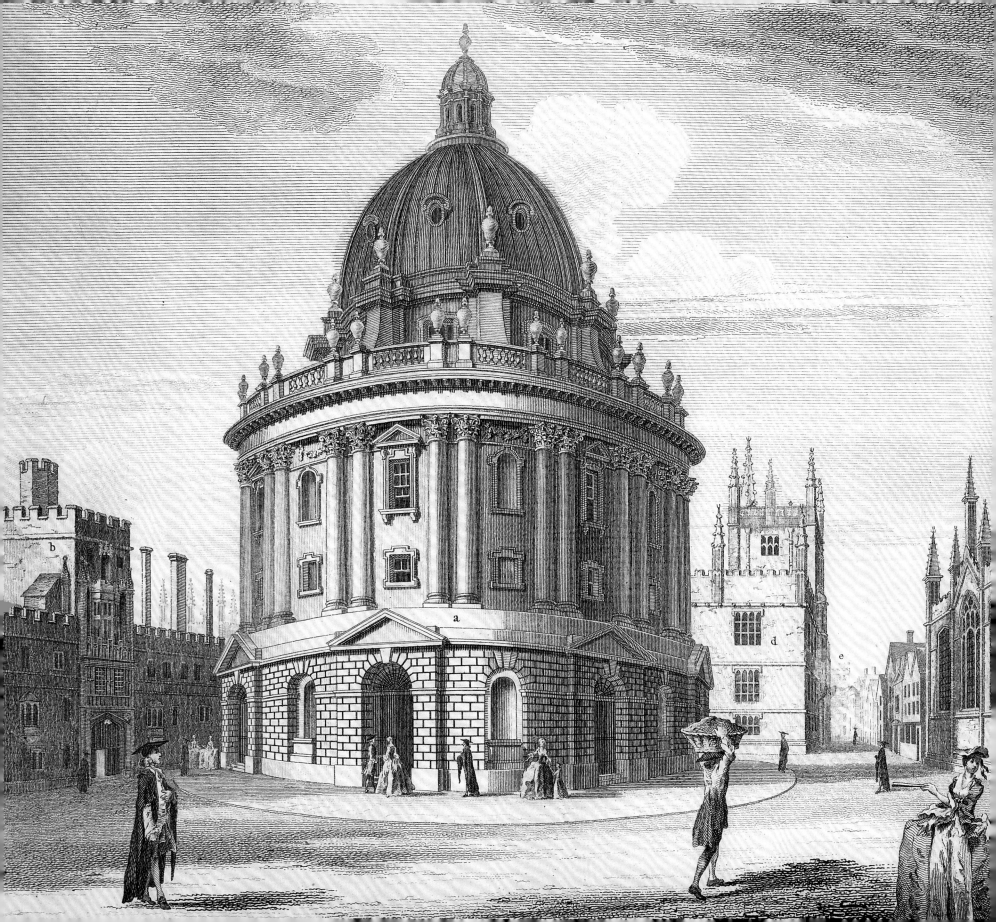

1736 and in the following year work commenced to Gibbs's final design, which is strongly Italianate in style, not surprisingly since Gibbs had trained in Rome.

The exterior gives an impression that is both massive and delicate, the great slabs of rough stone in the rusticated base contrasting with the ornate columns and balustrade, while the dome suggests a great church rather than a secular building. Indeed, it appeared not very long ago on the cover of a book claiming to be about 'The World's Great Cathedrals'. The ground floor was originally an empty space open to the outside, which could be closed by iron gates; the upper floor alone formed the library. The outside niches have always been empty. If the exterior is beautiful, the interior is breathtaking: the marble floors, the pillars, the delicate plasterwork and the dark book-cases lining the bays all combine to make this what would later be termed a *Gesamtkunstwerk*, rather than strictly a work of architecture; it is scarcely surprising that it was eleven years in the building. Old pictures show that the central area was originally empty of books or desks, and for many years casts of large classical statues were placed there, further enriching this unique library. It was not originally part of the Bodleian Library, and only became known as the Radcliffe Camera after the Radcliffe Trustees offered it for use as a Bodleian reading room, which it became in 1862.

Radcliffe Square from the south-east, 1755. The screen of All Souls is on the right, the Schools Quadrangle beyond the Radcliffe Library and Brasenose to the left.

EIGHT VIEWS OF OXFORD

THE QUEEN'S COLLEGE

THE QUEEN IN QUESTION was Philippa of Hainault, wife of King Edward III – she who saved the lives of the Burghers of Calais – and the foundation of the college goes back to 1340. This fact sometimes comes as a surprise to the casual visitor to Oxford, who has seen the obviously eighteenth-century statue of a queen over the obviously eighteenth-century gateway to the college, and who therefore imagines that the founder might have been Queen Anne, or one of her near successors. Queen's is undoubtedly the grandest classical building in Oxford and the explanation is that the late medieval and Tudor patchwork of buildings, which can be seen in the Loggan engraving, was completely swept away in the early eighteenth century. But neither was Philippa of Hainault exactly the founder of the college, that honour belonging to her chaplain, Robert Eglesfeld, who used his connections in the royal service to raise money for his new foundation.

The most famous theologian associated with Queen's was John Wyclif, who lived and studied there from 1363 to 1381. He gathered many disciples around him, who embraced his teaching on the need for radical reform of the Church. It was here that he worked on his translation of the Bible into English and here that he became the guiding spirit of the Lollard movement. In an utterly different world, more than three centuries later, there came the final piece of the queenly jigsaw, namely the statue over the gate: this is Caroline of Ansbach, wife of King George II, who gave money to the college during its radical rebuilding programme.

But who was the architect of the grandest piece of classical architecture in Oxford? It was long believed that Nicholas Hawksmoor was the master hand behind this triumphant structure, but hard evidence for this is entirely lacking. It is true that Hawksmoor did produce plans for a new college, as did George Clarke, but they differ in many ways from the building that finally emerged. The most likely candidate for the modification of the plans and the building work is now thought to be William Townesend, the master-mason who was involved in a great deal of the eighteenth-century rebuilding of Oxford. The library was one of the earliest fruits of the rebuilding, dating from the 1690s, and is one of the finest and most memorable chambers in Oxford, with its sumptuous stucco ceiling and carved wooden bookcases. The two quadrangles, north and south, are divided by the chapel and the hall, and the cupola on the roof at the point where they intersect is the central point of the whole structure. Although not identical, this cupola matches and balances the one over Queen Caroline above the main gateway. Absolutely distinct and unmistakable, the front wall of Queen's, the cupola and the two symmetrical wings have formed an Oxford landmark for three centuries. Memories of Wyclif and the storms of the fourteenth century are indeed hard to reconcile with the vision of this classical edifice.

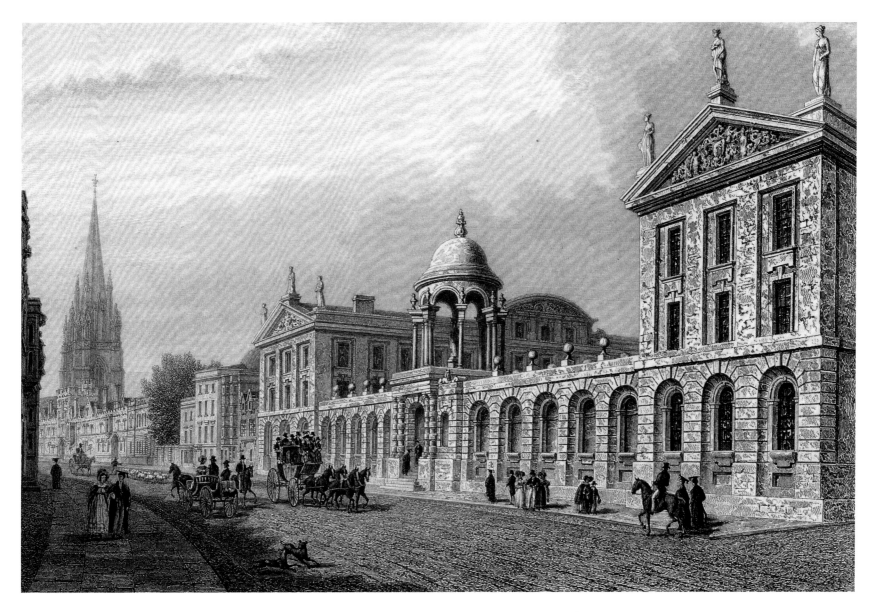

*The High Street front of The Queen's College, 1837. The eighteenth-century rebuilding of Queen's resulted in the
most comprehensive transformation of any medieval Oxford College – into what some consider a neo-classical masterpiece.*

MEMORIALS OF OXFORD

ALL SAINTS CHURCH

IN THE YEAR 1700 the spire of the medieval church of All Saints collapsed and most of the building was virtually destroyed. An appeal for funds to rebuild brought responses from a large number of donors, from Queen Anne downwards. We might have expected that an architect of the stature of Wren or Hawksmoor would have been entrusted with the work, but instead it was Henry Aldrich, dean of Christ Church, a connoisseur of art and a remarkable amateur architect, who oversaw the new design. Other buildings in which Aldrich is thought to have had a hand are Trinity College Chapel, The Queen's College Library and Christ Church's Peckwater Quadrangle. Aldrich, however, died in 1710, and at that point Hawksmoor was consulted, although some features in the final structure, completed in 1720, differed from both Aldrich's and Hawksmoor's intentions. Aldrich's original ideas were magnificently successful and externally the new church, with its massive classical columns and matching pilasters, could easily be mistaken for one of the post-fire London churches by Wren or Hawksmoor. The interior is exceptionally light and spacious, with two layers of windows around three sides and no columns to interrupt its lofty single space, in which the Corinthian pilasters match those outside. The culminating feature is the soaring tower, whose square base is surmounted by what is in effect a circular temple composed of twelve more columns, finally topped by a slender spire. It is not known who made the final design for the tower, but it is hard not to infer that the architect was seeking here to create a town church that would in some way match the spire of the University Church of St Mary a couple of hundred yards away on the High Street; certainly All Saints became an Oxford landmark. Unfortunately the original builders used poor stone; the church had to be repaired a number of times over the years and the entire tower was rebuilt in the 1870s.

By the mid-twentieth century, there was a distinct over-capacity among the churches of Oxford. As everywhere else in England, parishes were amalgamated and some churches had to close or were converted to other uses. For All Saints Church, which could seat some four hundred people, the happy solution was its conversion into a new library for its neighbour, Lincoln College. This was carried out with a minimum of alteration – except that the floor was raised in order to add a basement reading-room – and a noble church was preserved. Whether this would have comforted men of Aldrich's generation and later for the loss of its true spiritual function is another matter.

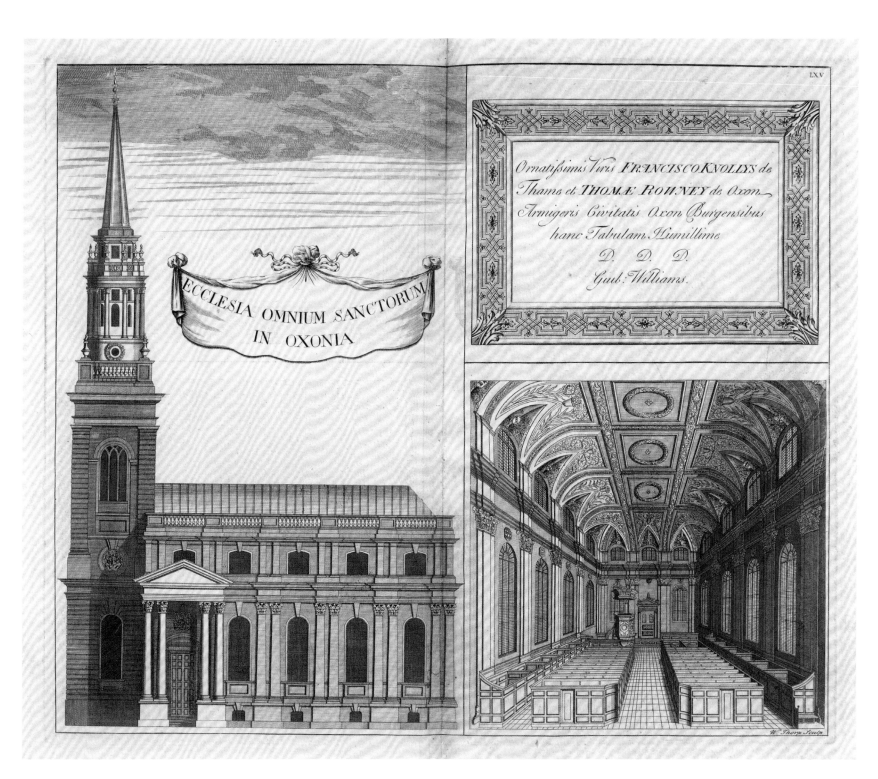

ECCLESIA OMNIUM SANCTORUM
IN OXONIA

Ornatissimis Viris FRANCISCO KNOLLYS de
Thame et THOMÆ ROWNEY de Oxon.
Armigeris Civitatis Oxon Burgensibus
hanc Tabulam Humillime
D. D. D.
Gub: Williams.

All Saints Church, 1733. Completed in 1730, All Saints was probably designed by Henry Aldrich,
dean of Christ Church, with some input from Nicholas Hawksmoor. It is now the library of Lincoln College.

OXONIA DEPICTA

BROAD STREET

RUNNING PARALLEL to the High Street, but only half its length, Broad Street – originally known as Horsemonger Street – rivals the High as the heart of Oxford and it narrowly wins the competition. Its form is more idiosyncratic than the High, like a bottle with a neck at both ends and swollen in the middle. Turning into Broad Street from the west, one is faced by Balliol's rather stern, intimidating walls, which end at the opening where the beautiful gates of Trinity stand, giving a glimpse of the Wren-like elegance of the chapel of that college. Then there is one of the world's most famous bookshops, Blackwell's, its two entrances separated by the pub that stands between them. For a couple of generations the northern end of Broad Street was dominated by the 'New Bodleian' library, designed by Sir Giles Gilbert Scott and built in 1937–40. This was a building of the 1930s and looked it, and few people have ever really taken it into their hearts. A number of shops and houses were demolished to make room for

it and pictures taken from Parks Road after their removal reveal a wonderful view of the Clarendon Building and the Sheldonian, a view that was soon shut for ever. Recent renovations to the New Bodleian have swept much of this away, opening up the building to the street as the renamed Weston Library.

The perfect austere classicism of the Clarendon Building is one of the great inspiring sights of Oxford, but inspiration turns to puzzlement at the rounded back of the Sheldonian and to laughter at the zany heads which guard it. Exeter College, with its central tower, its gables and arched windows, is everyone's idea of an Oxford college, although like many others it reveals greater beauties inside the walls. Between the Sheldonian and Exeter stands one of the most intriguing buildings in Oxford, the Old Ashmolean Museum, although the ceremonial entrance is tucked away at the side.

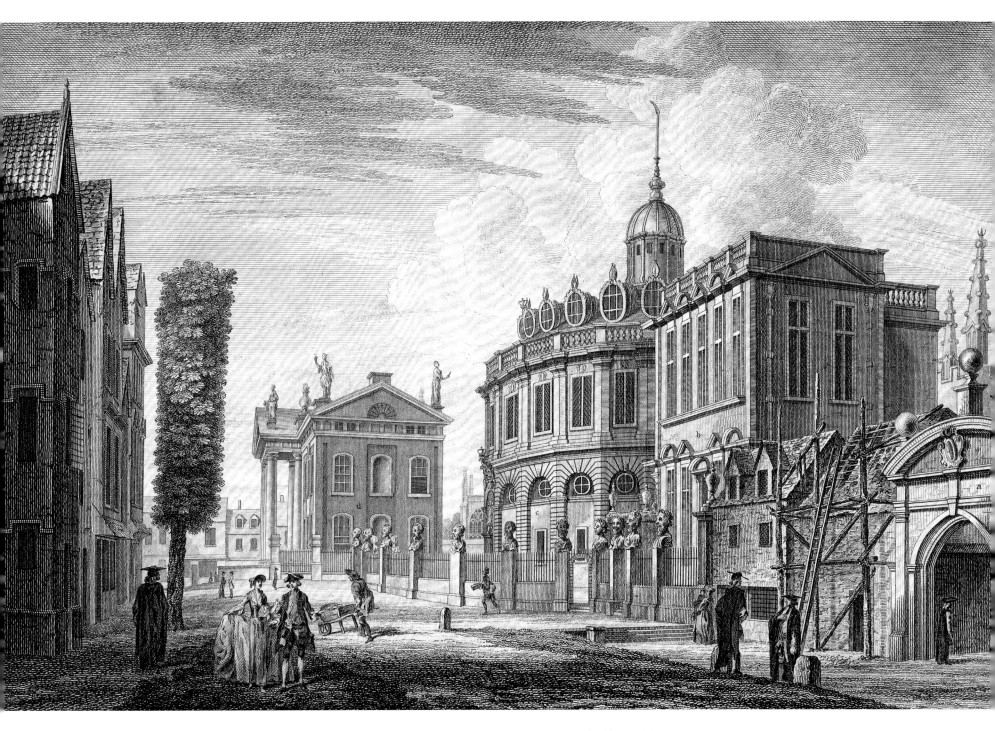

*Broad Street looking east, 1755. With three colleges, three university buildings and the university
bookshop within its two hundred yards, Broad Street may claim to be the physical heart of Oxford.*

EIGHT VIEWS OF OXFORD

THE RADCLIFFE INFIRMARY

AGAIN THE NAME RADCLIFFE, and the third institution which imprinted this man's memory on Oxford is the Infirmary at the northern end of St Giles, which opened for business in 1770. Like the Observatory, but unlike the Library, this was a project initiated by the trustees of the estate long after Radcliffe's death and it is interesting to note that, where £40,000 was devoted to the Library, £4,000 was considered sufficient to found a hospital. Indeed, the beginnings were small and an imaginative scheme of charitable funding was set up to maintain and enlarge it, with subscribers and donors buying the right to send patients there and to act as governors. Strange and complex as this may now seem, it worked well, and for a century and half before public funding became the norm the Radcliffe Infirmary continued to grow and diversify its facilities, helped by a number of major donations and bequests. From the outset it was a university institution, its governors and senior medical staff being university figures, and, although the Infirmary obtained a royal charter in 1885, this situation was little changed by it. In the twentieth century a second founder appeared in the figure of Lord Nuffield, who within the university funded a full clinical faculty, which was attached to the Infirmary.

The building was originally designed by the curiously named architect Stiff Leadbeater, but he died while the work was in progress and it was completed by John Sanderson. In appearance it closely resembled the familiar pattern of an eighteenth-century country mansion, with its central pedimented entrance and grand external stairway, flanked by two symmetrical wings. Accommodation was provided for sixty-eight patients in four wards, and there were six physicians, six nurses, an apothecary, servants and porters. A strict disciplinary code was in force and patients could be turned out for any form of misconduct. The Infirmary was well abreast of the latest medical practice: electrical treatment was available very early, while the first operations under anaesthetic came in 1847, only weeks after the first use of ether in London. In 1941 the first injections of penicillin were given to an Infirmary patient. In the post-war world the Infirmary was fast outgrowing its original site in the city centre, and a major public hospital for the new age was planned and built at Headington, opening in 1971 and retaining the historic name of Radcliffe. The original building now forms part of the Radcliffe Observatory Quarter, housing the offices of the Humanities Division.

The Radcliffe Infirmary, 1760. The new hospital is in the background, while in the foreground
Dr Radcliffe welcomes the sick, accompanied by Asclepius, Greek god of medicine.

OXFORD ALMANACK

PEMBROKE COLLEGE

PEMBROKE was the first of three colleges (followed by Worcester and Hertford) which were transformations of academic halls. Founded officially by King James I in 1624, on the site of Broadgates Hall, it was named for William Herbert, earl of Pembroke, who was then chancellor of the university. However, neither the king nor the chancellor backed up their support with money or endowments, and Pembroke instead owes its existence to a complicated diversion of a bequest originally intended for Balliol. The hard cash that guaranteed the birth of the college was that of Thomas Tesdale, a wealthy merchant of Abingdon, enabling the last principal of Broadgates Hall, Thomas Clayton, to become the first master of Pembroke College. Existing buildings were naturally taken over and the college was rebuilt piecemeal. The entrance range which we now see was built in 1830 in the Oxford Gothic style, the work of the Oxford architect Daniel Evans, with its attractive Oriel windows. Uncharacteristically, Loggan showed the front of the college incorrectly, with the entrance tower in the centre (where it was supposed to be rebuilt), rather than at the west end.

The most famous figure to have studied in Broadgates was Edmund Bonner, bishop of London, often seen as a leading persecutor of Protestants during the English Reformation, who spent the last years of his life in prison in the reign of Queen Elizabeth. On a different plane was the dramatist Francis Beaumont, contemporary of Shakespeare, who partnered John Fletcher to produce some fifteen plays for the London stage in seven years. From Pembroke itself came Sir Thomas Browne, John Pym, the Parliamentarian, Sir William Blackstone, the great legal scholar, and George Whitefield, co-founder of Methodism.

Perhaps the most celebrated figure, however, is the poor, uncouth Staffordshire schoolmaster who stayed just one year before poverty forced him to abandon Oxford and seek his living as a hack writer in London's Grub Street. Samuel Johnson was so poor that at times he kept to his rooms for want of shoes and socks to venture out in. A friend who tried to help him with the anonymous gift of a pair of boots was rewarded by the sight of Johnson flinging them out through his window. Much later, lauded and famous, Johnson returned several times to Oxford, and was awarded a first degree and a doctorate. When he heard of the young poets then in the college he exclaimed 'Sir, we are a nest of singing birds'. Reynolds's portrait of Johnson hangs in the college, which also possesses some of his manuscripts and one of his teapots.

At almost exactly the time that Johnson was receiving his doctorate, a young man named James Lewis Smithson was studying at Pembroke. He became one of the foremost chemists of his age and also an ardent republican, choosing an unusual way of perpetuating his name. He bequeathed a huge sum of money to the government of the United States to found a learned institute in his name, and the Smithsonian Institution was established in Washington in 1846.

Pembroke College with Tom Tower in the background, 1838. The older buildings in the shadow of Tom Tower were once part of the Wolsey Almshouses; later acquired by Pembroke, they now form the Master's Lodgings.

OXFORD ALMANACK

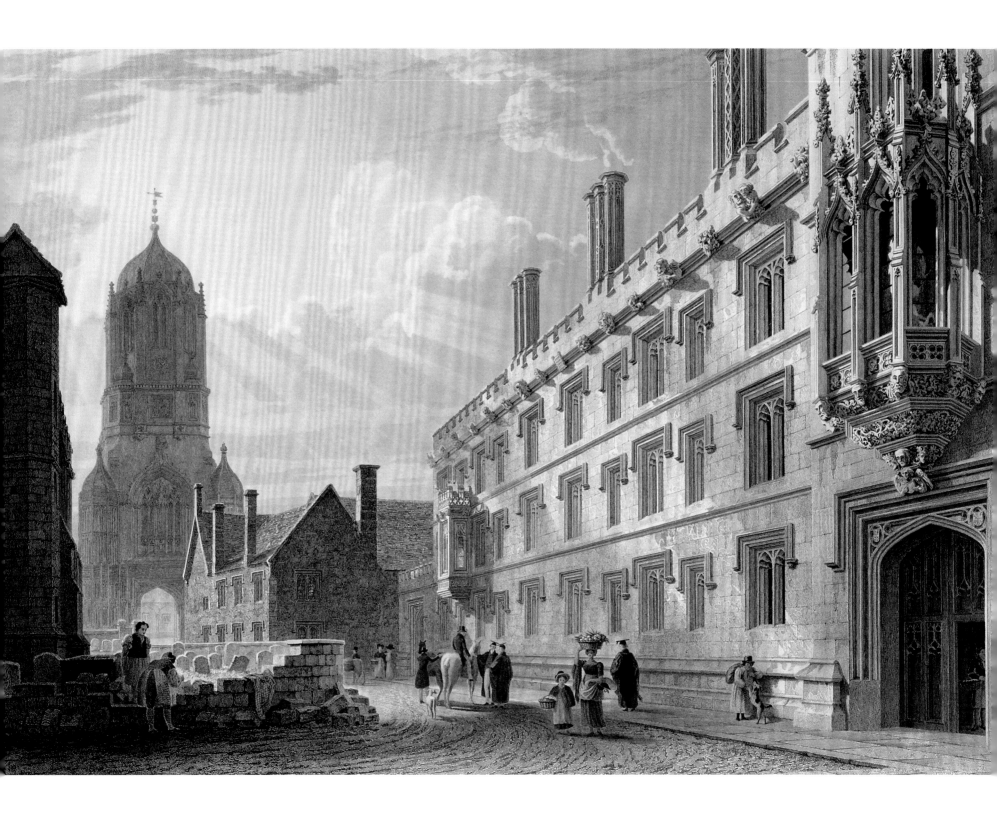

BRASENOSE COLLEGE

MONG ALL THE OXFORD COLLEGES, the early history, and the very name, of Brasenose are the most whimsical and puzzling. One of the medieval academic halls boasted a bronze sanctuary knocker with a half-human face, which was the original 'brazen nose'. This hall was an ancient institution mentioned in 1279, but it was dissolved and other halls occupied its site. It was in 1509 that the college proper was founded by the then bishop of Lincoln, William Smyth, and a prominent lawyer, Richard Sutton; but it is not clear what exactly spurred them to revive the ancient name and to commission a new replica of the grotesque door-knocker. The new college prospered financially and intellectually and included among its sixteenth- and seventeenth-century members John Foxe, of *Foxe's Book of Martyrs*, and Robert Burton, author of *The Anatomy of Melancholy*. Much later, in the nineteenth century, the college acquired a great reputation for sporting prowess and numbered among its alumni William Webb Ellis, the father of Rugby football.

The buildings around the old quadrangle at the front of the college, facing the Radcliffe Camera, still embody much of the original structure of the Tudor period, though naturally much altered over time. However, in the 1720s a grandiose scheme for a complete rebuilding of the college to plans by Hawksmoor was under consideration. This included a large neo-classical front, moved south to face the High Street, and four elaborate cupola turrets. This plan, which would have radically transformed the site and the High Street, was rejected and never built, but striking images of the new design have survived. A less significant but curious feature appears in all the pictures of the college from the eighteenth and nineteenth centuries, namely an imposing lead statue of *Samson smiting the Philistine*, a copy of the work by Giambologna which stands in Florence. Popularly known as 'Cain and Abel', it suffered the indignity of being vandalized by generations of Brasenose undergraduates, until it was removed in 1881.

Famous among those who studied or taught at Brasenose in the Victorian era are Walter Pater, the moving spirit of the aesthetic movement, John Buchan, the novelist, who wrote a history of the college, Sir Arthur Evans, discoverer of the Minoan civilization on Crete, and Sir Douglas Haig, the British commander-in-chief during much of the Great War. By a strange sequence of events, the original medieval brazen nose was finally returned to the college, having been found on a house in Stamford, Lincolnshire. Apparently it was taken there by a group of scholars who migrated to Stamford around the year 1330 to escape faction-ridden Oxford. In 1890 the college succeeded in buying the house, with the sole purpose of acquiring the knocker, which was then hung in the hall, after more than five hundred years' absence from Oxford.

Brasenose College, 1803. Two tourists admire the 'Cain and Abel' statue, while the dome of the Camera and the spire of St Mary's loom over the old quadrangle.

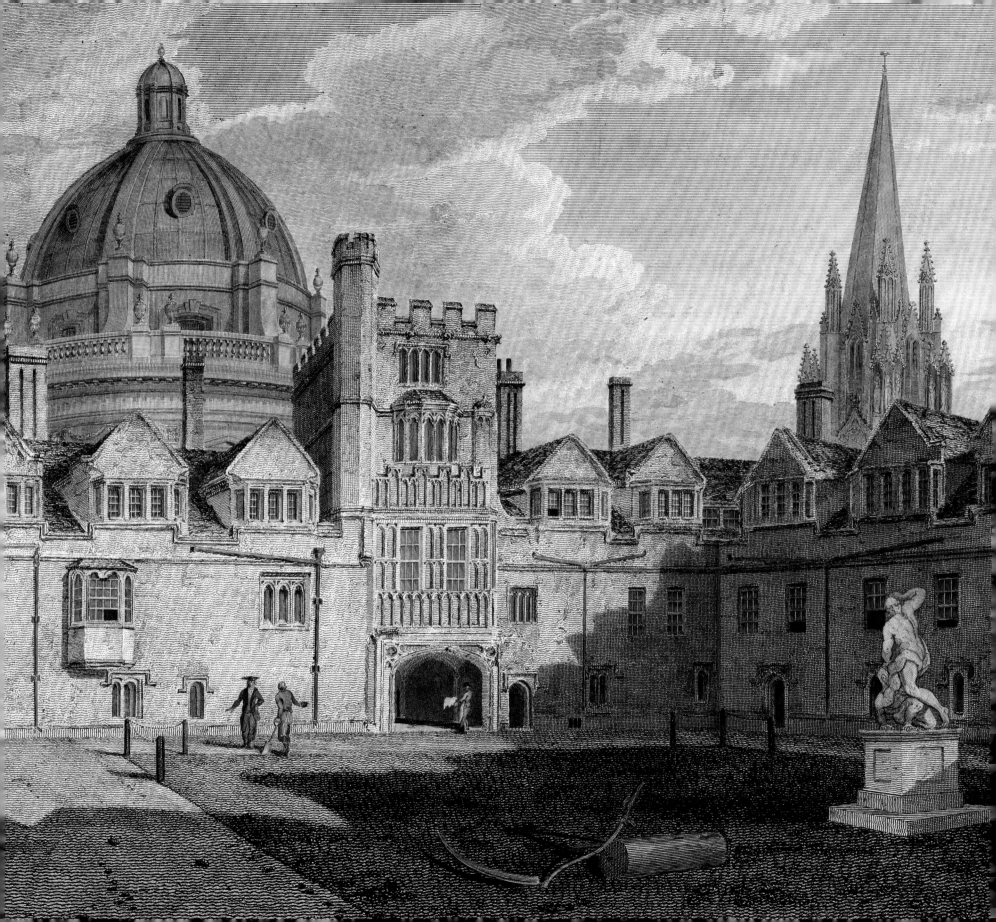

THE HIGH STREET

OXFORD HIGH STREET, 'the High', is one of the great streets of the world, on both historical and aesthetic grounds. Commentators have agreed that one its greatest charms is its graceful and gradual curve, which brings fresh vistas into view as you explore it. Its gentle downhill gradient from west to east is less often commented on, but is well known to cyclists. Added to this is the fact that its breadth is beautifully proportional to the height of the buildings, each complimenting the other. Its sides are lined, in little more than half a mile, by seven colleges, two outstanding churches, and many fine houses dating from the seventeenth to the nineteenth centuries.

The High was long known as Eastgate Street, which led from Carfax, the heart of the town, to the eastern gate in the walls, reacting a furlong before the crossing of the River Cherwell. The Carfax end was the site of shops, inns and the market, originally held on stalls in the open street, then after the 1770s in the newly built covered gallery. The tower of the former All Saints Church is the first landmark, then that of the University Church, and, at street level, its Baroque porch. The Gothic front of Brasenose is a product of the nineteenth century; that of All Souls is much older (but has been re-faced), contrasting markedly with the Hawksmoor Baroque of the inner quadrangle, the style in which it was intended to rebuild the entire college. This never happened, but The Queen's College next door was radically rebuilt and is now one of the most striking urban classical buildings in England. Between the two colleges grows the successor to an eighteenth-century sycamore tree, which unexpectedly punctuates the stone façades. Passing St Edmund Hall, Magdalen College, with its tower, and Magdalen Bridge marked for centuries the effective boundary of the city, with the Botanic Gardens on the opposite side giving a promise of the meadows and the river that lay beyond. On the southern side of the High stand University and Oriel colleges, with Merton and Corpus Christi behind them.

The High has been depicted over and over again in drawings and prints, lightly sprinkled with horse-riders, admiring visitors, placid dons and a few errant dogs. But the curve of the street has made it always impossible to capture more than a section of it. The view towards the west is most favoured, with the rich façade of Queen's contrasting with the more angular one of University College, and the great medieval spire of St Mary's beyond them. These elements together comprise an immensely satisfying image of Oxford's major thoroughfare.

The High Street looking west, 1814. The deep shadows on this atmospheric view remind us that the angular front of University College is in almost permanent shade, while the graceful neo-classical lines of Queen's are bathed in sunlight; the flower-sellers by the gate are a typical Ackermann detail.

HISTORY OF OXFORD

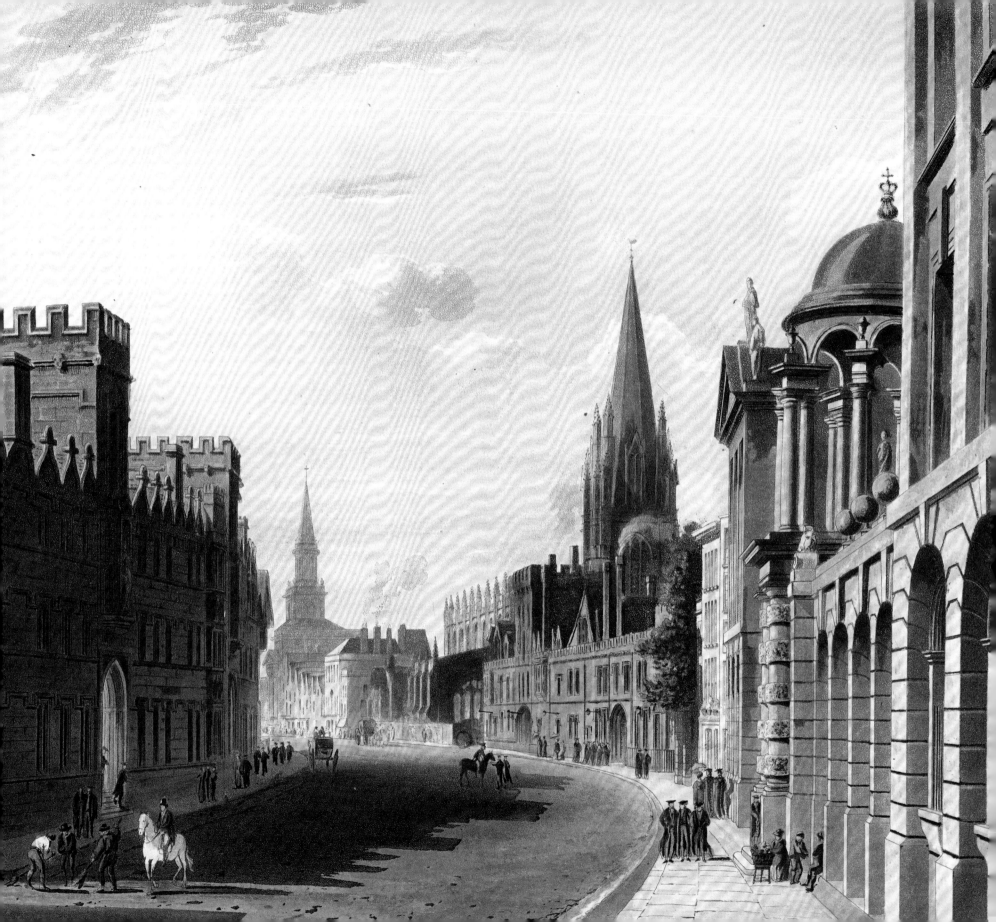

MAGDALEN BRIDGE

ENTION OF 'THE RIVER' in Oxford is usually taken to mean the Thames, but the Cherwell is only marginally less important, lying across the eastward road to and from London. It has often been the site of greeting for royal or notable visitors to Oxford, or of their leaving, as with Queen Elizabeth in 1566. Even before the Norman Conquest a crossing is recorded on the present site of Magdalen Bridge and this may have been the original 'Oxen-ford' which gave its name to the city, though this has also been identified with other river crossings. The early bridge was wooden and known simply as the East Bridge, but by the sixteenth century a much improved stone bridge had been built, possibly financed by William of Waynflete, the founder of Magdalen College, which would certainly explain its renaming. This structure lasted for almost three centuries before wear and flood damage compelled its complete rebuilding in the 1770s, to designs by John Gwynn, based on eleven arches of varying dimensions. Its length was extended to some 500 feet, in order to cross the water-meadows and the Cherwell leat before arriving at the Plain, where a toll-house was erected to collect dues from travellers. The design originally called for ornate statues on the balustrade, but these were never built. The bridge was widened twice during the nineteenth century, on the second occasion, in 1882, to accommodate the new trams. The bridge became long ago popular for leaping into the water on May morning, or after examinations, a practice now frowned on. Along with Folly Bridge and the Cherwell Boathouse, it is also one of the points from which punts can be hired. With the growth of Oxford's eastern suburbs, the flow of traffic became incessant, and prints like these take us back to a more serene age.

Magdalen Bridge, 1814. The view is taken from the spot where the now-vanished Toll House once stood and, to the right, the old church of St Clement's, demolished and rebuilt about a decade later on the Marston Road.

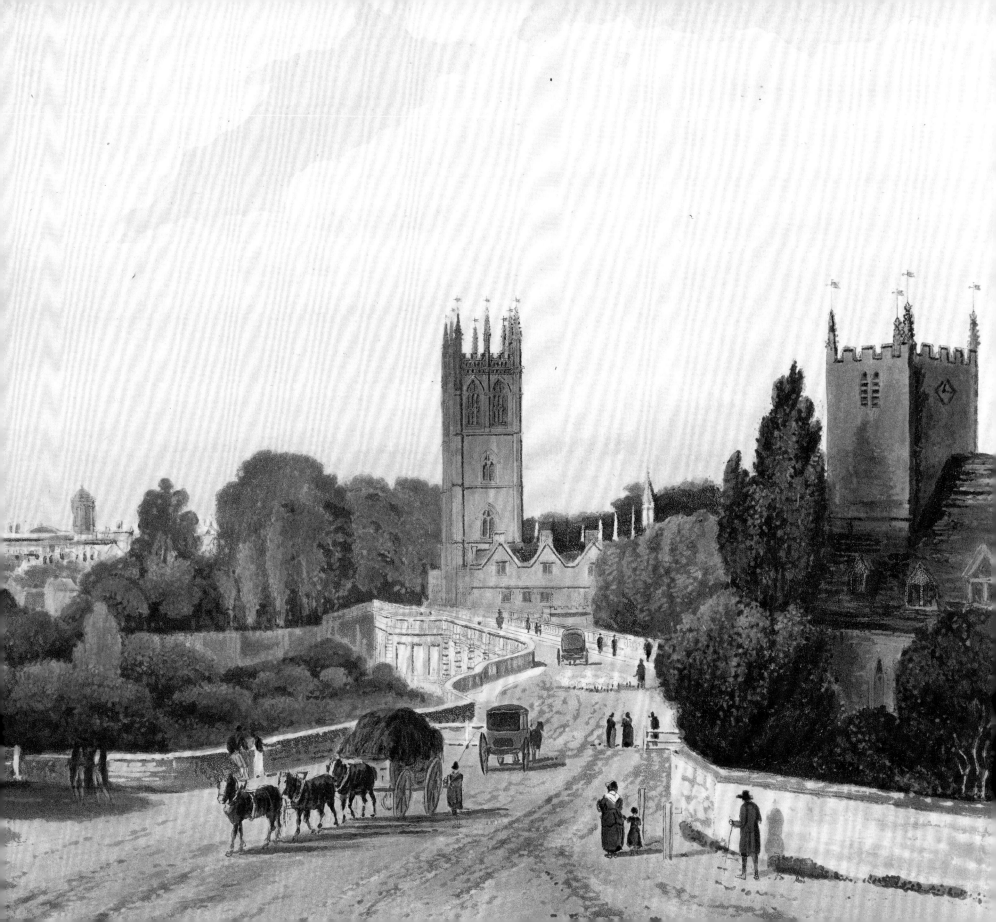

EXETER COLLEGE

EXETER had the unfortunate distinction of being founded by a man who was publicly murdered. Walter de Stapeldon, the bishop of Exeter, founded the college to educate the sons of his diocese, that is, of Devon and Cornwall. But he was also a politician, a loyal servant of King Edward II, and he shared the deep unpopularity of that monarch and his favourites, the Spencers. In 1326 Edward's estranged queen, Isabella, invaded England from France. The king fled London, leaving Stapeldon with instructions to defend the capital, but the unhappy bishop was cornered by a hostile mob and torn to pieces in Cheapside; his mangled remains now rest in a fine tomb in Exeter Cathedral. The college came into being in 1314, but remained poor and very limited in size until the 1560s, when its fortunes were dramatically transformed by a second founder, William Petre. Petre was another royal counsellor, this time to the Tudor monarchs, but who managed to keep his head, and went on to enrich his old college with endowments, new fellowships and bequests. These last included many fine books and manuscripts, including the Bohun Psalter, a fourteenth-century illuminated manuscript that was given to Petre by Queen Elizabeth.

The buildings of Exeter were successively enlarged or rebuilt at different times, but always in the familiar Tudor-Gothic style, so that its structure forms an architectural palimpsest. Little remains that is earlier than the seventeenth century, when the Turl Street frontage was created, although what we now see was remodelled in the 1830s. The original entrance was from Somnore Lane, facing the city wall to the north. Within the quadrangle, a magnificent new Jacobean hall was built on the south side, but in what was already an antiquated style, like that of Wadham. A two-aisled chapel formed the northern boundary of the quadrangle (this is the college layout shown in the Loggan view, with the work in Turl Street apparently half completed). The nineteenth century saw another wave of rebuilding, but still in the medieval style. The rebuilt Broad Street front was the work of George Gilbert Scott in the 1850s, who also created a new library and the exquisite chapel. This last is Victorian Gothic at its purest, said to be modelled on the Sainte Chapelle in Paris, which had itself undergone a major renovation a few years earlier by French neo-Gothic enthusiasts and was presumably seen by Scott. Exeter Chapel is home to the magnificent tapestry of *The Adoration of the Magi*, designed and executed by two former students, William Morris and Edward Burne-Jones, probably the most celebrated artists associated with Oxford. Other notable Exeter men of the nineteenth century include Francis Palgrave, of *Golden Treasury* fame, Charles Lyell, the great geologist, Frederick Maurice, the Christian Socialist, Hubert Parry, the composer, and R.D. Blackmore, author of *Lorna Doone*. The twentieth century is scarcely inferior, with J.R.R. Tolkien, Nevill Coghill, his pupil Richard Burton, and Roger Bannister, the last representing Exeter's great sporting traditions.

Exeter College looking north along Turl Street with Trinity College Chapel in the distance, 1843.
The Turl Street front of Exeter is early Victorian 'Oxford Gothic'.

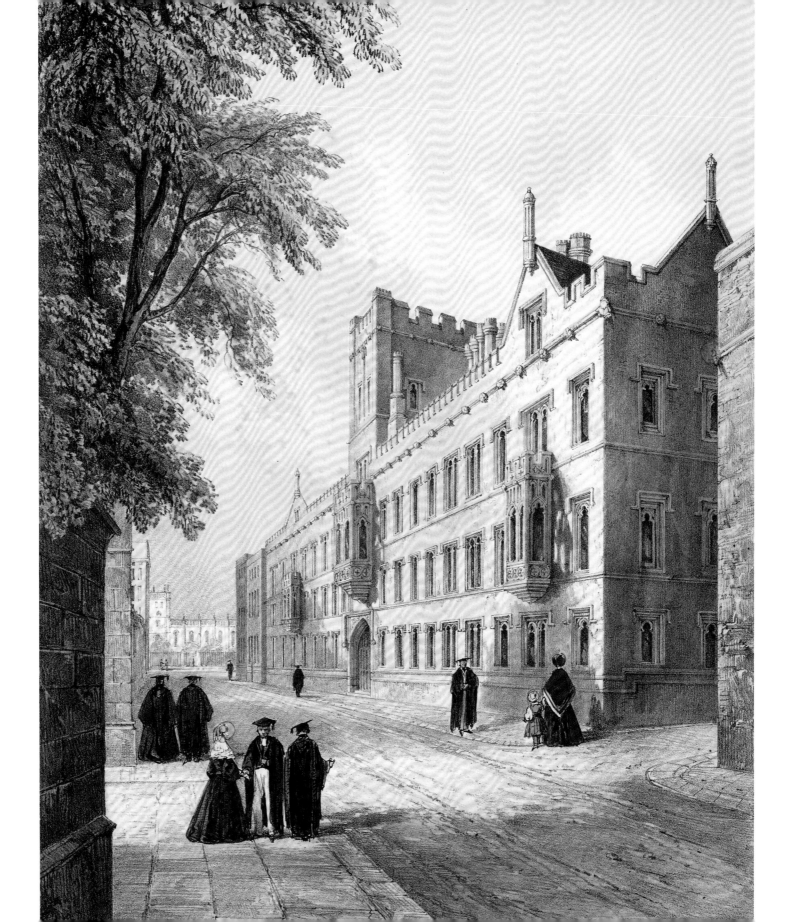

THE PRINCE REGENT IN OXFORD

IN JUNE 1814 the prince regent, the future King George IV, made a three-day visit to Oxford, attended by the tsar of Russia, the king of Prussia and other royal personages. This was just two months after Napoleon's forced abdication and exile to Elba, so the visit must be seen as a victory celebration by the three allied nations who had brought about his downfall. Each of the monarchs stayed in one of the colleges: the prince regent with the dean of Christ Church, the tsar with the warden of Merton, and the king with the president of Corpus Christi. The open-air reception seen here in the High Street outside The Queen's College was followed by a banquet in the Radcliffe Library and fireworks afterwards. Next day the royal visitors were given diplomas in the Sheldonian and listened to celebratory odes in Latin and Greek, naturally on the themes of victory and peace, which the three glorious monarchs and their armies had so recently achieved.

This unique event was commemorated in a painting by George Jones which was exhibited at the Royal Academy in 1815 and is now in Magdalen College (there is also a preparatory sketch in the Ashmolean Museum and another of the degree conferment ceremony in the Sheldonian Theatre). Jones would later achieve fame as a painter of battles and military scenes. It is not known for certain that the artist was present in Oxford during those three days. Between 1803 and 1815 he was serving in the army, including several years with Wellington in Spain, and he is said to have returned to civilian life only after Napoleon's final defeat at Waterloo. He made several famous paintings of the battle and became known as 'Waterloo Jones'. He painted other commemorative pictures of events at which he was not present, up to and including the Indian Mutiny, as well as biblical and historical subjects. He certainly had the skill and technique to create a picture like this without being an eye-witness, but to our minds some of the interest of the picture is taken away if we know that it may have been purely a studio exercise. However, this view would certainly not have been shared by Jones's contemporaries, for whom historical and commemorative painting was a perfectly legitimate and, indeed, highly popular genre. The engraving after the painting was made in 1815 by Charles Turner, one of the most skilled and prolific English engravers of his time, who was a native of nearby Woodstock.

The prince regent in Oxford with the duke of York and the prince of Orange being received by the chancellor and dignitaries of the city, 1814. Following Napoleon's fall and exile to Elba, this was a victory-celebration visit by the prince, who was also accompanied by the king of prussia and the tsar of Russia. The crowd is outside Queen's and Magdalen Tower can be seen in the background.

CHARLES TURNER AFTER GEORGE JONES

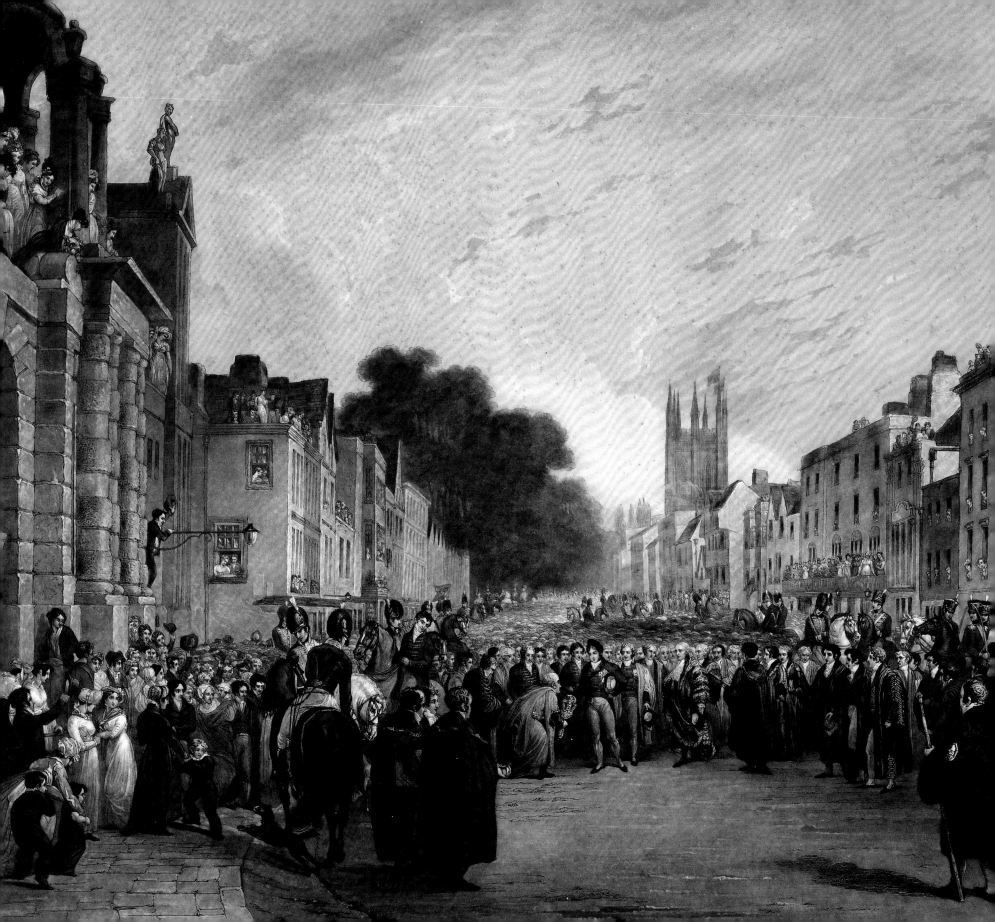

JESUS COLLEGE

THE TRUE FOUNDER of Jesus College, in 1571, was Hugh Price, a son of a butcher who became a canon lawyer. He was a Welshman from Brecon, and his foundation would always have strong Welsh connections – indeed, there is an Oxford chair of Celtic which is attached to the college. However, when Price requested the queen's support for his enterprise, she was pleased to give it, but on condition that she be honoured as the founder; and what could Price do but agree? So it is that the college's official title must always include the words 'of Queen Elizabeth's Foundation' and her portrait by Zucchero naturally hangs in pride of place in the college hall. Jesus was the only Oxford college founded during her reign and clearly she was anxious to be connected with it, provided somebody else did the necessary work and paid the bills. The site purchased on Turl Street was formerly that of the academic hall called White Hall and, as money was scarce, some time would pass before the original houses were replaced by a unified college structure around a quadrangle. The hall and chapel were built by the 1620s, then, half a century later, after the English Civil War, work was begun on a second quadrangle to the west; this has a series a roof gables topped by curious loops, exactly like those of University College. The hall, chapel and library are fine Tudor survivals and in the Hall the eighteenth-century rococo plasterwork ceiling contrasts very effectively with the dark wooden panelled walls. The library was enriched in the earliest years by the founder's namesake, Sir John Price, also from Brecon, who had been one of Henry VIII's agents during the Dissolution of the Monasteries, and Price acquired a large number of medieval manuscripts, which he gave to the college and which are now in the Bodleian Library.

The most famous figure of the modern age to be associated with Jesus is T.E. Lawrence, who was a student there from 1907 to 1910. Lawrence first travelled to the Near East to study Crusader castles while still an undergraduate, and his original work on this subject earned him a first-class degree. Lawrence's later uniqueness was that he was an intellectual who had first-hand experience of bloodshed, and it was this that gave his writing its great power. It would be hard to imagine a greater contrast than that between Lawrence and the other leading figure from Jesus's modern history, the avuncular socialist prime minister Harold Wilson.

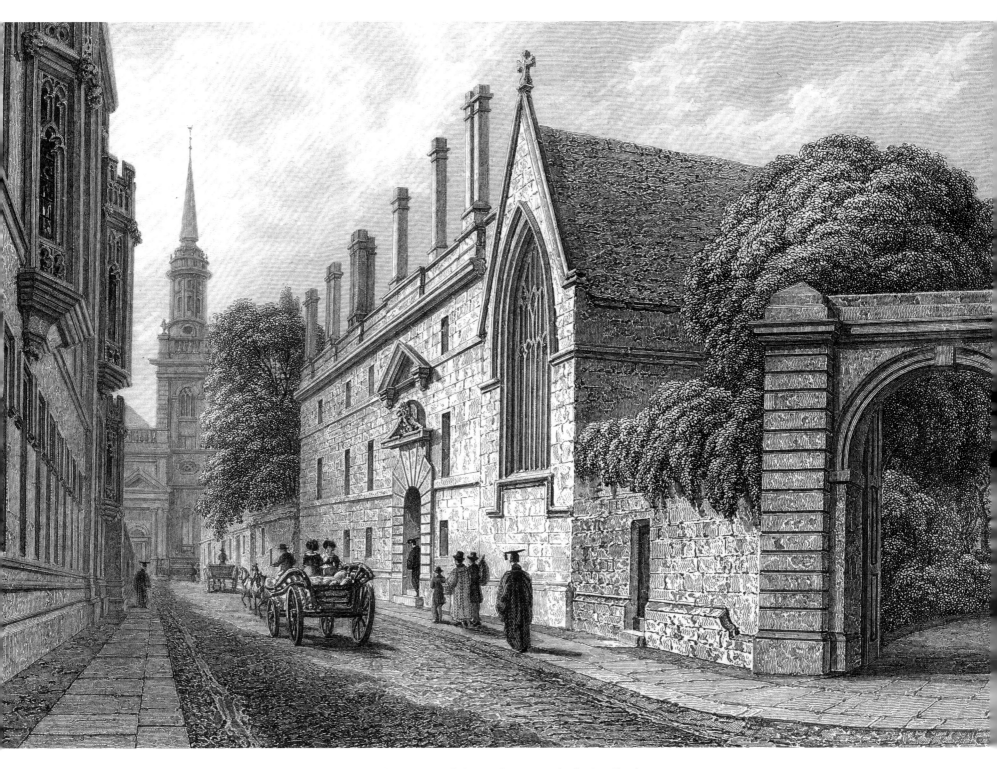

Jesus College looking south along Turl Street towards All Saints Church, 1837.
Ingram's views are small, precisely engraved and mostly convey an impression of a very restricted and ordered society.

MEMORIALS OF OXFORD

ST EDMUND HALL &
ST PETER'S-IN-THE-EAST CHURCH

THE EARLIEST PHASE of Oxford's academic history, in the late twelfth century, belonged not to the colleges but to the academic halls, which were the forerunners of the colleges. The simplest way of thinking of the halls is to liken them to private schools run by a master and taking fees from his pupils both for tuition and lodging. The hall was simply a house, usually leased, and usually in the area north of the university church, which has always remained the heart of the academic quarter. Like any other private enterprise, the halls might come and go, and well over a hundred are known to have existed by the fifteenth century. The great difference with the colleges was that the latter were constituted as formal, legal entities, usually possessing property and endowments, which together ensured their continuance in perpetuity. As the colleges prospered they could offer superior accommodation and facilities and attract more students, thus signalling the slow decline of the halls, so that, by the time of the Reformation, only eight halls survived. A few halls did, in fact, metamorphose into colleges: Worcester grew out of Gloucester Hall, Hertford out of Hart Hall, Brasenose out of the hall of the same name, Pembroke out of Broadgates Hall, and so on, while others were acquired by colleges for their land or buildings, such as St Alban Hall, absorbed by Merton as late as 1881. Magdalen Hall was destroyed by fire in 1820, took over briefly the then dormant Hertford College, but ceased to exist when Hertford was re-founded.

Among all the academic halls, the last survival into the present is St Edmund Hall, now indeed a college, but retaining its 800-year-old name. That name comes from St Edmund of Abingdon, archbishop of Canterbury from 1234 to 1240, who had previously taught in a house on the site of the hall during the 1190s. The land and its buildings came into the possession of Osney Abbey and the Dissolution threatened the hall with closure. It was saved by its close relationship with its neighbour, The Queen's College, which acquired the freehold and certain powers, but also gave its protection, promising to preserve the hall forever. Much later, in a series of stages, Queen's relinquished its hold, so that in 1957 St Edmund Hall was granted a royal charter and incorporated as a college. The main quadrangle is on a far more intimate scale than that of Oxford's grand colleges and has a charm which they miss entirely; the chapel and library block is a perfect example of late Stuart elegance and monumentality combined. It may have been in this chapel or this quadrangle in 1768 that six young men excited comment when they were heard talking of 'regeneration, inspiration, and drawing nigh unto God'. When the six Methodists refused to stop teaching their novel form of religion, they were expelled from the university and the affair became a *cause célèbre*, attracting the attention of Samuel Johnson, who, despising Methodism as he did, declared that young men went to a university to learn, not to teach, and that their expulsion was quite proper.

To the north of St Edmund Hall is the ancient church of St Peter's-in-the-East, so named to distinguish it from St Peter le Bailly, by the city's west gate. The crypt and chancel were constructed early in the twelfth century, replacing an earlier structure on the same site of wood and stone. The crypt is highly unusual in that it contains a *confessio*, or relic chamber. St Peter's-in-the-East served as the university church on several occasions when St Mary's was being renovated. The church was deconsecrated in the 1960s and reopened in 1970 as the main library of St Edmund Hall.

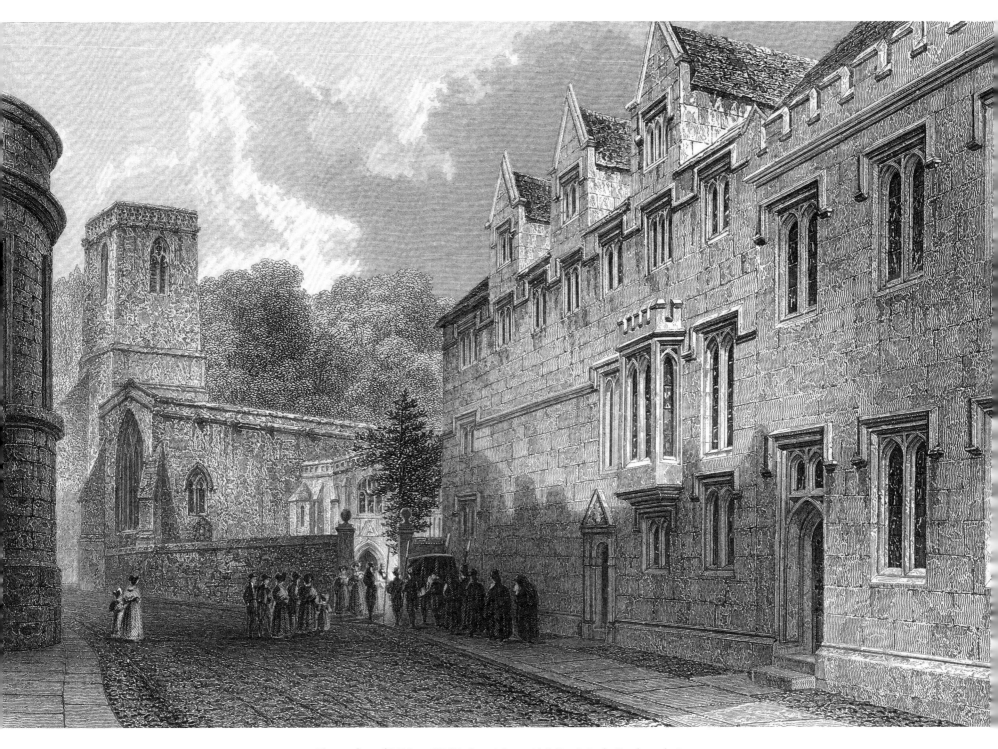

The west front of St Edmund Hall in Queen's Lane with St Peter's-in-the-East beyond, 1837.
A procession is seen entering the churchyard. The church is now the main library of St Edmund Hall.

MEMORIALS OF OXFORD

THE RADCLIFFE OBSERVATORY

THE NAME AND THE WEALTH of Dr John Radcliffe had already left an enormous mark on Oxford when, in 1771, largely as a result of petitioning by Thomas Hornsby, the tenth Savilian Professor of Astronomy, the trustees of his estate agreed to fund the building of a new observatory for the university. Classical astronomy on the Ptolemaic model had been taught in Oxford since the Middle Ages, when the cycles and epicycles of the heavenly spheres and the power of the stars over human life were its dominant themes. But by the time Henry Savile founded a chair of astronomy in 1619 there was a very different intellectual climate – that of the Copernican age. The Savilian professors were required to teach also optics, geography and navigation, but were prohibited from venturing into 'the doctrine of nativities', in other words, astrology. Two of the most distinguished early Savilian Professors of Astronomy were Christopher Wren and Edmund Halley, and an earlier observatory, built in 1705, was located on the roof of Halley's house in New College Lane (vestiges of which survive), while the first Savilian Professor used a room in the tower of the Schools Quadrangle for his observations. Halley's successor, James Bradley, was a pioneer in attempting to measure the speed of light.

The new Radcliffe Observatory on the Woodstock Road, adjacent to the Radcliffe Infirmary, was initially designed by Henry Keene, but completed and modified by James Wyatt, and was a very different affair from Halley's rooftop study. On its completion in 1794 it was considered to be architecturally the finest observatory in Europe and many visitors noted that it was better equipped than the Royal Observatory at Greenwich. Obviously neo-classical in style, the three stories form a series of symmetrical steps, culminating in the central octagonal tower, which immediately became a landmark of the Oxford skyline. The tower was directly copied from the 'Tower of the Winds' in Athens, an ancient structure which had only lately been revealed to English eyes, in the book *Antiquities of Athens* published by Stuart and Revett in 1762. On the eight sides of the Oxford building, Wyatt had copied the original carved figures of the winds that blow from the eight compass points, while on the second storey these were supplemented by twelve new zodiacal figures. The building was capped by a group sculpted in lead showing Hercules and Atlas holding up the globe. It contained a dwelling-house for 'the Observer', that is, the Savilian Professor of Astronomy, lecture rooms and purpose-built space for many valuable instruments, including a ten-foot reflecting telescope made by William Herschel. However, the active life of this splendid building turned out to be surprisingly short. In the 1870s a newly founded Department of Astronomy required a more modern building in the Parks, equipped for techniques such as stellar photography, and, by the 1930s, all astronomical work in the older building had ceased. Wyatt's neo-classical masterpiece was taken over by Green Templeton College in 1977 and forms the centrepiece of the Radcliffe Observatory Quarter, which includes a new Mathematics Institute named for Sir Andrew Wiles, who proved Fermat's Last Theorem.

The interior of the Radcliffe Observatory, 1814.

HISTORY OF OXFORD

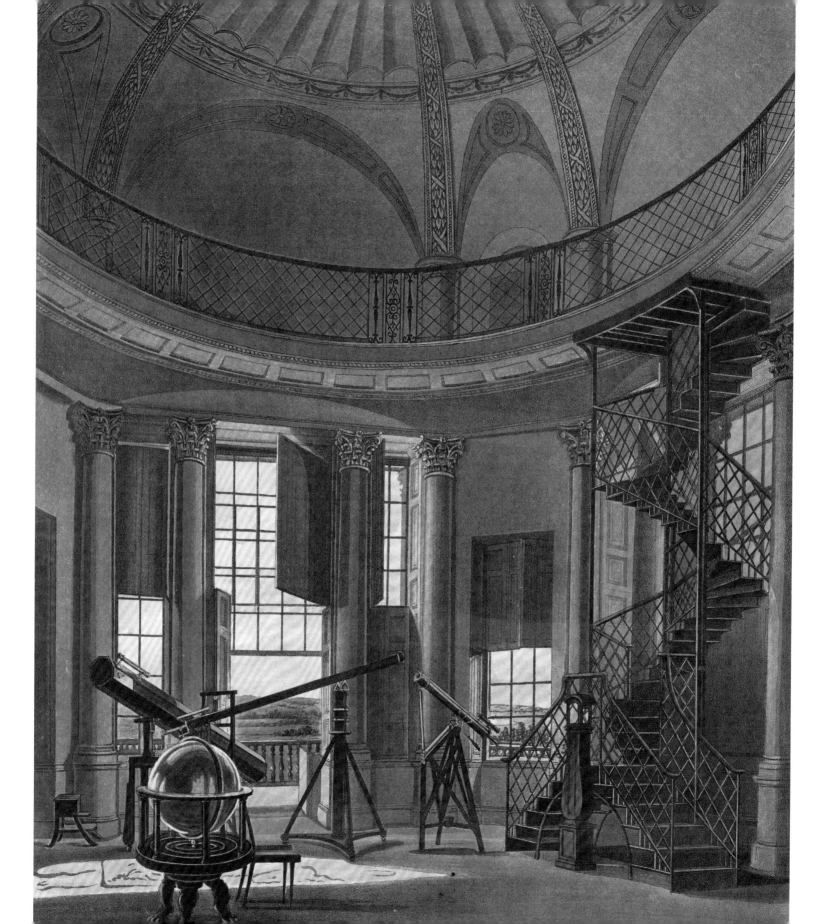

The Radcliffe Observatory on the Woodstock Road, 1814.
The last of the three landmark buildings in Oxford bearing Radcliffe's name,
it is capped by a superb neo-classical octagonal tower.

HISTORY OF OXFORD

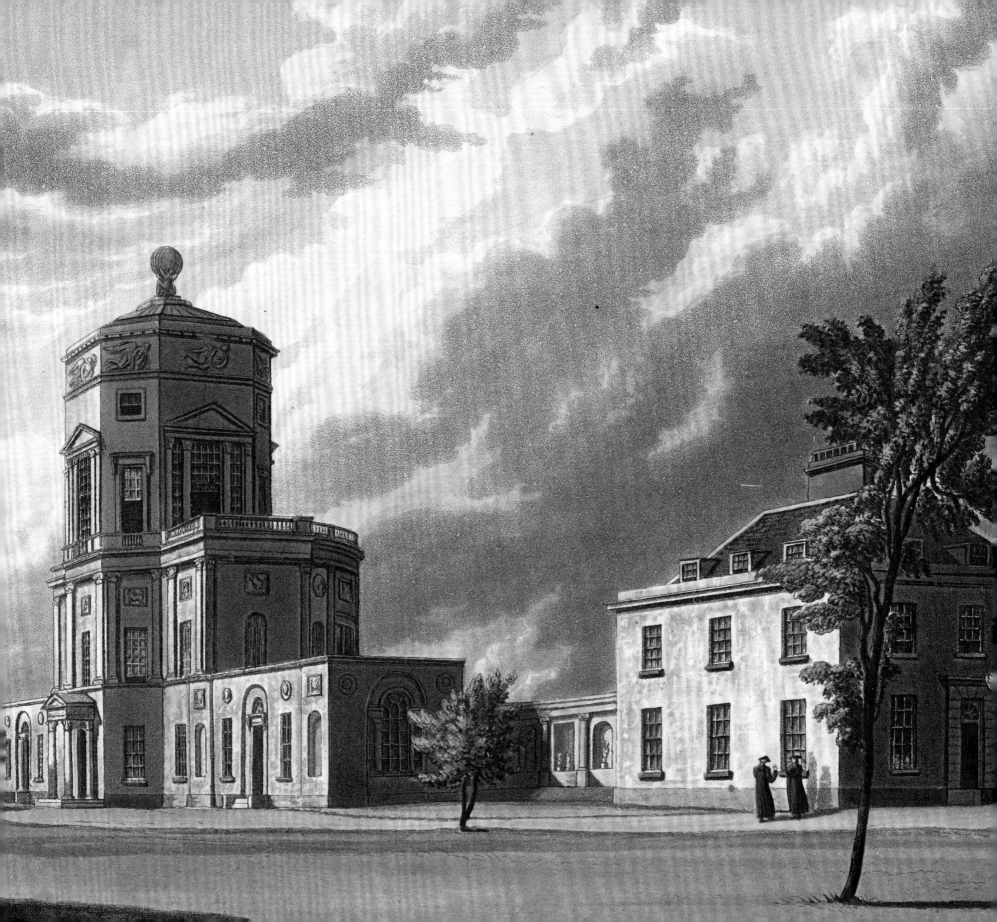

OXFORD FROM HEADINGTON HILL

TRADITION HAS IT that in the year 1669 a flying coach made the first single-day journey from Oxford to London. The coach would naturally have crossed Magdalen Bridge and ascended Headington Hill, but not by the route which we now know. Shortly after the climb began, it would have forked right on to Cheney Lane, skirting south of Headington and then over Shotover Hill to Wheatley. This was the original London Road, although why it should have included the stiff climb over Shotover, which rises more than 350 feet from the Plain, is difficult to understand, since passengers were forced to climb down and lighten the horses' load. It was in the 1770s that a turnpike road was laid out between the Plain and Headington itself, a road which now ran directly up the hill and on to Wheatley, by-passing Shotover; this road became the main route as we know it.

This fine print of 1808 was taken from a drawing by J.M.W. Turner by James Basire. It shows the London coach rolling down Headington Hill, while on the left the cutting of Cheney Lane can clearly be seen. On the right is the terraced walk raised above the road and built in the eighteenth century, to which 'Collegians often resort to taste the refreshing sweet air'. The air on the hill was long recognized as being far superior to that in the city itself. But this was not the only attraction of the Headington Road; undergraduates apparently found animal sports, such as cock-fighting, taverns and disreputable houses to frequent, which were safely off the radar of the college proctors. Headington was also the site of quarries from which much stone was taken for college building. Originally a type of hard stone was used for the medieval colleges, but, when later styles demanded more detailed carving, softer stones were chosen, much of which did not wear well and had to be extensively replaced. From the late eighteenth century, wealthy Oxford residents began to move out to new villas in Headington, many of which survive. More recent residents of Headington include Sir Isaiah Berlin and C.S. Lewis. By the twentieth century Headington had become a suburb with little or no distinct identity from Oxford itself; but that distinctness is exactly what we sense still in this picture from 1808, with its open-air feel, as the passengers point excitedly to the towers of Oxford coming into view, seen clearly from the hillside across the open meadows.

View of Oxford from Headington Hill, 1808. J.M.W. Turner's drawing has a wonderful fresh-air feeling,
as the coach rattles down the steep hill with its passengers perched on the roof.

OXFORD ALMANACK

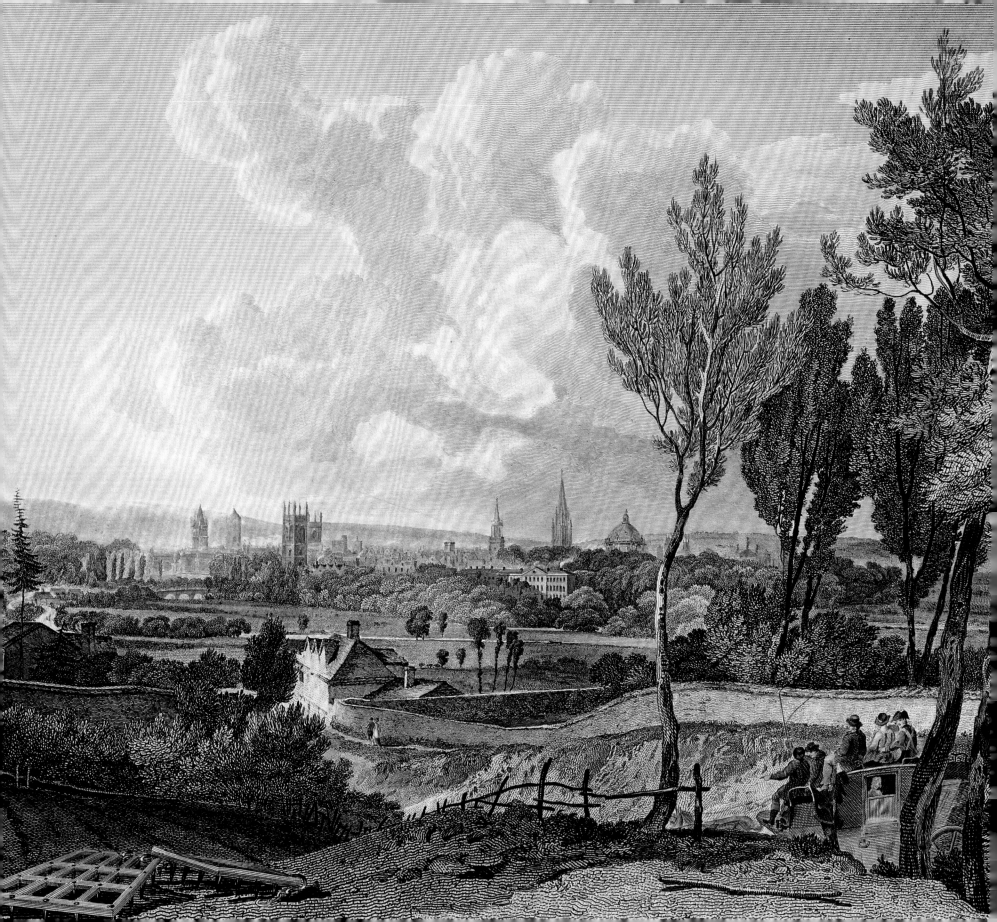

THE BOTANIC GARDEN

IT IS WELL KNOWN that Oxford's 'Physic Garden' was founded in 1621 and is the oldest of its kind in Britain, although several similar gardens had been established in Europe considerably earlier, such as the one in Padua, which dates from 1545. What seems to be completely unknown is *why* it was founded, with an extremely generous donation by Sir Henry Danvers, earl of Danby. Danvers was a curious figure, a page to Sir Philip Sydney, whose death he may have witnessed after the Battle of Zutphen in 1586, when Danvers was only thirteen years old. When he was still eighteen he was knighted in the field at the siege of Rouen. In England, at the age of twenty-one, he was outlawed for murder, after which he fled to Europe and found employment as a mercenary soldier. Somehow he lived down the accusation of murder and later served James I and Charles I as a soldier, governor and privy counsellor, became a Knight of the Garter, had his portrait painted by Van Dyck and died in 1644 in his home at Cornbury, Oxfordshire, 'full of honours, wounds and days'.

The splendid formal gateway of the Botanic Garden is known as the Danby Arch. In keeping with the ideas of the time, the garden was originally intended for the growing and study of medicinal herbs – a conceivable link with Danvers's military experience and his wounds – but practical gardening and scientific botany quickly became equally important. The famous John Tradescant (the elder) was chosen as the first keeper of the garden, but he could not take up the appointment, being near to death, so a local innkeeper and knowledgeable gardener named Jacob Bobart was given the job. Strangely and confusingly, there were two Jacob Bobarts, father and son, keepers in succession, just as there were two John Tradescants. The first catalogue of plants (1648) is attributed to the elder Bobart, but the formal design of the beds was the work of the first professor of botany in Oxford, Robert Morison, who was appointed by Charles II in 1669. While fulfilling a serious scientific and academic function, the garden, bordering the River Cherwell, has long been one of the favourite public spaces in Oxford.

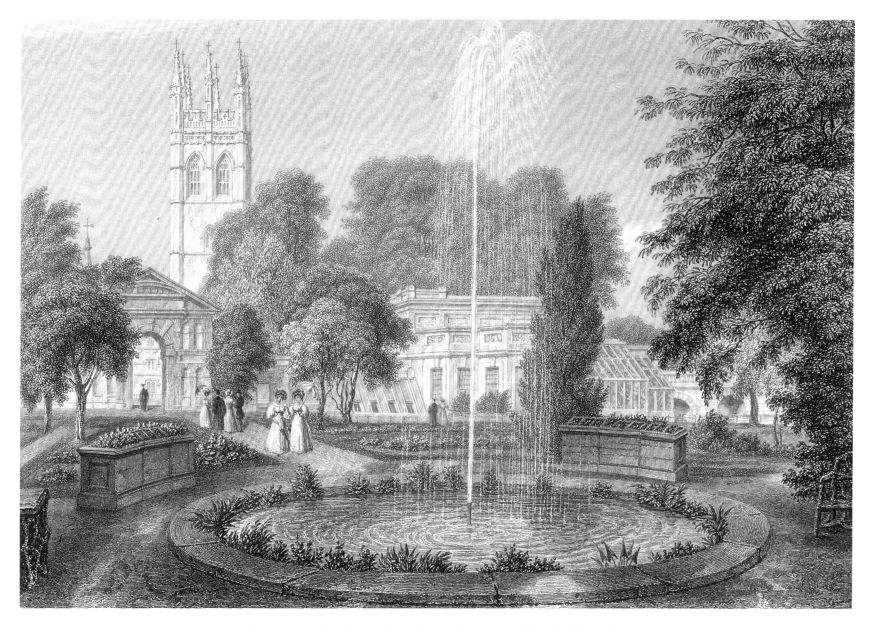

The Botanic Garden looking northwards towards the great gate and Magdalen Tower, 1837.

MEMORIALS OF OXFORD

VIEWS OF OXFORD

THE FIRST ENGRAVED VIEW of the city of Oxford as a whole, engraved by Frans Hogenberg from a drawing by Joris Hoefnagel, appears in the great series of city views published in Germany by Braun and Hogenberg in 1572, the *Civitates Orbis Terrarum*. This view is so generalized that few observers would guess which city it was, were it not for the city's coat of arms, which was also included. Perhaps there is a clue here, namely that to be successful a view must have some distinctive features to focus on, natural or man-made. In Oxford's case, the skyline came to be defined by – depending on the viewpoint – the Radcliffe Camera, Tom Tower, Magdalen Tower and the spire of All Saints Church. The spires of the University Church and of Christ Church Cathedral would be hard to distinguish from a hundred other such spires in England and the castle was not conspicuous. Both David Loggan's *Oxonia Illustrata* and William Williams's *Oxonia Depicta* included double prospects of the city, from the east and the south, while Hollar's plan of 1643 also incorporated a small prospect from the east. The Bucks published views from the south-west in 1731 and the south-east in 1753, while Josiah Boydell published a series of three views, from the south, east and west, in 1752. Boydell, like the Bucks, catered to the public's increasing interest in antiquities and topography. In these views a certain amount of artistic licence could be taken to improve the visibility of the buildings, and foreground figures, known as staffage, added to the charm of the scene, usually rustic characters gathering hay, or perhaps a few dons taking an evening stroll.

With the passage of time, these views inevitably reflected the changing artistic tastes and values of the society in which they became a commodity. While still focusing on the real, identifiable buildings of Oxford, the artists became more and more interested in the forms and shades of clouds and skies, wind and trees, in counterpointing the colleges, spires and towers with the landscape. In a word, they became increasingly romantic, and this romanticism towards nature was blended with a romantic feeling for Oxford as a place of youth and dreams. Prints such as those published by Ackermann and Delamotte were marketed very much as souvenirs for those who had studied at Oxford and wished to look back on their life there after they had left. In some of the mid-Victorian prints, figures who are clearly non-university personnel are placed in the scene, with the towers of Oxford in the distance, appearing to convey the message that these common people exist in a world cut off from the elite realm of wealth and learning which Oxford represented. The spirit of these later prints has travelled far from the severe architectural drawings of Loggan and Williams, published a century and a half before.

Evening view of the city from the east, 1822.
A romantic view towards the setting sun, while in the foreground haymakers are at work in the field.

OXFORD ALMANACK

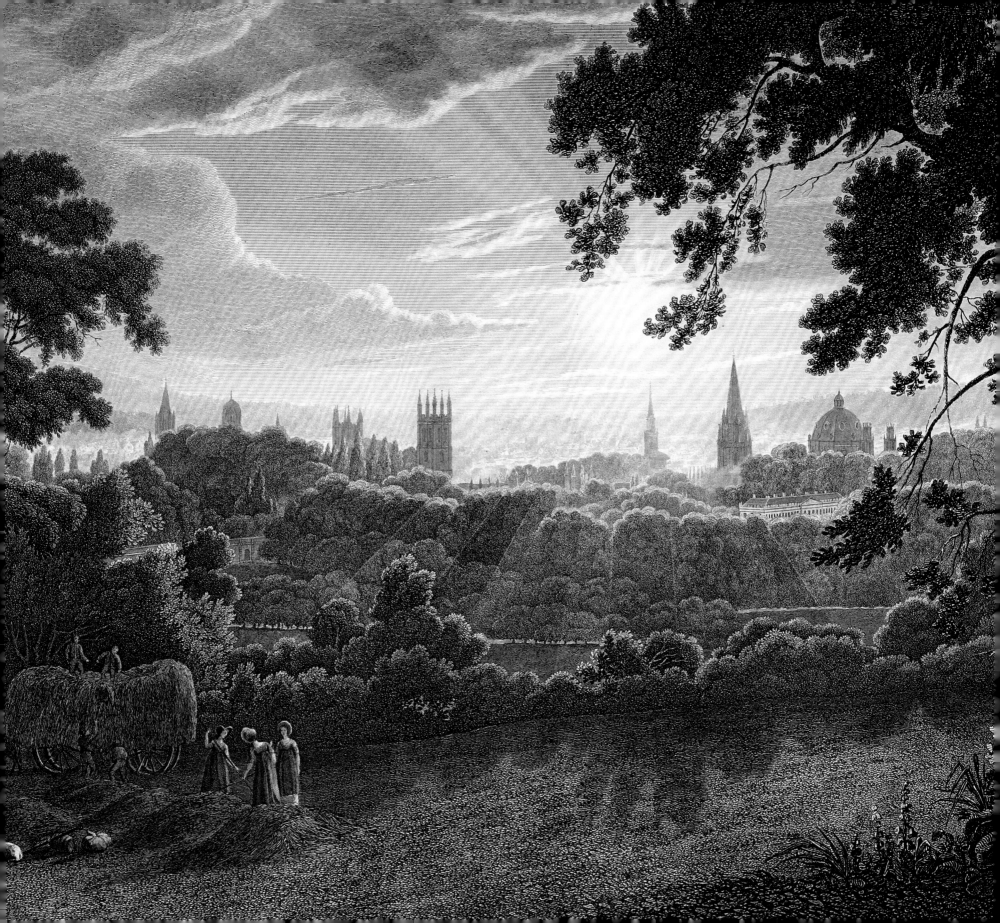

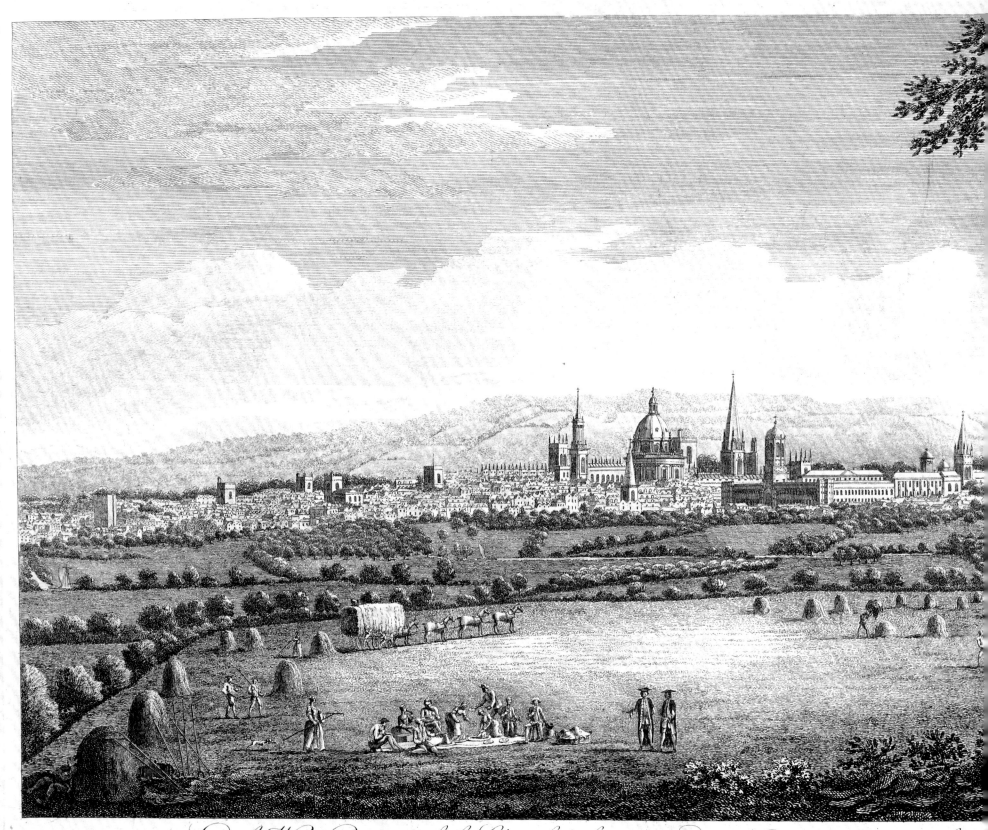

A West Prospect of the City of Oxford. *Veuë de la Ville d'Oxford.*

Publish'd according to Act of Parliament by Jn.º Boydell Engraver at the Unicorn the Corner of Queen Street Cheapside London 1751. Price 1.ˢ

Jnº. Boydell Del. et Sculp.

Côté de l'Occident.

49

View of Oxford from the west, 1751. The artist evidently wished to show
Oxford's colleges and towers rising clearly yet distantly above the natural rural landscape,
where haymakers are at work, observed by a couple of scholars in their caps and gowns.

JOSIAH BOYDELL

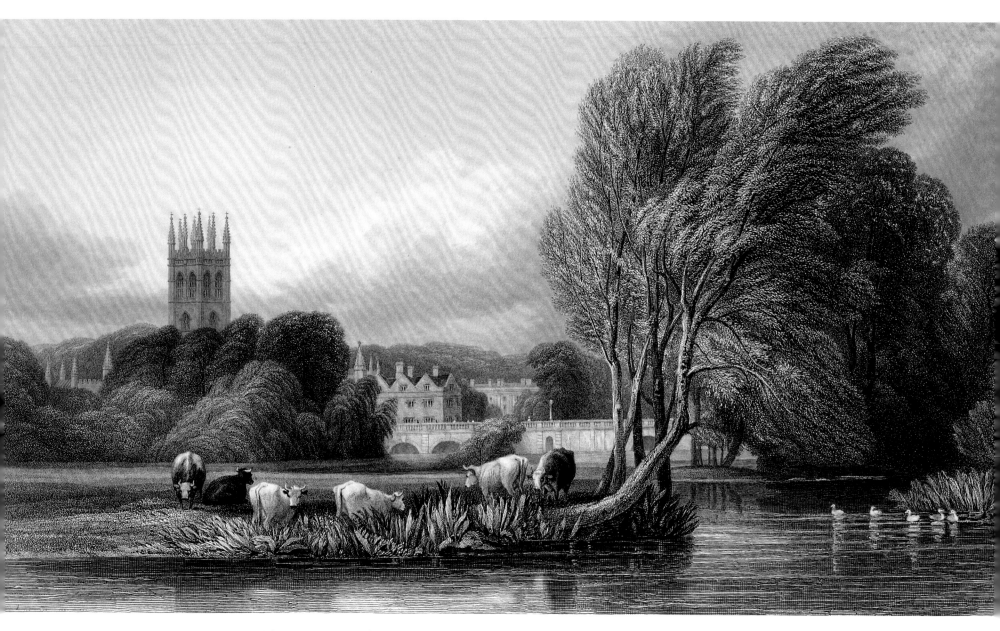

Magdalen Bridge and College from the south-east, 1855. A wonderfully atmospheric scene from the banks of the Cherwell, with the willows bending in the wind – although the water and the ducks look relatively unruffled.

OXFORD ALMANACK

WHITTOCK'S VIEW OF OXFORD

ALMOST A CENTURY AFTER the views of the Bucks and Boydell, a new, very fine and striking view of Oxford was published by Nathaniel Whittock (overleaf). In 1829 Whittock had published *Microcosm of Oxford*, the first series of Oxford images to use the increasingly popular technique of lithography. Whittock, who also produced aquatints, worked in London and Oxford and styled himself 'Teacher of Drawing and Perspective and Lithographist to the University of Oxford', echoing the title of 'Engraver to the University', which had been held by David Loggan, Michael Burghers and George Vertue. Whether by accident or design, Whittock's view is taken from almost exactly the same point as the later of the Bucks' engravings, somewhere east of the Cherwell and the Iffley Road. The interest in Whittock's view lies in two features – first, as we would expect, the new buildings that have appeared in the intervening hundred years, but still more interestingly the fact that this is a wholly different kind of image, constructed on different principles from those by which it was preceded.

To take the second point first, in many ways this view is actually more similar to the earlier scenographic maps of the city. Looking at Magdalen College in the lower right, we seem to be in the air several hundred feet at least above the buildings. There is no hill or building of that height overlooking the city from the east in that way, but there is the possibility that Whittock went up in a balloon in order to plan this work; unfortunately there is no way of verifying this. If not, it would have been possible for him to construct this view by carefully spreading out the distance between the buildings. In this way he could create the space which would enable him to place the beautifully drawn buildings so that they could all be clearly seen, even at a great distance, whereas in reality those in the foreground would inevitably hide those behind – in the college quadrangles for example. This method is similar to what we now call an axonometric projection, where space is spread out proportionately in several planes; this is not so precise as that, but it is halfway to it. The visible sign of this is that the main streets must appear far wider than they are in reality. The whole effect is quite different from earlier perspective views: this is not a natural view, tinged with picturesque elements, but a more modern work of art, beautifully executed, but also practical and highly informative, holding up a mirror to the city.

The new buildings added since the 1750s are not in the city centre but on the periphery – the new Ashmolean, the University Press, the Martyrs' Memorial and the Radcliffe Observatory. Not very long after this print was made, Magdalen Bridge would be widened, St Martin's Church at Carfax would be demolished, leaving only the tower, and the suburban spread would begin. However, ninety per cent of this picture would have been recognizable at once to Oxford inhabitants of the 1750s. Whittock created here an immensely satisfying and lovingly drawn image of Oxford on the eve of an era of restless change.

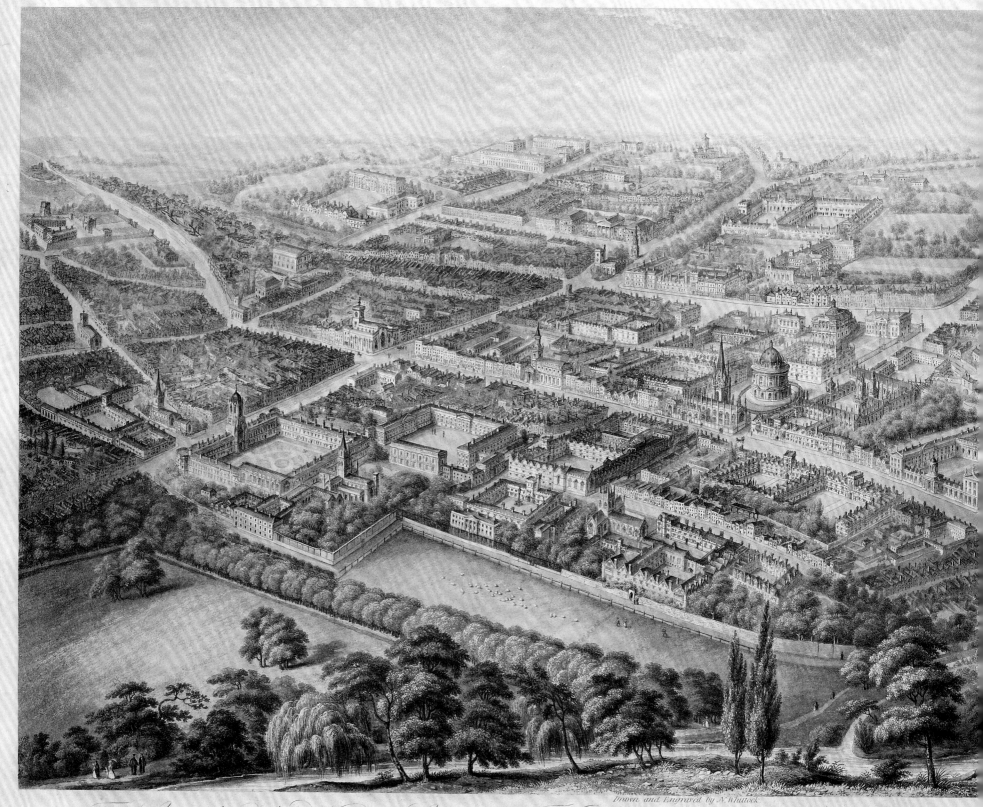

To his Grace, the Duke of Wellington. Chancellor. The Rev.ᵈ Vice Chancellor and the

This birds-eye View of the UNIVERSITY AND CITY OF OXFOR

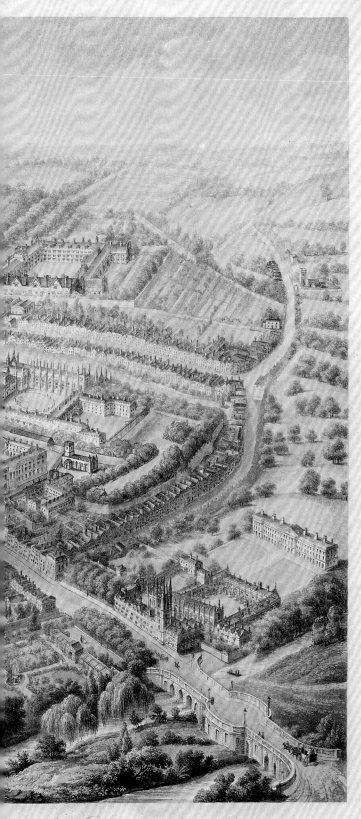

Bird's-eye view of Oxford from the south-east, 1848.
This was an innovative type of non-naturalistic plan that spreads out the streets
to offer a panorama in which almost every significant building can be identified.

NATHANIEL WHITTOCK

WORCESTER COLLEGE

ORCESTER IS DISTINCTLY DIFFERENT: it stands on a site distant from all the other colleges; its double-winged façade is unlike any other (although something similar was once planned for Wadham); and its history is so unusual that it is difficult to say whether it is one of Oxford's younger colleges or one of its oldest. Officially founded in 1714, its roots go back more than four centuries before that to 1283, when it was a monastic college for students of Gloucester Abbey, and was soon thrown open to all Benedictines. The college in this original form ended with the Dissolution, but it was back in business by 1560 as an academic hall, appearing on the Agas/Ryther map as Gloucester Hall. On the south side of the present-day main quadrangle, a row of what look like cottages are survivals of the monastic living quarters. Gloucester Hall survived, if it did not exactly flourish, for 150 years, during which time it came into the possession of St John's College. In the 1690s, it was almost by chance that the news spread in Oxford that a Worcestershire baronet named Sir Thomas Cookes was planning to found a new college and had £10,000 lying ready to be spent on this project. Gloucester Hall had fallen on hard times and this was seen as a potential lifeline. After some tricky manoeuvering, Cookes's money was pledged, royal approval was secured and Richard Blechinden, a vice-president of St John's, became the first provost of Worcester College, christened in honour of Sir Thomas Cookes's home-county. His portrait hangs in pride of place in the college hall.

A design for the college, in which Hawksmoor had a hand along with George Clarke and others, was published in Williams's *Oxonia Depicta* of 1733, but the building was not completed for some fifty years, and then not as planned. The two symmetrical wings that we see from Beaumont Street house the hall and the chapel on either side of the main entranceway. Behind, the grassed quadrangle was left open to the countryside, where by the 1820s a beautiful landscaped garden had been fashioned, which made Worcester the only Oxford college with a lake in its grounds. Later in the nineteenth century, the chapel was radically remodelled by William Burges to give Worcester the most sensational – quasi-Byzantine college chapel in Oxford. In all its various incarnations, Worcester has nurtured writers of idiosyncratic greatness. In the late 1300s, Thomas of Walsingham studied there, composer of the celebrated St Albans Chronicle, the primary source for our knowledge of fourteenth-century England – the Lollards and the Peasants' Revolt. In the seventeenth century the gifted but unlucky Cavalier poet Richard Lovelace was a student there, said by an Oxford contemporary to be 'the most amiable and beautiful person that eye ever beheld'. In the Romantic era, Thomas de Quincey commenced his opium habit while still an undergraduate there and, at the cost of personal tragedy, placed opium firmly on the map of English literature and social life.

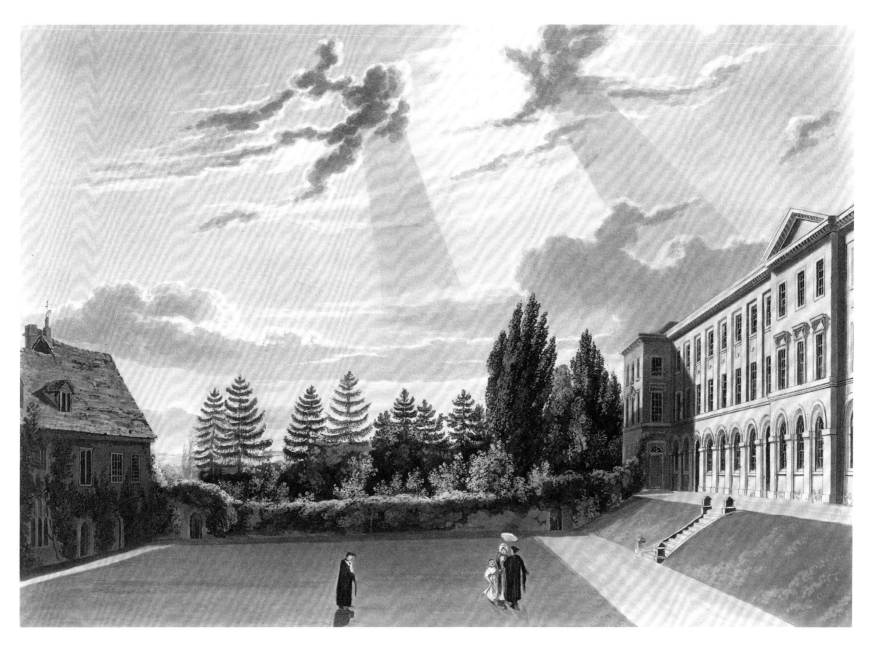

*Worcester College, 1814. Behind the neo-classical building at the western end of Beaumont Street
lies the large landscaped college garden, the only one in Oxford to possess a lake.*

HISTORY OF OXFORD

OXFORD UNIVERSITY PRESS

THE OXFORD UNIVERSITY PRESS celebrated its quincentenary in 1978, but the idea that the university has been publishing books since 1478 is a fantasy; it is to project our conception of book publishing back into the Late Middle Ages. Certain texts were printed in Oxford from that date onwards, at first very infrequently, and not in any sense by the university, and there was certainly no Gutenberg, Caxton or Manutius in Oxford. A century and a half would elapse before anyone began to consider seriously what the role of the university in relation to printing and publishing might be, and that person was Archbishop Laud. He established a board of delegates, senior figures in the university, to oversee the activities of the press, while his other major innovation was to obtain for the university the legal privilege to print bibles and prayer-books. A generation later, this privilege was exploited by John Fell, dean of Christ Church, who also arranged accommodation for a printing press in the Sheldonian Theatre; the imprint of the theatre, often within a vignette, began to be used on title pages. With this highly visible base for its activities, the press acquired a more obvious identity, but its workings, its finances and its place within the university still remained opaque and byzantine, since it needed to employ expert intermediaries to run the press and sell the books, which the delegates themselves clearly could not do. It has often been said that the publication in 1702 of Clarendon's *History of the Rebellion and Civil Wars* was a turning-point in the history of the

press, and that it paid for the new home into which the press moved, the Clarendon Building. This was not wholly true but it was the most successful book yet produced in Oxford, with the result that from 1713 onwards the 'Clarendon Press' became the new imprint, and it was here that the expanding activities of the academic press and the bible press first began to earn significant sums of money.

A century later the press was far outgrowing the Clarendon Building and a much larger modern site was planned, on the water-meadows north of Worcester College, in the area known as Jericho. Between 1825 and 1828 the massive structure took shape to the design by Daniel Robertson. It was built in the neo-classical style, on a quadrangular plan to resemble a college, but it was in truth a factory which used the machinery, steam and smoke of the Industrial Revolution to produce learned works in their thousands, and bibles in their millions. To house the workers, the whole suburb of Jericho as we now know it sprang up around the factory. Here the Oxford University Press finally made the transition to being a large successful modern publisher, especially for producing classic works of reference prefixed with the word 'Oxford', which gave its books the guarantee of scholarship and excellence – dictionaries, multi-volume histories, standard texts of scores of authors, anthologies and literary companions. The edifice is still Walton Street's landmark, but printing ceased there in 1989.

The Oxford University Press on Walton Street, 1832. The press had outgrown the Clarendon Building and it was in this new building that it was transformed in the nineteenth century into a worldwide publishing enterprise.

OXFORD ALMANACK

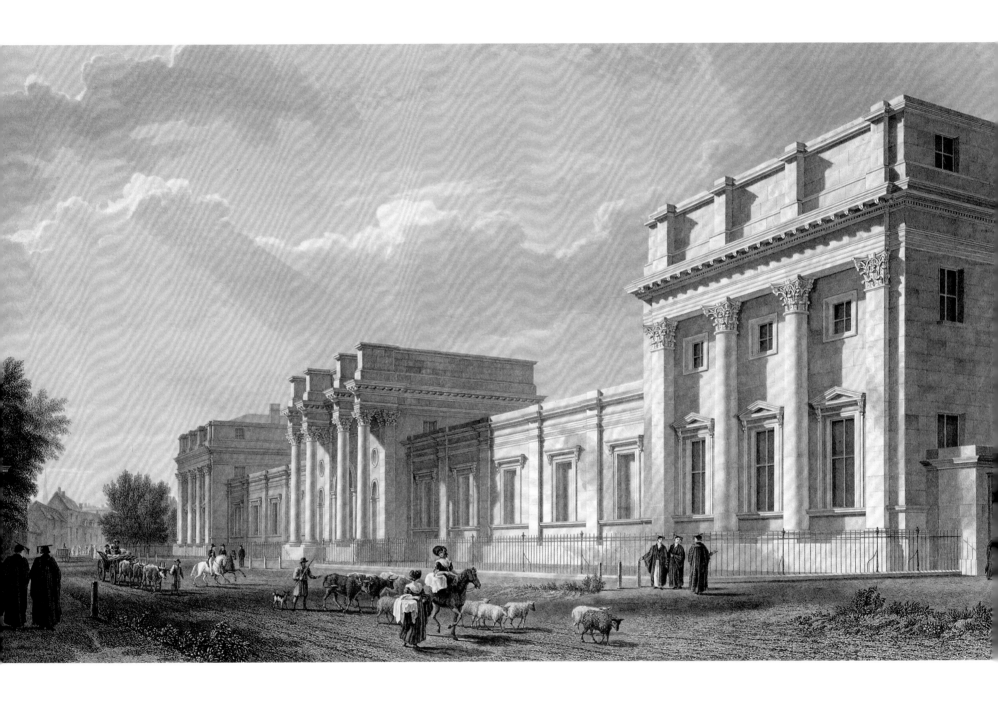

THE ASHMOLEAN & THE TAYLORIAN

THROUGHOUT THE EIGHTEENTH CENTURY, the university acquired by bequest many large collections of antiquities and works of art, for which it had no adequate home. Some of them were displayed or stored in the Bodleian Library and the Old Ashmolean Museum, but by 1800 they were both overflowing. By the late 1830s the concept of a new museum building was widely seen as both necessary and desirable, and a neo-classical edifice was commissioned for that purpose from the architect Charles Cockerell. It was stipulated from the first that the new building must be Grecian in character, but the breathtaking new building which opened on Beaumont Street in 1845, then known as the University Galleries, showed that its designer had reinterpreted his classical models very freely, so that the elevations are ornate and almost sculptural, looking like a Renaissance version of classicism. The grandeur of the structure is further heightened by its being raised up on a massive platform as high as a human figure. This was the last classical-style building in Oxford, just as the British Museum (completed 1847) was in London, before the Gothic style became all-conquering in public architecture. Once opened, the new galleries, obedient to the law that nature abhors a vacuum, received a flow of further gifts, in the form of paintings, sculptures, prints and drawings, antiquities, tapestries, musical instruments and *objets d'art*, all forming a rich and disparate array of treasures which would make the Ashmolean one of the most delightful of English museums. One of its special glories is the display relating to the Minoan civilization of ancient Crete, which was first uncovered by the archaeologist Sir Arthur Evans, the keeper of the Ashmolean from 1884 to 1908. The latter was also the year that the museum acquired its current name of the Ashmolean, which had previously only been applied to an extension built in 1899; at the same time the Broad Street building was redesignated the Old Ashmolean.

While the new Ashmolean was being planned, the way was being cleared for a new foundation for the study of modern languages and the decision was taken to bring the two institutions together. The languages foundation had a curious history, for it had been conceived by the eighteenth-century architect Sir Robert Taylor, who had died a full half-century before, leaving a sum that was gigantic in its time to provide for the study of subjects that were nowhere catered for officially in the university. In view of the sum involved, Sir Robert's family understandably objected to this arrangement and the bequest was held up in the courts until 1834, when £65,000 was released. When work finally began, Cockerell was instructed to fashion the entire eastern wing of his building into the Taylorian Institution, containing a comprehensive library and teachings rooms for the literature of France, Spain, Germany and Italy, to which Scandinavian and Slavonic studies were later added. The four female statues high up on the east front represent the four original languages. The high-ceilinged and galleried main reading room is one of the loveliest spaces in Oxford in which to study – studious, elegant without being overwhelming, and tranquil.

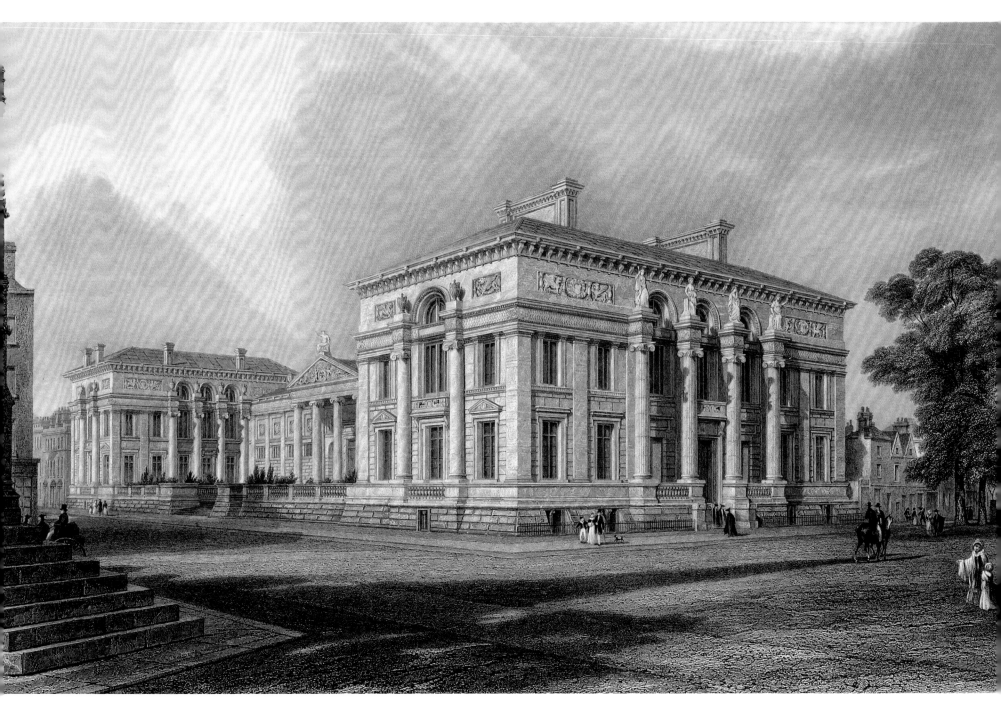

The Ashmolean-Taylorian building, 1848. It is difficult now to picture Beaumont Street and St Giles without this building that is classical in style, yet so richly and freely imagined; the architect was Charles Cockerell and it was opened as the University Galleries in 1845.

OXFORD ALMANACK

LINCOLN COLLEGE

FOUNDED IN 1427 by Richard Fleming, bishop of Lincoln – whose huge diocese covered much of central England, including Oxford itself – Lincoln was the archetypal small, quasi-monastic college – established solely to support and teach orthodox religion, not richly endowed, and housed in a court-like structure on Turl Street, built around a single open quadrangle. Its fortunes improved only slowly and by the end of the fifteenth century the fellows still numbered fewer than twenty. During the long years of the Reformation, Lincoln was one of several Oxford colleges which clung tenaciously to the Catholic faith. The rector from 1539 to 1556 was Hugh Weston, a prelate in high favour during the reign of Mary Tudor who was appointed dean of Windsor and presided at Cranmer's trial. But he was later deprived of office for gross immorality and confined in the Tower of London. Weston left a bequest in his will for the scholars of Lincoln to say masses for his soul.

In the early seventeenth century, another bishop of Lincoln caused the second quadrangle to be built to the south, together with a new chapel famous for its wonderful carved woodwork. One of the undergraduates around this time was William Davenant, who succeeded Ben Jonson as unofficial poet laureate, and who was later rumoured to be Shakespeare's natural son, his mother supposedly being Jennet Davenant, wife of an Oxford innkeeper. During the English Civil War, in which Davenant played a swashbuckling role, cavaliers very much like him moved into the college rooms. In the eighteenth century, two of the most famous fellows were John Radcliffe, whose relations with his college were strained, causing him to leave his immense wealth to the university rather than to Lincoln, and John Wesley, elected in 1726. Wesley and his brother Charles were the leaders of the 'Holy Club', or 'Methodists', who practised daily devotions and charitable works that were very much out of keeping with the life of other Oxford academics in the eighteenth century. He was, however, generally respected and preached the university sermon in St Mary's many times. The great nineteenth-century figure in the college was Mark Pattison, rector from 1861 to 1884. He was a formidable intellect, a progressive in religious matters, and keenly interested in university reform. Pattison was well known to George Eliot, and he has often been suggested as the model for the dried-up scholar Casaubon in *Middlemarch*, but there are strong arguments against this theory. Nevertheless, Pattison is one of those scholars who, without producing a great number of published works, created a personal legend in Oxford.

Lincoln College seen from the south-west with the chapel on the right, 1843.
The colourful, picturesque figures make up a considerable part of the appeal of Delamotte's views.

COLLEGES, CHAPELS AND GARDENS

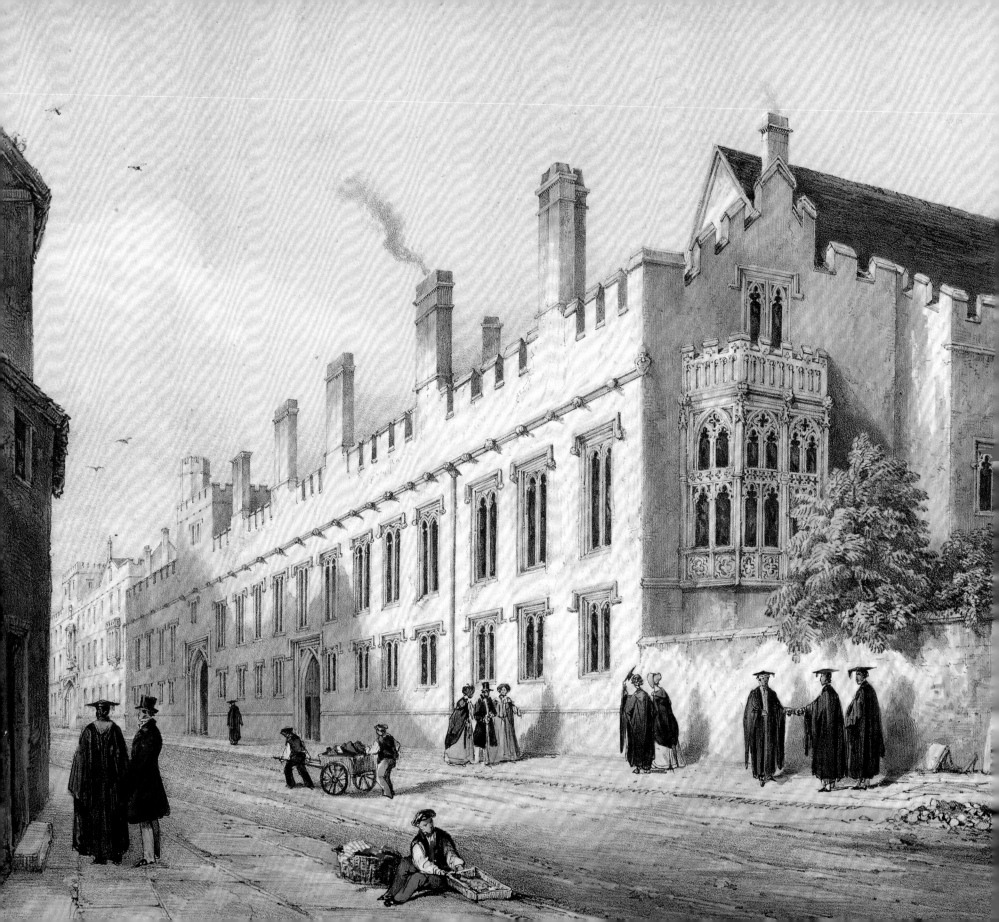

OXFORD CASTLE

ALTHOUGH having almost no connection with the university, the Castle Mound with its buildings was an Oxford landmark for at least eight centuries, before modern buildings obscured the view of it from most directions. It was built within a few short years of the Conquest by the Norman landowner Robert D'Oilly, on a site where an earthen rampart already existed. The surviving tower, known as St George's Tower, is among the oldest English examples of Norman military architecture and its stones may incorporate part of the Anglo-Saxon fortifications of the city. It has not, however, enjoyed, or perhaps suffered, a very romantic history, being rarely burned or besieged, visited by kings or used to hold famous prisoners. The one great story is that the Empress Matilda, during the years of civil war in the 1140s, had taken refuge from her cousin, King Stephen, in the castle and succeeded in escaping unseen across the ice- and snow-covered meadows by dressing herself all in white. After the early 1300s, the castle played no important military role until the English Civil War, when it was garrisoned first by King Charles and then by the Parliamentarians, but it was not the scene of any fighting, although prisoners from both sides were confined there.

The castle had also long been used as a shire hall and as a gaol. The first function was moved to the Town Hall in the sixteenth century, but the second pointed the way to its future identity, which survived until the late twentieth century. The prison quarters were periodically enlarged and rebuilt in the nineteenth century and public executions took place until the 1860s. Recent developments have seen the prison building and its surrounding area transformed into a shopping, entertainment and hotel complex, which would probably have seemed grotesque to earlier generations.

Although the university had almost no connection with the castle, there were one or two links. In 1613 Christ Church bought the whole site (except for the moat), King James I having sold it two years earlier to investors. For the next century and a half, the college then leased it to the keepers of the prison, during which time it had an evil reputation, but so did all prisons at that time. Around 1780 the prison reformer John Howard wrote a damning report of it and, soon afterwards, Christ Church sold it to the county authorities, who slowly but steadily modernized the prison. Debtors, pickpockets, drunkards and brawlers were the commonest inmates of the prison, but about this time a Frenchman was held in the castle and tried for stealing a haul of valuable coins from the Ashmolean Museum. His name was given as Lemaitre, but there is a strong suspicion that he was Jean-Paul Marat, the future revolutionary leader, who was certainly in England at the time. He was sentenced to five years on the hulks in the Thames, but is believed to have escaped. If this is true, he was the castle's most notable and surprising prisoner and, through the Ashmolean, provides a tenuous link between castle and university.

Oxford Castle, 1837. In this view the Castle appears to be a splendid structure, but the remains of the ancient building had long been transformed into the county prison and it was much rebuilt throughout the eighteenth and nineteenth centuries.

MEMORIALS OF OXFORD

BALLIOL COLLEGE

No college in Oxford can boast a more picturesque story of its foundation than Balliol. John Balliol, thirteenth-century lord of the northern manor of Barnard Castle, came into conflict with the bishop of Durham and insulted him. His punishment was twofold: he was whipped at the door of Durham Cathedral and compelled to perform a significant act of charity. This act was to lease a house in Oxford, on the northern side of Broad Street, and establish a group of poor scholars there. When Balliol died in 1269, his widow Dervorguilla maintained the foundation and expanded the number of scholars and its endowments. The debate as to which Oxford college is the oldest seems to depend on the criterion one chooses. Since Balliol is known to have been in existence on Broad Street by 1265, it is fair to say that it forms the oldest continuously inhabited collegiate site in Oxford. The buildings on that site have been repeatedly renewed or replaced over six centuries, so that its architectural history is complex, but it stood aside coldly from the neo-classical vogue of the eighteenth century and has championed the traditional Oxford Gothic ideal, whether in its Tudor or Victorian form. The frontage now seen on Broad Street was largely the work of the architect Alfred Waterhouse in the 1860s, and its massive business-like sternness inspired Oscar Wilde's remark, '*C'est magnifique, mais ce n'est pas la gare*'. By contrast the new chapel designed by William Butterfield in the 1850s was the target of endless criticism for scaling the heights of Gothic extremism and it narrowly escaped demolition half a century later.

In the nineteenth century a succession of masters supported many initiatives to raise academic standards in the university. One was to award scholarships and fellowships by open competition, rather than by private patronage, and another was to foster the personal tutorial system. This process reached its culmination under Balliol's famous master Benjamin Jowett, who set out deliberately to create an elite class of intellectual men of action, dedicated to public service, especially in national and imperial government. Among Jowett's protégés were Lord Curzon, Archbishop Frederick Temple, Herbert Asquith, Sir Edward Grey and Alfred Milner. This blend of academic excellence and political success prompted Asquith to define Balliol's great gift to its members as 'effortless superiority'. This quality was exemplified by Balliol's celebrated fictitious graduate, Dorothy L. Sayers's uniquely talented Lord Peter Wimsey. Jowett himself confessed to 'a general prejudice against all persons who do not succeed in the world'. Jowett's Balliol became the cynosure of Oxford, although its members were laughed at by students of the more relaxed colleges as the 'Sons of Belial'. However, Balliol at the time was also supportive of many innovations, such as the teaching of science and the admission of women to the university.

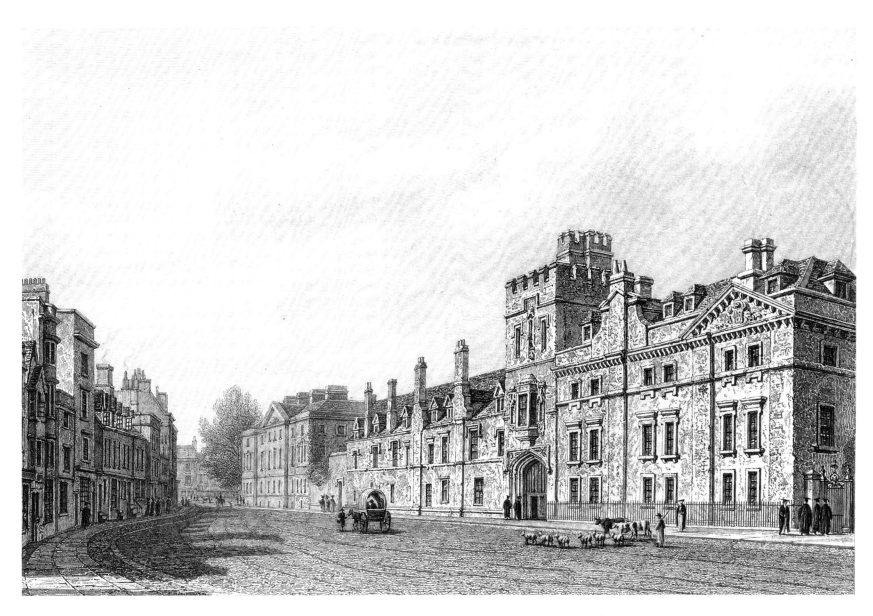

Balliol College from the south-east, 1837. This view just precedes the major rebuilding of the 1840s and clearly shows the deterioration of the stone which prompted it, a common problem for many of the colleges.

MEMORIALS OF OXFORD

THE MARTYRS' MEMORIAL

T HE MEMORIAL to the Oxford's religious martyrs of the Reformation was conceived and built in 1841–43. Its owes its existence to the fear and hostility inspired by the Oxford Movement, which sought to recall the Church of England to its Catholic heritage. Launched in 1833 by Keble, Newman, Pusey and Froude, the Oxford Movement's critics were anxious to counteract it by recalling in their turn the tyrannical power of Catholicism, to which the martyrs fell victim, and which claimed their lives.

Now a familiar landmark in the city, on whose steps tourists sit and smoke and eat snacks, it is easy to forget the inconceivable horror of the scene which it commemorates – Christians publicly burned alive in the heart of a great university by other Christians because of the precise words in which they chose to express their faith in God and Christ. Bishops Latimer and Ridley were burned together in October 1555 on the spot in Broad Street marked by a cross. Latimer's words at the stake quickly became famous: 'Be of good comfort Master Ridley; we shall this day light such as candle, by God's grace, in England as I trust shall never be put out'. In spite of this, Ridley suffered a slow and agonizing death. The process against Thomas Cranmer, archbishop of Canterbury, took longer, but he shared the same fate in March 1556, steadfastly extending into the flames his hand with which he had signed his earlier recantation.

The memorial was designed by Sir George Gilbert Scott, and was modelled on the 'Eleanor crosses' erected in various places by King Edward I in memory of his queen. The martyrs themselves are represented by three statues, Cranmer facing north holding a bible in his hand, with Ridley and Latimer facing east and west respectively. Some early pictures of the memorial, but not this one, show it protected by a railing. The inscription on the base reads:

To the Glory of God and in grateful commemoration of His servants, Thomas Cranmer, Nicholas Ridley, Hugh Latimer, Prelates of the Church of England, who near this spot yielded their bodies to be burned, bearing witness to the sacred truths which they had affirmed and maintained against the errors of the Church of Rome, and rejoicing that to them it was given not only to believe in Christ, but also to suffer for his sake; this monument was erected by public subscription in the year of our Lord God MDCCCXLI.

The Martyrs' Memorial from the north, 1850. The Memorial had been erected in 1841, prompted by the Catholicizing tendencies of the Oxford Movement, to remind England of its Protestant heritage.

OXFORD ALMANACK

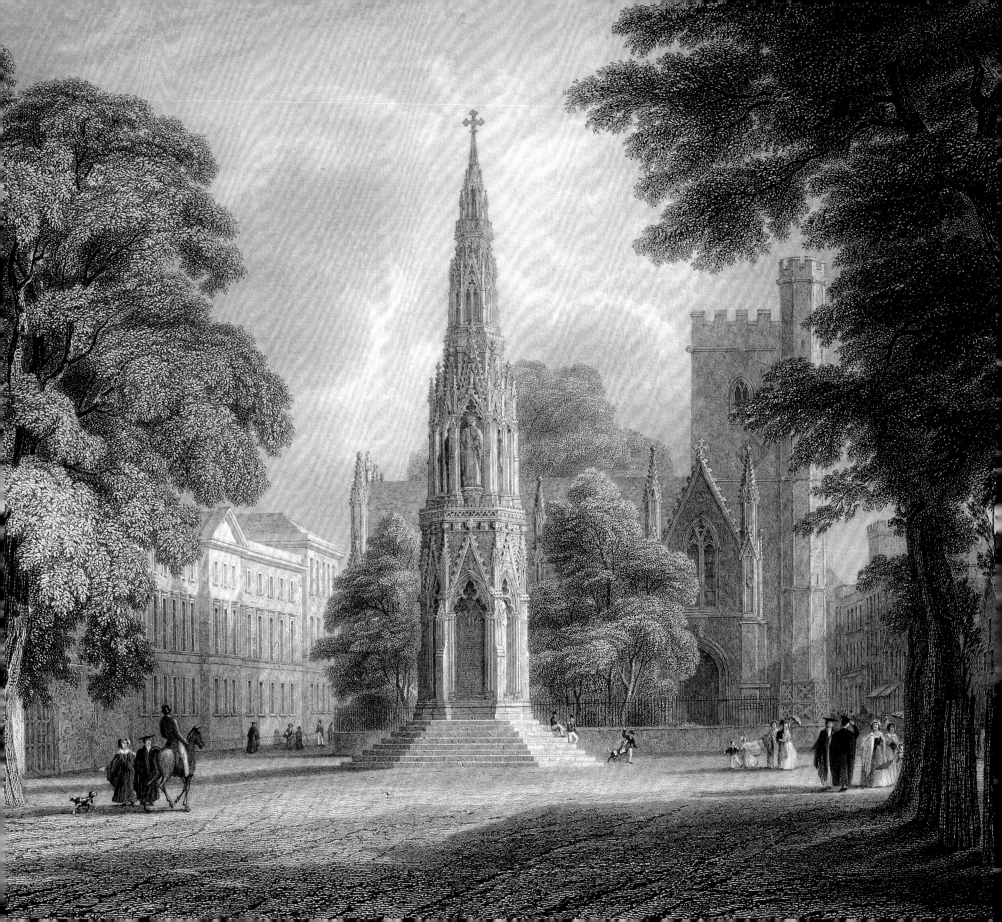

ST GILES

ST GILES is the noblest and most spacious street in Oxford, in fact it is so broad that it may be termed a boulevard, like the Champs Elysées in Paris or Berlin's Unter den Linden, and like them it is lined near its edges with great trees. It has more sky than any other street in Oxford and, orientated north to south, it receives long hours of sunlight on both its sides, unlike the High Street, whose south side is all too often sunk in shadow. This intriguing open space in the heart of city has an early medieval church placed symmetrically at each end, St Giles to the north – dedicated to an immensely popular saint in England in the Middle Ages, revered as the patron saint of the poor and the crippled – and St Mary Magdalen to the south. Both are now islanded in ceaseless road traffic, St Mary Magdalen's situation being the worse of the two. By St Giles Church, the great boulevard branches in two, to become the Woodstock Road and the Banbury Road.

Judging from the old maps, St Giles was the first suburb outside the walls of Oxford and was built up with houses along its entire length by the sixteenth century, although it remained rural in feel. Old prints show herds of sheep and cattle being driven through it to market. The imposing front of St John's College stands on the east side, while the southern end was transformed in the nineteenth century by the building of the Taylorian-Ashmolean and of the Martyrs' Memorial. Both sides of the street have ancient inns: on the east is the Lamb and Flag, the emblem of St John the Baptist, named for the neighbouring college on whose property it stands, while on the west lies the more famous Eagle and Child, haunt of Oxford's first historian, Anthony à Wood, in the seventeenth century, and now celebrated as the meeting place of the Inklings writers' group, which included J.R.R. Tolkien and C.S. Lewis.

St Giles with its church in the background, 1837. This is another picture which, whether by accident or intention,
underlines the still rural character of Oxford at that time, offering us an image of almost idyllic innocence and peace.

MEMORIALS OF OXFORD

THE UNIVERSITY MUSEUM

AT THE MID-POINT of the nineteenth century, Oxford was awakening to the need to make new provisions for the teaching of science. Consequently, an Honours School of Natural Science was begun in 1850 and a related new museum was planned, to be dedicated to the world's fauna. This was opened in 1860 in a building which remains a gem of Victorian Gothic architecture, designed by Benjamin Woodward. One of the leading proponents of the scheme was Sir Henry Acland, professor of medicine and a close friend of Ruskin, who also influenced the design of the new building. The use of iron pillars and a glass roof may have been influenced by the Crystal Palace, but the elaborate stone columns carved from a huge variety of rock-types, and the decorations based on natural forms, reflected Ruskin's didactic energy, as did the eloquent statues of great scientists which surround the main hall. One rather whimsical feature was the design of a new laboratory, which formed an annex on the southern corner, for it was modelled directly on the Abbot's Kitchen at Glastonbury.

The finished structure was immediately filled with the natural history items from the Ashmolean, together with the geological collection of William Buckland, Oxford's pioneer geological teacher, and the vast number of insect specimens bequeathed to the university by F.W. Hope. The University Museum at once became the centre of a number of scientific departments, including Zoology, Geology, Chemistry, Physics, Mineralogy and Medicine itself, but they soon outgrew their first home and moved into expanded premises. Thus the museum can be seen as the nucleus of the science area, which came to dominate the whole district around the Parks.

There was naturally some resistance to the new institution among the conservative elements within the university. The historic clash of two cultures occurred in the museum itself in 1860, in the famous debate on the Darwinian theory of evolution, where the anti-Darwinian position was voiced at length by Samuel Wilberforce, the Bishop of Oxford. Wilberforce's light, satiric view of the new science was generally agreed to have been vanquished by Thomas Huxley. The museum was soon recognized as a brilliant new feature on the Oxford landscape and it became the model for the much larger South Kensington Museum of Natural History. The endlessly fascinating Pitt-Rivers Museum of Ethnology was built later and opened in 1890, in a linked structure behind (to the east of) the original zoological museum.

*The University Museum, 1860. This building represented the public triumph in Oxford of Victorian Gothic,
which had already appeared in several college chapels; the architect was Benjamin Woodward, but the inspiration was John Ruskin.*

OXFORD ALMANACK

KEBLE COLLEGE

IN JULY 1833 a young Anglican clergyman preached a sermon in the University Church of St Mary's on the theme of 'National Apostasy'. His argument was that the Church of England had become entirely subject to secular political control and was losing, if it had not already lost, its sense of identity as an independent spiritual force within the nation. The young clergyman was John Keble and the sermon stirred the consciences of many who shared his deep unease about the relations between Church and State. This event is acknowledged to be the birth of the Oxford Movement, which came into being within weeks of the sermon and which numbered Newman, Pusey and Froude among its leaders. The influence of the Oxford Movement on the character of the Anglican Church, as it developed throughout the Victorian era and beyond, was incalculable.

Keble was already famous as a poet, the author of *The Christian Year*, a cycle of devotional poems which sold in its tens of thousands, and he was, like Newman, a fellow of Oriel College. A few years later, however, he withdrew from Oxford itself and for thirty years served as the Vicar of Hursley near Winchester, while still remaining an inspirational figure for the Oxford Movement. He died in 1866 and the desire among his friends and supporters to create a memorial to him led to the foundation of the first entirely new Oxford college since Wadham in 1612. The aims and ideals of the new college were to foster the Anglican tradition and also to open Oxford to students who were not children of the rich. They were to be educated especially, but not exclusively, for the Church. Funds were raised by public subscription and a large plot of land was bought from St John's College, opposite the newly opened University Museum. Work began in 1868 and continued for more than ten years. The architect was William Butterfield, who created a novel form of neo-Gothic executed in polychrome brick, which offended many, but seemed to express the twin ideas of looking back to the medieval Christian past, but also forward to a dynamic future. The interior of the chapel is a dazzling exercise in Victorian High Gothic.

At first Keble differed from all other Oxford colleges in being governed by a council which included members from outside the college and outside Oxford. Also there were none of the rich endowments enjoyed by other colleges, the finances being provided entirely by students' fees, as in a private school. From the first there was debate and disagreement as to whether it was or was not a purely theological college. During the course of the twentieth century it was perhaps inevitable that its close links with the Anglican tradition would be loosened and that Keble should become a college open to all branches of secular learning, even though its members are still surrounded by reminders of that tradition.

Keble College Chapel, 1878. Constructed in the 1860s and 1870s, Keble was the first new Oxford college to be built in more than 250 years. It was avowedly Anglican in spirit and the chapel is Gothic in style.

OXFORD ALMANACK

ST CLEMENT'S CHURCH

THE TINY MEDIEVAL CHURCH of St Clement stood originally on the Plain, at the approach to the east side of Magdalen Bridge, or the East Bridge as it then was. The parish of St Clement's lay astride the London Road and became a place of inns, shops and market stalls. Having been severely damaged by the making of fortifications during the Civil War, St Clement's grew steadily in the eighteenth and nineteenth centuries as poor people moved out of the city, for example when they lost their homes to new college building. It was known as a place where many college servants lived and had its own Michaelmas Fair, as well as bull- and bear-baiting.

By the 1820s the church was clearly inadequate for the growing population, and the old church was replaced by a new one built on a site a short distance to the north-east, on the Marston Road. This was one of only a handful of churches and chapels built in Oxford since the Reformation, modelled on the well-preserved medieval church of St Mary the Virgin in Iffley. It was designed in the spare Norman-Romanesque style, partly in a reaction against florid ornament, which would have been out of

place in a working-class parish, and partly because it was less costly. But the gaunt purity of the new church drove one observer to compare it rather crudely to a boiled rabbit. No trace of the old church remains on the Plain, but its medieval bells were taken to the new church. This was built by public subscription, and was completed in 1830. No less a figure than Newman was appointed a curate there, as a kind of guarantee to the subscribers that 'every exertion shall be made to recover the parish from meeting-houses, and on the other hand ale-houses, into which people have been driven for want of convenient Sunday worship'.

When this engraving of it was made, the church was less than ten years old, and the tall arched windows give an indication of the genuine nobility, albeit on a small scale, that the architect, Daniel Robertson, was able to achieve. But there is no doubt that the charm of this picture comes as much if not more from the figures of the three gentlemanly anglers, presumably undergraduates of Magdalen, demonstrating their skills among the reeds and willows of the Cherwell, in their exquisite white shirts and top hats, a sylvan image from Oxford's vanished past.

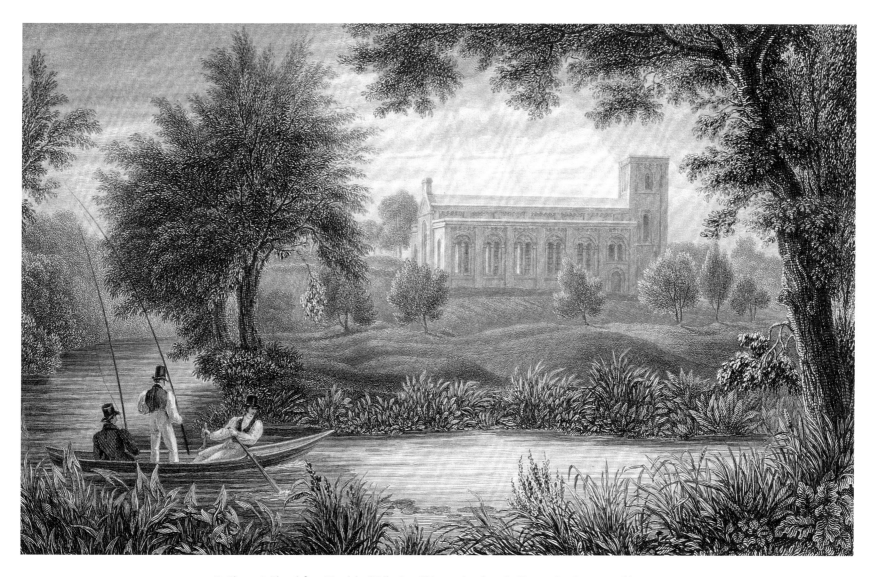

St Clement's Church from Magdalen Walk, 1837. This new church on the Marston Road was opened in 1830, but the real subject of this picture is surely the three exquisitely dressed anglers rowing past on the Cherwell.

MEMORIALS OF OXFORD

ST EBBE'S CHURCH

OXFORD, with its fine architecture of colleges, chapels and libraries, its churchmen, scholars, writers and philosophers, is a place of history and of intellectual achievement. But, like any city, Oxford has had its underside, its places shut away from learning, dignity and ease, and confined instead in the harsher realities of poverty, disease and deprivation. The parish of St Ebbe's became such a place, although so close to the heart of the city, only a few minutes' walk from the gates of Christ Church. From the earliest records it seems to have been a district where the poorest of the population made their homes, a place of plague and periodic flooding from the river nearby. By the seventeenth century it bordered a site of large market gardens, from which the name Paradise appeared on old maps in the fields to the south-west. These gardens, however, did not survive the coming of the industrial age and, in 1820, the parish was profoundly affected by the siting there of a coal-gas extraction plant. This provided work, although hard and poorly paid, while the fumes overspread most of the parish. Unclean water supplies led to cholera outbreaks during the nineteenth century. These living conditions were of course noticed, and many charitable organizations, including some from the colleges, attempted to intervene.

The gas-works finally closed shortly after World War II, but this was of little comfort, because the next act in the St Ebbe's story was about begin, with still more dire results. In the wave of urban renewal from the 1950s to the 1980s, new roads, new car parks and a major new shopping centre effectively destroyed St Ebbe's as a place to live. Virtually all the old housing stock was demolished against the express wishes of most of the inhabitants, many of them being moved to new estates far from the city centre. The revulsion against this type of scorched-earth development came too late for St Ebbe's, but it helped to save Jericho from a similar fate.

The old church of St Ebbe, a medieval saint, was dedicated around the year 1005. Despite periodic repairs, this had to be demolished in 1813, and the new church built in its place is seen here. This picture is a delightful and whimsical snap-shot of street life in the 1830s, which the artist must surely have seen – he can hardly have invented a pair of buskers on stilts with their publicity agent blowing his horn, especially since this was to illustrate a serious historical work. The picture is a reminder of the potential for an unexpected human element to appear in the story of Oxford, especially in its unofficial underside.

St Ebbe's Church, 1837. The most whimsical of all the illustrations in Ingram's work, this is less an architectural record than a piece of street life.

MEMORIALS OF OXFORD

THE EXAMINATION SCHOOLS

THE EXAMINATION SCHOOLS building on the High Street is monumental in several ways. In the first place, its vast and ornate structure is a monument to the individual genius of the architect, Thomas Graham Jackson, who left his imprint very clearly on Oxford, with his work for Hertford, Trinity and at Brasenose. Jackson was first a student and then fellow of Wadham, and was active from the 1860s until World War I. In his work, Jackson reacted against the Victorian passion for the Gothic, and developed an eclectic style, merging elements from the English, Flemish, French and Italian Renaissance. He spoke of his design for the new Schools as being inspired by 'a haunting vision of Elizabethan and Jacobean work', and the building is indeed reminiscent, both inside and out, of a Jacobean country house, with its mullioned windows, tall chimneys and ornate porch, beyond which is a high, galleried hall, which leads into the ground-floor rooms, and to the stairs up to the three imposing 'writing rooms' on the first floor. The country-house image is even clearer in the courtyard façade on the eastern side. The entire scheme of decoration, in stone, plaster and woodwork, is on a lavish scale. With construction in progress initially from 1876 until 1882, the building was so costly that some of the design elements were not completed until thirty years later, while certain planned external decorations never appeared at all.

This great edifice was also a monument to a fundamental change in the life of Oxford University, namely the introduction in the 1850s of written examinations as the essential stepping stone to the award of a degree, as opposed to the traditional *viva voce* exams of the past. These written exams had to be arranged by the university and the only site available, the old Schools Quadrangle, was soon seen to be inadequate and, in fact, was urgently required by the Bodleian Library to house the ceaseless inflow of new books. The Examination Schools may therefore be seen as a visible symbol of the process of change imposed on Oxford by the two Royal Commissions into the working of the university, the first set up in 1850 and the second in 1871, a process which disturbed the peace of centuries and which, once begun, has never ceased. Jackson meanwhile exercised his artistic talent, which was exceptional for an architect, not merely on new buildings, but in designing glassware, organ cases, book covers, and even a college barge for Oriel. In 1892 he put forward his vision of the architect's creative role as, potentially, the designer of man's total environment in his book, co-authored by Norman Shaw, *Architecture: a Profession or an Art.* He was knighted in 1913.

The Examination Schools with Magdalen Tower beyond, 1883. This drawing was by the architect himself, Thomas Graham Jackson, who left a great personal mark on Oxford in the later nineteenth century.

OXFORD ALMANACK

HERTFORD COLLEGE

THE FULL STORY of Hertford College through the centuries would defeat all but the most dedicated student of Oxford history. An academic hall from around the year 1300, known then and long afterwards as Hart Hall, it finally and permanently achieved the status of a college in 1874. The long years in between are a chronicle of mergers or conflicts between Hertford and some of the other colleges, especially Exeter, which was the landlord of its site on Catte Street, and Magdalen, which absorbed Hart Hall for a time in the nineteenth century. These conflicts concerned land, buildings, money, statutes, administration and authority. At some periods the hall flourished, indeed from 1740 until 1805 it was recognized as a college; but there were intervening periods of decline and inactivity. A hall differed from a college mainly in not owning its own site and buildings, and in not possessing endowments which would give it financial security and independence, and as such its fortunes would rise and fall more drastically than those of the colleges. At times Hart Hall was academically successful and popular. Its early students included John Donne, who matriculated there in 1584, possibly because it was reputed to have Roman Catholic leanings – Donne was born into a devout Catholic family. Hart Hall had no chapel then, so that recusants found it easier to hide their secret affiliation. The celebrated Whig leader Charles James Fox enjoyed a happy Oxford career at Hertford in the 1760s.

It was in the mid-Victorian era that the fortunes of Hart Hall improved to such an extent that the new principal, Dr Michell, appointed in 1868, resolved to achieve full collegiate status. This he did with the aid of the banker Charles Baring, who pledged a very large sum to found fellowships and improve the buildings. Michell's successor, Henry Boyd, was able to rebuild much of the old fabric of the college, employing the talents of the leading architect Sir Thomas Jackson, who favoured an amalgam of styles and motifs from a number of past architectural traditions. He virtually rebuilt Hertford, contributing two of Oxford's most distinctive structures, one within the college walls, the other in the public street. The first is the spectacular turret staircase to the upper hall, modelled on those of the French chateaux; the second is the covered bridge which spans New College Lane and links the two wings of Hertford. Disliked by purists, the bridge has nevertheless become possibly the most photographed landmark in Oxford; although popularly known as the Bridge of Sighs, its Venetian model was in reality the Rialto Bridge. Hertford's fame in the twentieth century was boosted considerably by the fact that it was Evelyn Waugh's college and his satirical portraits of Oxford and its personalities somehow became identified in the public imagination with it.

A.ERNEST.SMITH 1891.

Etched by A. ERNEST SMITH

THE NEW HALL OF HERTFORD COLLEGE

The new hall of Hertford College with the dome of the Radcliffe Camera beyond, 1891. This is another of Jackson's works, showing his eclectic style, the ornate external stair turret clearly influenced by French Renaissance models.

OXFORD ALMANACK

LADY MARGARET HALL

'FOR THE RECEPTION OF WOMEN desirous of availing themselves of the special advantages which Oxford offers for higher education': this was the principle behind the founding of Lady Margaret Hall in 1878, the first women's college in Oxford. Technically in 1878 it was not yet a college, nor was it a part of the university: it was at first a hall or hostel, where women might live while they attended classes in other parts of the university. In the early years the young ladies were chaperoned to these outside lectures, but this quaint custom was dropped before very long. Entry into higher education was just one aspect of the movement for women's emancipation, which was gathering pace in late Victorian England. Lady Margaret Hall came into being as an institution with explicit allegiance to the Church of England, and the first chairman of its governing council was Edward Talbot, Warden of Keble College and later Bishop of Winchester. The first principal was Elizabeth Wordsworth, the daughter of a devout Anglican family which numbered within it several bishops. The hall was first sited in one of the large new villas on the Norham estate, leased from St John's College. It remained in Norham, but extensive new buildings reaching down to the River Cherwell were added periodically, together with the unusual Byzantine-style chapel by Giles Gilbert Scott. The hall was named for Lady Margaret Beaufort, the mother of

King Henry VII, a great patron of learning and of the pre-Reformation Church, of whom Stow wrote, 'It would fill a volume to recount her good deeds'.

Within a very few years of its opening, tutors were being appointed to teach within the hall itself, and it was evident that a historic change was under way in Oxford, which many found alarming. Pusey thought that the appearance of women's halls was 'one of the greatest misfortunes that has happened to us, even in our own time in Oxford'. C.L. Dodgson (Lewis Carroll) advanced the highly original suggestion that an entirely separate university for women might be founded. The university itself evidently could not decide how to handle the challenge of women's education. By 1894 it had accepted that women could sit the normal degree examinations, but, with a logic worthy of Lewis Carroll himself, that women could not be awarded degrees, even though, in 1907, ten women obtained First Class Honours. It must have been the social upheaval of the Great War and the arrival of female suffrage which wrought the decisive change, for when this anomaly was debated again in 1920 it was no longer contested, and women were at last admitted as full members of the university. However, an arbitrary limit of 780 was set to the number of women who might attend the university and each college was allowed a quota. This rule was not removed until 1956.

Lady Margaret Hall, 1922. This shows the entrance hall, built in 1909.
The early women's colleges made a clean break with 'Oxford Gothic' and adopted the Queen Anne style.

OXFORD ALMANACK

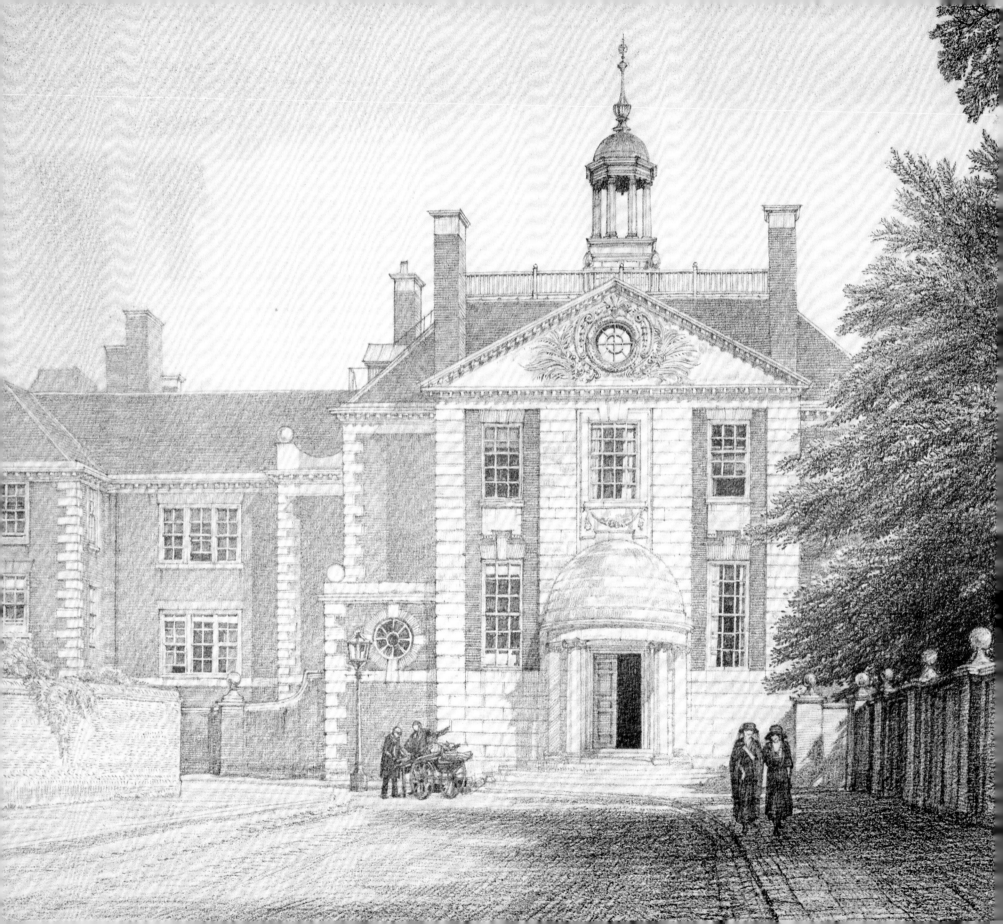

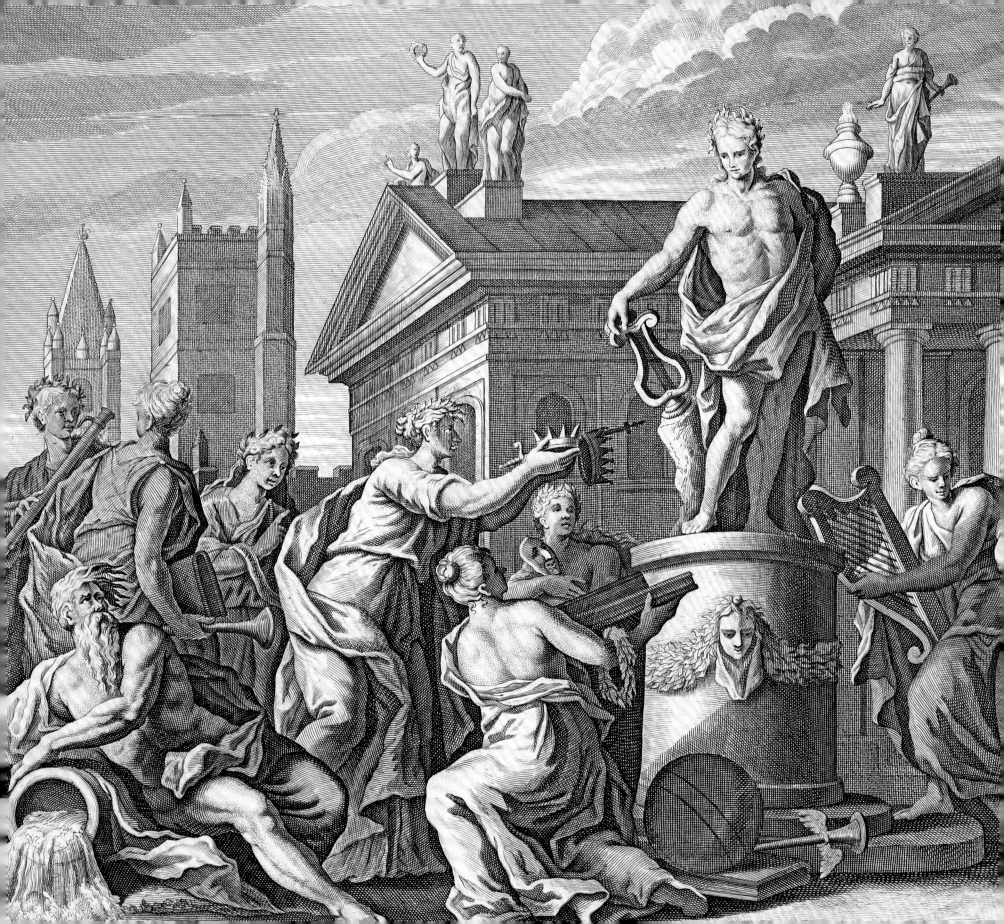

ARTISTS AND ENGRAVERS

PAGE	SUBJECT	SOURCE	ARTIST	ENGRAVER / LITHOGRAPHER
2, 33	Interior of the Divinity School	*History of Oxford*	Frederick Mackenzie	F.C. Lewis
6–7	The university buildings	*Oxonia Depicta*	William Williams	
11	OI title page	*Oxonia Illustrata*	David Loggan	
12	Clarendon Building	Almanack, 1720	James Thornhill	Michael Burghers Claude du Bosc
14	Design for Brasenose College	*Oxonia Depicta*	William Williams	
17	View of Oxford from New College Tower	*History of Oxford*	William Westall	John Bluck
18	The Codrington Library of All Soul's College	*History of Oxford*	Augustus Pugin	John Bluck
21	View of New College from the gardens	*Memorials of Oxford*	Frederick Mackenzie	John le Keux
22–3, 25	The Agas/Ryther map	*Oxonia Depicta*	After Augustine Ryther	William Williams
27	The Schools Quadrangle	*Oxonia Illustrata*	David Loggan	
28–9	The Bodleian Library	*Oxonia Illustrata*	David Loggan	
30–1	The interior of Duke Humfrey's Library	*History of Oxford*	Augustus Pugin	J.C. Stadler
33	Interior of the Divinity School	*History of Oxford*	Frederick Mackenzie	F.C. Lewis
35	New College looking east	*Oxonia Illustrata*	David Loggan	
37	Magdalen College looking east	*Oxonia Illustrata*	David Loggan	
39	Merton College	*Oxonia Illustrata*	David Loggan	
40	Christ Church west front	*Oxonia Depicta*	William Williams	
41	Christ Church Hall	*History of Oxford*	Augustus Pugin	John Bluck
42–3	Christ Church	*Oxonia Illustrata*	David Loggan	
44	Christ Church Hall staircase	*Memorials of Oxford*	Frederick Mackenzie	John le Keux
45	Christ Church Cathedral	*History of Oxford*	Frederick Nash	F.C. Lewis
47	St Mary the Virgin	*Oxonia Illustrata*	David Loggan	
49	Interior of the Sheldonian Theatre	Oxford Almanack, 1820	John Buckler	Joseph Skelton
50	South side of the Sheldonian Theatre	*Oxonia Illustrata*	David Loggan	
51	North side of the Sheldonian Theatre	*Oxonia Illustrata*	David Loggan	
53	University College	*Oxonia Illustrata*	David Loggan	
55	Design for Wadham College	Oxford Almanack, 1738	'Mr Green'	George Vertue
57	St John's College	*Oxonia Depicta*	William Williams	W.H. Toms
59	Corpus Christi College	*Oxonia Depicta*	William Williams	
61	Trinity College	*Oxonia Depicta*	William Williams	
63	The Clarendon Building	*History of Oxford*	Frederick Mackenzie	J.C. Stadler

NOTES

David Loggan had various assistants in the preparation of the plates for *Oxonia Illustrata*, including Michael Burghers, but none of their names appears on any of the plates.

William Williams is believed to have engraved many of the plates for *Oxonia Depicta* himself, but other names do appear on some of the plates. These have been shown where applicable.

Given the large number of copies of the Oxford Almanack that needed to be printed and the finite life of copper plates, it was quite usual for more than one plate to be engraved, sometimes differing in detail and occasionally by more than one engraver. Where applicable both engravers are named.

PICTURE SOURCES

Ashmolean Museum, University of Oxford, Hope Collection: pp. 80–1, 120–1

Ashmolean Museum, University of Oxford, Hope Collection: p. 101

OXFORD, BODLEIAN LIBRARY:

Delamotte, *Original views of Oxford, its colleges, chapels and gardens*, 1843 (G.A. Oxon.a.30): pp. 99, 129

Williams, *Oxonia Depicta*, 1733 (G.A. fol. B 33): pp. 6–7, 14, 40, 57, 59, 61, 85

Loggan, *Oxonia Illustrata* (Arch.Antiq. A II.13): pp. 11, 27, 28–9, 35, 37, 39, 42–3, 47, 50, 51, 53

The Oxford Almanack, 1673 (G.A. Oxon a.88c): pp. 135, 141, 147, 149, 151

A century and a half of designs for the Oxford Almanac, 1866 (G.A. Oxon a.92): pp. 12, 49, 55, 68, 77, 78, 79, 80–1, 89, 91, 111, 115, 118, 125, 127, 139

Ingram, *Memorials of Oxford*, 1832 (Johnson e.2411): pp. 103, 105

Ingram, *Memorials of Oxford*, 1832 (G.A. Oxon 4° 795): pp. 21, 44, 71, 83, 113, 133, 137, 143, 145

Gough Maps 26: pp. 65, 66–7, 116–17

Gough Maps 27: pp. 69, 87, 93

Gough Maps Oxfordshire 2: pp. 22–3, 25

Combe, *A history of the University of Oxford*, 1814 (Sackler Library Rare Book Room XXXVI. C. [fol.]): pp. 2, 17, 18, 30–1, 33, 41, 45, 63, 73, 75, 95, 96–7, 107, 108–9, 123

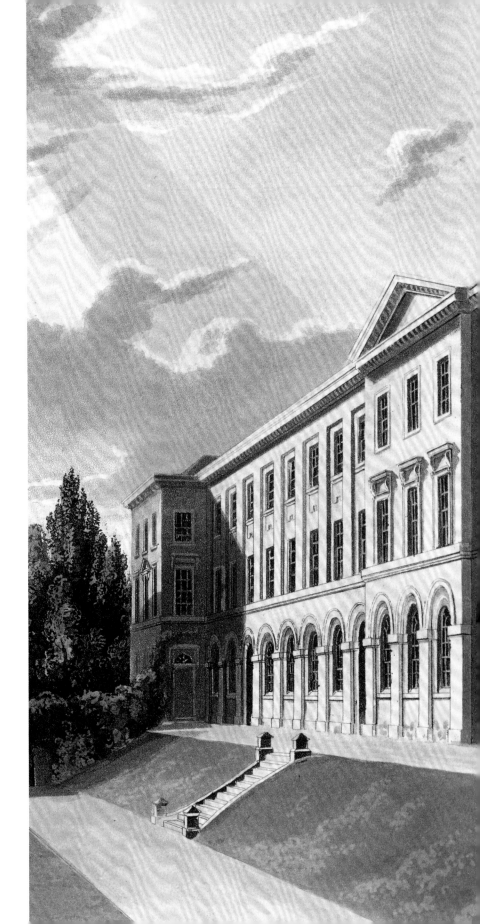

BIBLIOGRAPHY

Buck, Samuel and Nathaniel, *Buck's antiquities: or venerable remains of above four hundred castles, monasteries, palaces, &c., &c. in England and Wales* (London: Robert Sayer, 1774)

Colvin, Howard Montagu, *Unbuilt Oxford* (New Haven, CT: Yale University Press, 1983)

Coombes, William, *A Collection of Views in England and Wales* (London: John & Joseph Boydell, 1790)

Coombes, William, *History of the University of Oxford, its Colleges, Halls, and Public Buildings* 2 vols. (London: Published by L. Harrison & J.C. Leigh for Rudolph Ackermann, 1814)

Curl, James Stevens, *The Erosion of Oxford* (Oxford: Oxford University Press, 1977)

Donowell, John, *Eight views of the colleges and other public buildings of Oxford* (London: John Tinney, 1755)

Geraghty, Anthony, *The Sheldonian Theatre: Architecture and Learning in seventeenth-century Oxford* (New Haven, CT: Yale University Press, 2013)

Green, V.H.H., *A History of Oxford University* (London: Batsford, 1974)

Hebron, Stephen, *Dr Radcliffe's Library* (Oxford: Bodleian Library, 2014)

Hibbert, Christopher & Edward (eds.), *The Encyclopaedia of Oxford* (London: Macmillan & Co. Ltd., 1988)

Ingram, James, *Memorials of Oxford, historical and descriptive accounts of the colleges, halls, churches and other public buildings* (Oxford: John Parker, H. Slatter & W. Graham, 1837)

Kemp, Martin, *The Chapel of Trinity College Oxford* (London: Scala Arts & Heritage, 2013)

Kentish, Brian, (Magna Gallery): *A Catalogue of Antique Maps and Prints of Oxford and Oxfordshire* (Oxford: Magna Gallery, 1987)

Loggan, David, *Oxonia Illustra Sive Omnium Celeberrimae istius Universitatis Collegiorum. Aularum, Bibliothecae Bodleianae, Scholarum Publicum, Theatri Sheldoniani; nec non Urbis Totius Scenographia. Delineavit & Sculpsit Dav: Loggan Univ. Oxon. Chalcographus* (Oxford, 1675)

Nattes, John Claud, *Oxford Delineated; or A Graphic and Descriptive Tour of the University of Oxford* (London, 1833)

Malton, Thomas, *The Oxford Visitor, or Picturesque Views of all the colleges and halls of the University, public buildings City of the City of Oxford* (London: Sherwood, Neely & Jones, 1822)

Markham, Felix, *Oxford* (London: Weidenfeld & Nicolson, 1967)

Ollier, Charles, *Original Views of Oxford, its Colleges, Chapels and Gardens from drawings made expressly for this work by William Alfred Delamotte. Executed in Lithograph by William Gauci, with Historical and Descriptive Notices by Charles Ollier* (London: Thomas Boys, 1843)

Petter, Helen Mary, *The Oxford Almanacks* (Oxford: Clarendon Press, 1974)

Prest, John (ed), *The Illustrated History of Oxford University* (Oxford: Oxford University Press, 1993)

Royal Commission on Historical Monuments: *An Inventory of the Historical Monuments in the City of Oxford* (London: His Majesty's Stationery Office, 1939)

Ryman, James, *Illustrations of Oxford with Select Views of The Colleges, Halls, and other Public Edifices, Including the most Recent Additions and Alterations, with historical and descriptive letter press* (Oxford: James Ryman, 1839)

Skelton, Joseph John, *Oxonia Antiqua Restaurata*, 2 vols. (Oxford: J. Skelton, 1823)

Slatter, Henry, *Views of All the Colleges, Halls and Public Buildings in the University of Oxford with Descriptions which point out to strangers all the places and curiosities more particularly of their notice* (Oxford: Henry Slatter & John Munday, 1824)

The Victoria County History of Oxford, vols. III and IV (Oxford: Oxford University Press, 1954 and 1979)

Summerson, John, *Architecture in Britain, 1530–1830* (London: Penguin, 1953)

Tyack, Geoffrey, *Oxford: An Architectural Guide* (Oxford: Oxford University Press, 1998)

Tyack, Geoffrey, *The Bodleian Library Oxford* (Oxford: Bodleian Library 2000)

Whittock, Nathaniel, *The Microcosm of Oxford Containing a series of Views of the Churches, Colleges, Halls and other Public Buildings of the University and City of Oxford* (London: Bumpus, Hinton & Harris, 1830)

Williams, William, *Oxonia depicta, sive Collegiorum et Aularum in Ipclyta Academia Oxonienis Ichnographica, Orthographica, et Scenographica. Delineatio ... 65 Tabulis Encis eypressa A Guilielmo Williams Cui accedit Uniuscujusque Collegii, Aulaeque Notitia* (Oxford, 1733)

INDEX

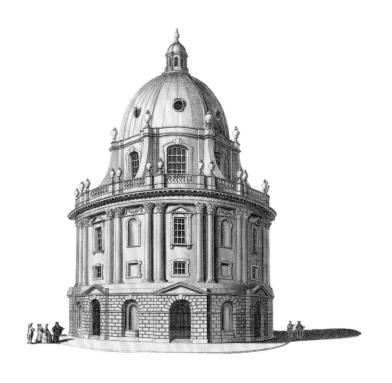